LOUISIANA

A LAND APART

To mom
& DAD WITH
ALL MY LOVE
CHRISTMAS '85
John

GALERIE PRESS INC. LAFAYETTE, LA.

BY PHILIP GOULD

TEXT BY NICHOLAS R. SPITZER

LOUISIANA

A LAND APART

GALERIE PRESS INC.
ISBN #0-917541-01-4
Library of Congress #84-072896
First Edition, 1985

Copies of this book can be purchased by contacting:
GALERIE PRESS INC.
P.O. Box 4608, Lafayette, LA 70502
318-234-5076

CONTENTS

THE COVER: Dewey Balfa, a Cajun fiddler
recognized at home and abroad as a
leader in the renaissance of Cajun culture,
plays at his home south of Basile.

BACK COVER: The New Orleans skyline
glows in a light winter fog from
across the Mississippi River in Algiers.

DESIGN AND ART DIRECTION: Lee Wilfert Nevitt

TEXT EDITING: Barry Ancelet, Sandy Hebert LaBry, and Paul Stahls

TYPESETTING: Print Media, Inc., Lafayette, LA

ARTWORK: Jeff Hand

MARKETING CONSULTANTS: Murphy and Murphy, Inc.

PRINTING: In Korea through Creative Graphics International, Inc., New York, N.Y.

FOREWORD

The first years I lived in Louisiana, I took the state for granted. I was aware of the diverse regions within Louisiana but seldom thought of the state itself. Even when I returned to the Bayou State in 1978 after working three years for the *Dallas Times Herald,* I was more interested in south Louisiana's Cajuns. While photographing for a documentary project on Cajun culture—which later became a book entitled *Les Cadiens d'Asteur/Today's Cajuns*—I learned much about south Louisiana, but comparatively little about the rest of the state. That soon changed.

While completing the Cajun project, I received an assignment from the (then) upcoming magazine *Louisiana Life* to photograph a cover story on Louisiana's Highway One for the magazine's premiere issue. Highway One traverses Louisiana, rising out of the Gulf of Mexico in Grand Isle and rolling out of the state in the Ark-La-Tex corner 400 miles to the northwest. It crosses through Louisiana's principal cultures and terrains, with the exception of New Orleans.

While driving along Highway One for the story, I began to see other regions in Louisiana and how they fit together in the state. The idea of Louisiana itself as a place became intriguing. The Bayou State is a place of regions—of northern red dirt hills where people drink iced tea, of swamps full of crawfishermen and oil wells, and of a Mississippi River port city, surrounded by marsh and water, that seems more like a city-state than an American city. Though Louisiana is quite different from one region to the next, it is held together by an enigmatic thread. The thread can be portrayed as a highway, but it shows itself in other ways. Anyone seeking success in statewide politics must find in that thread, the elusive common denominator of appeal that touches voters whether in Minden, Maurice or Metairie.

Historically the thread was barely visible. Linked by poor roads, different regions of the state had little if any contact with each other. During the last generation, however, improved transportation, communications and a massive oil industry transformed Louisiana. In the process, the state began to meet itself. Shreveport entrepeneurs tasted Cajun culture and cuisine while working in Lafayette's Oil Center. New Orleanians took government jobs in Baton Rouge or work in other parts of the state. People throughout Louisiana traveled to the Gulf to take jobs offshore, and last year people from all parts of the state became better acquainted with New Orleans while visiting the World's Fair.

I was aware of these trends as I began work on this book. After determining what photographs I already had, I set out, with road map and cameras beside me, to do some extensive trans-parish beating of the bushes in search of other images. Guided at first by my own instincts, as well as suggestions from colleagues, I looked throughout Louisiana for those moments of life that were telling of different regions and their place in the state.

When driving across the state, I often tried to determine where different regions actually begin. Going into north Louisiana the change seems nebulous, usually happening somewhere between towns like Ville Platte and Turkey Creek. Rolling south from the Mississippi line through Independence, Hammond and Ponchatoula towards Lake Pontchartrain, the landscape changes rapidly from piney woods to coastal marsh. As one drives from Baton Rouge to New Orleans through Mississippi River parishes full of plantations and refineries, the transition of culture and terrain is gentler. Changes in regions are often marked by signs recognized only by local people: a highway overpass, a gas station or a forest. Sometimes family names on car dealerships and political signs posted along the roads offer good clues.

Occasionally, my travels grew out of various magazine assignments and special projects. Perhaps most interesting was an assignment by Metaform, the firm that designed the state pavilion's "Louisiana Journey" exhibit for the 1984 World's Fair. I was hired to photograph people and good times at fairs and festivals all over the state. Through the magazine assignments, I saw a family reunion in Unionville; I tasted New Orleans Mardi Gras; I stood in the muddy water at a river baptism in Newelton; I looked again at Cajun culture and Louisiana's marshes and bayous; I saw Catahoula dogs chase cattle and snuggle up like children to their owners; I smelled the smoke from burning sugar cane stalks; I saw fortune and failure as men drilled deep into the Tuscaloosa Trend; and I saw Louisiana politics in action as Edwin Edwards sought the governor's chair for an historic third term.

This book is the result of my exploration of the Bayou State. It is not encyclopedic; rather *Louisiana: A Land Apart* is a portrait. After completing it I realized that, though the different regions of Louisiana have become increasingly united, cultural diversity in the state remains strong. In fact, different areas have acquired an even stronger pride in their cultural identity. Whether Cajun, Coushatta, Creole, Isleño, Italian, Yat, black, confederate or "cowboy," peoples' sense of their culture and Louisiana's uniqueness as a state is now more pronounced than ever.

Philip Gould
Autumn 1984

INTRODUCTION

In the lush Louisiana spring of 1974, a man who lives among the rice fields of Acadia Parish was kind enough to take me in as a visitor. He put me up in the "outdoor kitchen," as he laughingly described his guest house in Cajun accented English. The man, a farmer, school bus driver and part-time insurance salesman, had a soft face, light brown hair and soulful French eyes. He was also a fine musician and had been tremendously effective in motivating people to recognize the value of Cajun culture. Now, nearly ten years since we met, he still drives the school bus and in that time has seen more than most in the way of hard times and loss. However, he would agree that he also has had more good friends than most. He still plays Cajun violin and sings his heart out, all the while etching the importance of traditional French culture into the minds of school children and harder-to-reach adults in south Louisiana. He is on the cover of this book. His name is Dewey Balfa, and I am glad he encouraged me to stay and work with Louisiana culture.

In the time since our meeting, I have made the transition from tourist and journalist to folklorist and civil servant. Since then I have also visited communities so isolated by rural remoteness or enclaved by urban ethnicity that they are unknown to many native Louisianians. I have traveled throughout the state from down low in the delta marshlands, among the Spanish and Slavonian cultures of St. Bernard and Plaquemines Parishes, to high in the hills to meet the sons of Choctaws and Anglo-Saxons in Sabine and Union Parishes. Though my first interest was French Louisiana, I soon realized that British, African, Hispanic, Native American and Asian cultures had also left their marks on the state.

Although many Louisianians either aren't aware of or take for granted the cultures and communities in their midst, there is no doubt that the native's view is still the essential one. Thus, all of the ideas expressed in the commentary here have been formed through discussions with Louisiana bluesmen and boat builders, historians and housewives, cooks and duck carvers, preachers and politicians, fishermen and farmers, loggers and roughnecks, among others. Additional ideas were gained by observing what people do, what they make, how they settle the land, how they work, how they play and what they believe.

Folklorists tend to focus on what is old and surviving from the past: a song about the Seven Years War sung in French by an elderly lady from Eunice; the use of Mediterranean pre-Roman colors and concepts in New Orleans' St. Joseph altars; or the presence of the Double Wedding Ring quilt pattern in Lincoln Parish. For example, I was particularly intrigued with the survival of African traditions equaled elsewhere only in the Mississippi Delta and the Georgia Sea Islands. The bright color schemes of the Old World still find their way into some blacks' clothing and houses. The body posture, the body art (handmade india-ink tattoos and gold-plated teeth), the spectacle of the Afro-Caribbean Mardi Gras Indians and the now rare singing of worksongs by which cotton was pressed and railroad tracks made straight, all continue to display the African cultural impact on Louisiana.

The special link that Louisiana had with Senegal, Dahomey and the Congo by way of the French colonization made its African cultural input unique in the United States. The mixture of that input with the European cultures of south Louisiana has produced music and food for which the state is especially famous. Old-time jazz entertains, but it also challenges the listener to comprehend call-response figures, blues tonalities and improvised riffs of Afro-folk origins mingled with the melodic sweetness and instruments of European music. The African-European mix is no less dramatic in rhythm and blues and the birth of rock and roll. Listen to Professor Longhair or Fats Domino, among others, and you hear African concepts of rhythm modified for the melodic instrument. Go north to the Louisiana delta side of the Mississippi River and the black-white musical exchange is equally intense. In that area it involves two folk populations (black and white) rather than the European elite influences found in New Orleans. Ferriday piano man Jerry Lee Lewis, who draws heavily on black blues, shows what it means to "drum" a piano. He has done so ever since his youthful participation in the ecstatic pentacostal religion and is not alone among Louisiana "rockabillies," only the best known.

Although Louisiana's cultural sources are not the only elements to observe in the Bayou State, they certainly form the human base for the state's uniqueness. From the general level of cultural "apartness" one can move closer to see, taste, touch and hear the specific ways Louisiana is different. Consider the music that Louisiana has produced—jazz, blues, Cajun, zydeco, rockabilly, gospel and old time country (some of which we share with the rest of the South, some of which is found nowhere but here). Then look at parallel unique examples in food (gumbo, muffalattas, jambalaya, red beans and rice, meat pies, crawfish bisque), architecture (Creole

cottages, camel-back shotguns, French barns, hip-roofed planta-tions), language (Cajun French, Creole, Isleño Spanish, Choctaw) and boats (Lafitte skiffs, pirogues, *chalands*, semi-submersible oil rigs), not to mention natural resources (crawfish, crabs, turtles, alligators, timber, oil, gas, sulphur, salt) and agricultural produce (hot peppers, perique tobacco, sugar cane, rice, yams). It is easy enough to say that these are the *things* that make the state a land apart. However, it is *people* who carry the cultures, populate the regions, sing the songs, cook the food, speak the languages, pray to the saints, belt the Bible, build the boats and pump the oil. They are the ones who make Louisiana so distinct.

Tradition is strong in Louisiana because many of its cultures have been here a long time. For example, Cajun music in varying forms has cooked with French flavor for over 200 years. *Bateaux* and pirogues have kept people afloat even longer. Gumbo, still a pan-West African word for okra, simmers Native American *filé* and Spanish pepper with local seafood, fowl and rice in a French roux-based gravy. North Louisiana dogtrot cabins, big houses and quilts have kept a lot of people warm for many winters.

Yet, there is a negative counterpoint to tradition in Louisiana where provincialism precludes progress and where literacy is not attained when needed. (Old folks who made a living from the land and water could not read books but could "read" the environment. Young people today often can't read either.) When the feudalistic politics of Cajun kings or redneck bosses transform parishes into fiefdoms and the state capitol into a political Tower of Babel, change is clearly preferable to tradition. When soda fountains and swim-ming pools have closed rather than admit everyone on a sweltering summer day, accommodation is better than tradition. When laissez-faire attitudes towards the disposal of ninetheenth-century farming and fishing wastes persist with twentieth-century poisons, tradition has to change.

As Louisiana's isolation decreased during the growth of the oil industry, many good things came: roads, bridges, schools, libraries and hospitals. The cover of the *Jefferson Parish Yearly Review* in 1938 showed the cornucopia goddess of industry spewing forth fruits of the labors of Louisianians in the oil, gas and sulphur fields. A few years earlier, bas-relief artists carved in the new state capitol limestone images of alligators happily floating over refinery smoke stacks. All this growth, industrialization and change brought new people, new names and new accents into Louisiana. Some people came for better, as we served the energy needs of what might otherwise be a hungry and cold nation. Some, however, came for worse as several south Louisiana towns became inflation-riddled, over-crowded, honky-tonk havens caught up in the bumper-stickered clash between oilfield class and trash.

Louisiana: A Land Apart gives us the visual idea that growth and change are not necessarily good or bad. The larger question is what will this state, so rich in natural and cultural resources, grow into? Will we move into the next century with our sense of place intact? When the oil is gone, like the once plentiful cypress before it, will we have other industries to keep people productive? Will the land and water be pure enough to grow food and fish? Will natives want to work and play here? Will tourists, who now support our third largest industry, still want to visit? Today, many of our traditional cultures are eroding like the state's marshy coastline. Will south Louisiana's Cajuns still sing "Jolie Blonde" in French or English or at all? Will north Louisiana dialects still be the tongue of tales told and rules laid down by parents to children? Will New Orleans remain a great city of the world by holding on to its cultural heritage or will it become just a rhinestone stud on the Sunbelt?

This book looks at Louisiana in the 1980's as these and many other questions are being asked, answered or put off. It shows that Louisiana, contrary to some provincial outside views, is not filled with web-footed people who wrestle alligators on their way to the dancehall. It shows Louisiana is not limited to moonlight and mag-nolias, nor is it a hillbilly backwater. Yet, Louisianians are not without a romance about themselves that is willingly shared with others. Old Creole days, antebellum mansions and manners, cruel carpetbaggers, turn-of-the-century Cajun *fais-do-do's,* old camp meetings, memories of Mardi Gras and African dances on Congo Square, machetes cutting cane and hands picking fields of cotton cannot be forgotten. Louisiana today is still part peasant, colonial, pioneer and frontier just as surely as it is part suburban and Sunbelt. It remains Cajun, Creole, good ol' boy, New Orleans Yat and black. At the same time, newer refugees from Asia, Latin American and the rest of the USA have joined the flow into America's least melted pot. As our memories join the past to the present, Louisiana continues to be a place where genteel lace curtains and Creole ironwork bal-conies are balanced by funky blues and mobile homes. Some plantation houses are romatically restored even beyond their former grandeur, while others fall into ruin. High-tech petro-engineering and computer navigation by supertankers coexist with low-tech levee sandbagging and shrimp net repairs.

Armed with its cultures, memories, families, politics, rituals and dreams, Louisiana rides into the future in pirogues, pick-ups, private jets, golf carts and Trans-Ams. It belongs to the old and new South and retains its French and Caribbean influences. A part of and apart from its past, Louisiana promises to remain America's "land apart" in the future.

Nicholas R. Spitzer
Summer 1984

THE LAND

Louisiana's physical landscape has been shaped by the hands of nature into prairies, *coteaux,* bayous, bluffs, marshes and islands. Louisiana's cultural landscape is measured by man in parishes, plantations, farmsteads, camps, neighborhoods, arpents, acres, gardens and yards. From oil to oysters, the land here is a natural and cultivated source of energy and food. On it we build trade centers and levees, grow cotton and corn, fish for shrimp and bass, play football and revel in Mardi Gras. The land is sacred beneath front yard Virgin statues, vault-filled cemeteries and Tunica burial mounds. The land of Louisiana can renew the spirit with a float trip down the Tickfaw River . . . or it can seem dispiriting as subdivisions swallow fertile farmland.

The state's terrain is varied. It descends from the north to the Gulf of Mexico with gently rolling hills, blufflands, prairies, swamp basins, coastal marshes and the lower delta. In much of the state the land seems more like a "waterscape." From the perspective of Louisiana's "beautiful swimmers"—crawfish, garfish and goo, to name a few—the water along the bayou bottom is as important as the surface. In the marshes shrimp and oysters depend upon a balanced flow of fresh water into salt for life.

The life supporting flow over the Louisiana land, however, can turn treacherous. Mention the years 1897, 1927, 1940, 1973, 1980 or 1983, and Louisiana folks will tell you about the floods. In the upper delta parishes—Concordia, Tensas, East Carroll and Madison—the locals check the river stages in the newspapers each spring the way some people read horoscopes. They know from experience that the same flow that brings rich topsoil and the fresh water for coastal marshlife can also bring death and destruction.

Louisiana people have seen the extremes of rain and currents often enough to presume that the water's volume and force will return no matter how much concrete is poured, no matter how many sandbags are filled. Yet fighting the flood takes on ennobling qualities. Appropriately known as the "Kingfish," Louisiana Governor Huey Long recognized the need to control water's negative impact on the state. During his term as governor, he erected bridges throughout the state and ring-leveed the Atchafalaya Basin. In his wake, politicians in their ties and tan raincoats still flock to the edges of a flood to bag a little symbolic sand.

The scope of the Mississippi River's continental drainage through Louisiana is impressive. It is the territory that Thomas Jefferson purchased from Napoleon in 1803. The Louisiana Purchase stretched from Minnesota, the Dakotas and the Rockies to the Father of Waters' outlet in the Gulf of Mexico.

Looking down upon this riverine labyrinth, the fourth longest such system in the world, a vast array of North American birds wing their way each winter to points south. The annual parade of fast-moving Canvasbacks, Canadian Geese, Ospreys and Blue Herons over this flyway watershed coincides with a slower migration of silt held in animated suspension until it settles in the river's "birdfoot" delta. The current mouth is approximately 6,000 years old (a mere wink in geological time). It is the seventh such outlet the Mississippi has created in the last 9,000 years.

Further upstream the Mississippi's fertile banks provided the lure for eighteenth-century concessions—the predecessors to French, Spanish and American plantations. The river was also the route into Louisiana for many raft-borne Southerners seeking a better life in the nineteenth century. The waterway floated enough cotton, furs and logs to make New Orleans America's leading port prior to the Civil War. In the twentieth century, the lower Mississippi Valley and Gulf Coast combined have become America's "South Coast": a maritime mammoth carrying grain, sugar, oil and coal-fired commerce in vast quantities. Heavy industry wedged among old plantations along the Mississippi between New Orleans and Baton Rouge has earned for the region the title "America's Ruhr Valley."

Today, the Mississippi has two mouths: the second is roughly 70 miles west of New Orleans. The River partially empties into the Gulf of Mexico through the Atchafalaya Basin, the largest river-basin swamp in the United States. As the Basin's main artery, the Atchafalaya River branches from the Mississippi at the Old River Control Structure near Simmesport. It flows past a levee-buttressed Morgan City to the Gulf. The Basin carries 30 percent of the Mississippi's water volume and 135 million tons of silt per year. The silt and water support hardwood forests and farmland in the Basin's upper reaches and Tupelo gum and cypress in the lower half. The southern half evokes surreal images of still, brown water, massive gators, cottonmouths, spooky cypress knees and purple-green carpets of water hyacinths.

The once abundant cypress in the Atchafalaya Basin was a commodity exploited into legend. By the 1930's much of this fine-grained, water-resistant wood had been cut, skidded out, sliced into boards and sent to build fine homes all over the country. Today the silent stumps left behind are like tombstones of the earlier swamp primeval, while large cypress "sinker" logs that remain are salvaged as wooden gold by boat and house builders alike.

The Basin is still amazingly full of crustaceans, fish, fowl and game, attracting droves of commercial fishermen and sport hunters. It is a home away from home to the "swampers" (craw- and catfishermen, turtle and frog trappers) who now live nearby in villages like Pierre Part, Catahoula and Henderson. The Atchafalaya's varied uses have often kept the Basin stuck in the ooze of controversy. Flood control engineers view it primarily as a Mississippi River escape valve floodway. Landowners want flood protection because they are cutting timber and draining the area for grazing and for growing soybeans. Sportsmen want to boat, shoot and hook in the Basin. Local swampers, often along with environmentalists, just want it left alone.

In the meantime, plenty of Louisiana's plain folks continue to build their lives in concert with the water-laced land. Thousands of houses are built on stilts, ferries are still numerous and free, and a few school boats make education accessible to the marsh. Interstate Highway 10 serves as a "swampland expressway" for cars, just as the Intracoastal Canal does for boats and barges.

Louisianians were the first to build offshore oil platforms in 1947. Since the oil boom, the sons of French farmers and fishermen have left traditional land and water trades to join people from north Louisiana, Texas, Michigan and Mississippi in seeking and refining black gold. But the cost to the land and water has also been great. The marshes are increasingly criss-crossed with channels to get boats and workers to and from oil rigs. Salt water is making its way into fresh-water marshes, threatening drinking water and marine breeding grounds. Names like "Tate Cove" and "Devil's Swamp" now mark areas where petrochemical waste "land-farming" has grimly reaped a silent harvest.

The folk economies that dug canals and *trainasses* for pirogues, hunted for ducks and cut logs for dogtrot cabins never made in 200 years the dent that the new technology has made in a single generation with deep-well injection, bulldozers and cross-cut lumbering. "People have got to eat," it is said, but food—our most basic energy source in the form of fish, game and vegetables—can only be produced if the landscape is respected by man and not exploited for short-term profit.

Louisiana's old material culture is our constant reminder of settlement and change on the landscape through time. Looking at this cultural landscape, one can see the influence of the French West Indies in hip roofs and wrap-around porches at plantations like Parlange, Destrehan, Melrose, and Cretien Point. The neoclassical columns, central hallways and exterior chimneys of other "big houses" allude to Anglo-Americans from the Upland South and the Atlantic Tidewater areas. Today the big house is a law office, a resort, a museum or headquarters for a refinery. Subdivisions called "Bocage" or "Plantation Trace" satisfy the continued need for plantation imagery in the mental landscape of some.

Equally important on the cultural landscape are the folk and vernacular settlements of shotgun houses, log cabins and Creole cottages. Though they are rarely commemorated with historical plaques, small cabins and country stores in north Louisiana remind us of the rambling hill farmstead of the Scotch-Irish with root cellar, well, smokehouse, barn and fields made in the forest clearing. Creole cottages in south Louisiana suggest influences from Normandy and the Caribbean with their double doors, central chimneys, sideways gables as well as single-pitch roofs. Rows of shotgun houses on present or former plantation properties symbolize another sort of column that held up the big house. The African labor force living in these buildings shaped the plantation landscape around them according to their cultural tendencies, available natural resources and social restraints. In south Louisiana today plantations, farmsteads and fishing camps still form continuous lines of settlement along such bayous as Lafourche, Terrebonne and Teche.

In north Louisiana people also settled in concert with the terrain. Small farms appeared on Macon Ridge and in the Dolet hills. Plantations were found on the floodplains of the Cane and Red Rivers. Anglos, Spaniards and Indians trapped and fished along the Black River, the Tensas Basin and Catahoula Lake. In the delta cotton was king, though not every man shared the royalty in the annual round of planting, chopping, harvesting and ginning.

Belonging totally to neither north nor south Louisiana's cultural landscape, the Florida Parishes are a mixture of modern plantations, timber camps and truck farms. The piney wood farms and lumber yards of St. Helena and Washington parishes are not unlike much of the Anglo-derived South. The northshore area along Lake Pontchartrain had more influence from French and Choctaw cultures. Today fishermen and tourists alike breathe the ozone-scented air and drink the spring water.

Intersections of rivers and bayous gave rise to the first Indian villages, while roads determined later settlements. The first roads in Louisiana, like the Camino Real to the north and the Old Spanish Trail to the south, connected early colonial settlements. However, water routes continued to be crucial; and towns like Houma and Pierre Part are the results of settlement at a bayou confluence. In north Louisiana courthouse-square towns sprung up at major cross-roads. Later settlements on the southwest prairies prospered only when the railroads came through in the 1880's en route to Texas. Huey Long's administration modernized the state roads. His pride was the Airline Highway, a four-lane road running out of New Orleans to Baton Rouge. Old juke joints, classic bars, hamburger stands and gas stations that line the old artery will speak one day to archaeologists of its past automotive glory.

Louisiana's largest cities, like the countryside, are laid out within the bounds of natural and cultural forces. New Orleans is defined by its crescent of land between Lake Pontchartrain and the Mississippi River. A maze of levees, canals and pumping stations works to keep the city dry and on the map. From the sky New Orleans looks like a giant web of avenues spun from midtown to the river. Downriver in Faubourg Marigny and the city's Ninth Ward, Old World hands seem to have laid out the buildings on angled back streets.

Not far away in Plaquemines Parish, small farms provide fruit and vegetables to New Orleans' old French Market and countless chain groceries. Just outside New Orleans in the opposite direction lies Bucktown, a tiny fishing village built on stilts and now surrounded by suburbs. Near the wharfside restaurants by Bucktown, shrimp are sometimes hauled in by cast net in plain view of the consumer.

Farther upriver the capital city, Baton Rouge, is trying to shine as the buckle of the Sunbelt. People have left the riverside downtown with its state politics and small-city pleasures for the groomed lawns and mini-marts of the Red Stick's vast suburbs. Old small-town Louisiana strives to be like the new Baton Rouge, which in turn emulates Atlanta or Houston. Country banks switch to drive-in tellers, and supermarket chains link the diminishing spaces between villages. People have long since electrified the rural landscape. Once wooden country churches now light the way for believers to their brick houses of God with flourescent bulbs. Urban religious centers even use video to spread the word farther than an electric light can shine.

Despite modern developments, some Louisianians have used their old knowledge of the land to continue to live in harmony with it. Crawfish are plucked from flooded rice fields by mechanical harvesters. On the coastal bayous many people fish for shrimp in the summer, trap in late winter and crawfish into the spring. Some supplement this work twice a month with seven-day shifts offshore. In north Louisiana daily work at the paper mill may be interspersed with raising hogs and tending to corn, melons and other crops. In cities barbers and bus drivers, lawyers and land leasers still ease their grocery bills and improve their diets with backyard gardens.

Much tradition persists on the landscape. The land is still where people toil to give shape to beliefs, desires and dreams. While some stay in the swamps to trap turtles, others have moved to town to work in offices. Many live somewhere in between and keep vans, boats or campers to get back to the land on their own terms. Still others never leave the urban New Orleans neighborhoods where their families have lived and worked for generations.

Today children who grow up playing video games in the suburbs may never see a mule-and-plow lifestyle. Ironically, ribbons of highway which cut efficiently through forests and hills have returned some small towns and rural farmsteads to isolation as travelers, preoccupied with destinations, zoom past. Fishermen and farmers continue to harvest goods from the environment; factories and cars continue to put bad things into it. In the increasingly fast steps of Southern Sunbelt civilization, the search must increase for a balance between nature and technology that will keep the Louisiana landscape a desirable place to live.

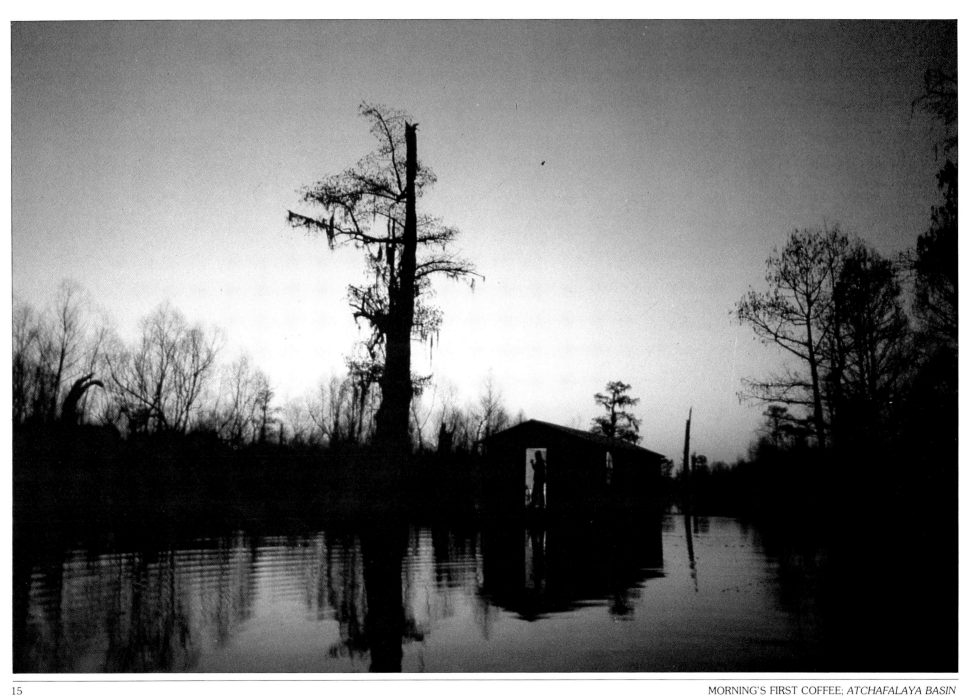

MORNING'S FIRST COFFEE; *ATCHAFALAYA BASIN*

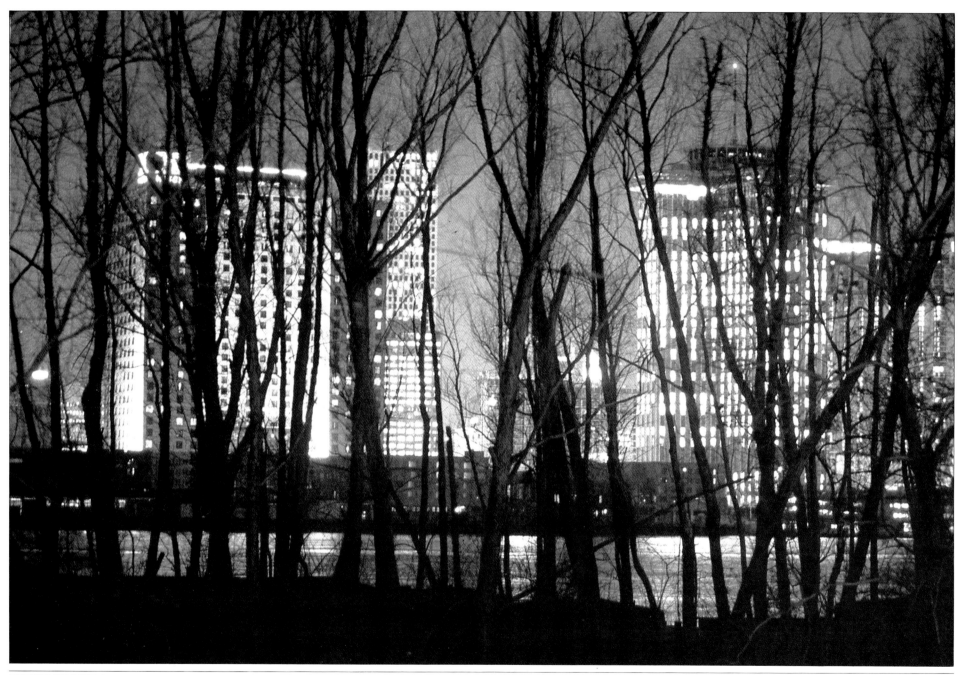

WINTER SKYLINE; *NEW ORLEANS*

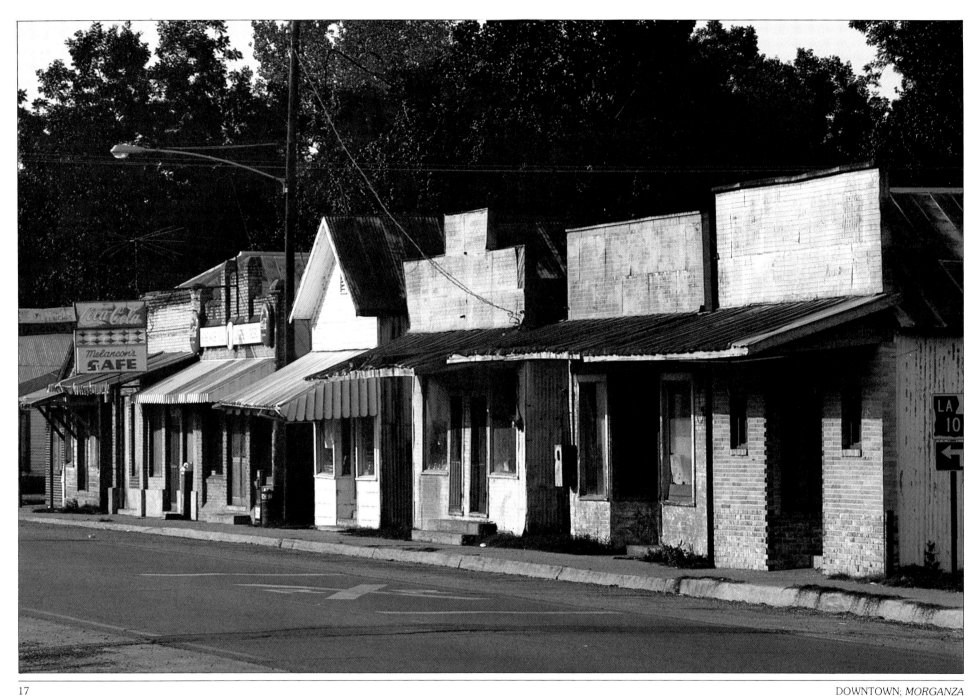

DOWNTOWN; *MORGANZA*

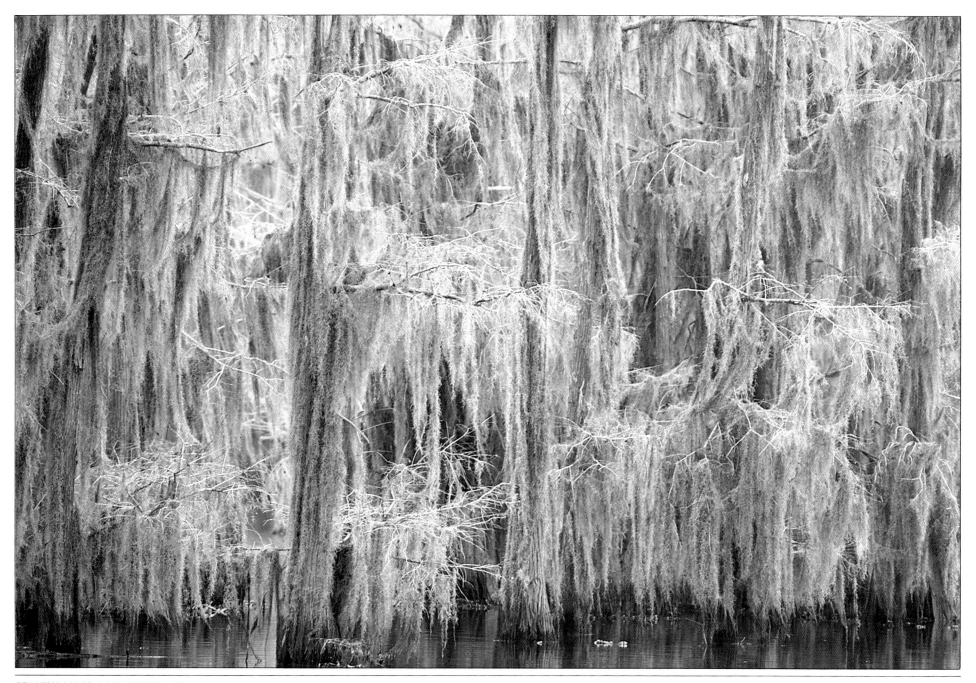

SPANISH MOSS; *LAKE BISTINEAU*

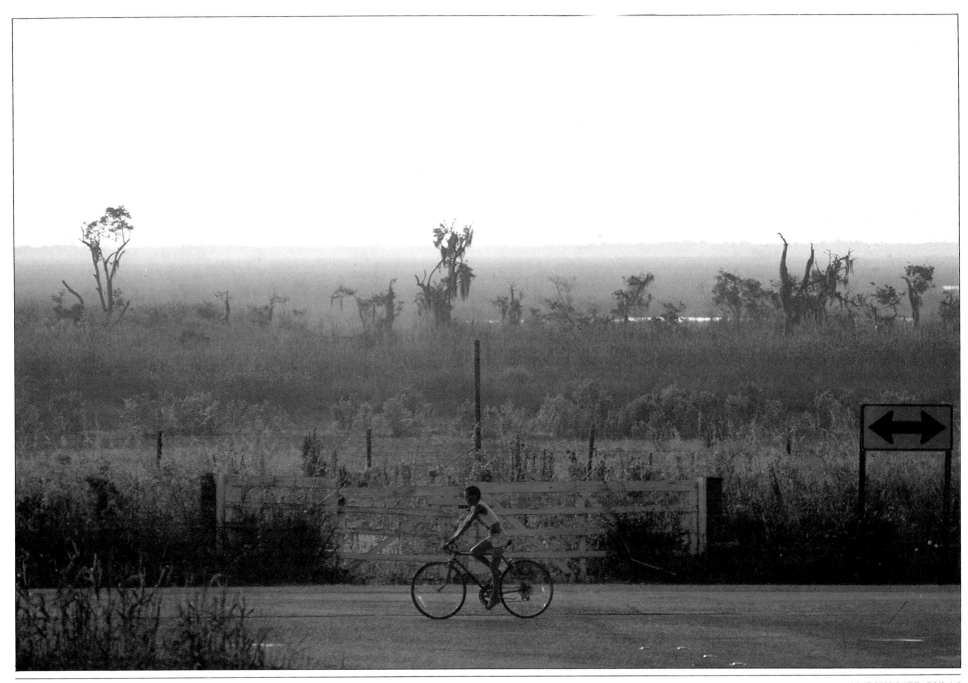

MARSHSCAPE; *DULAC*

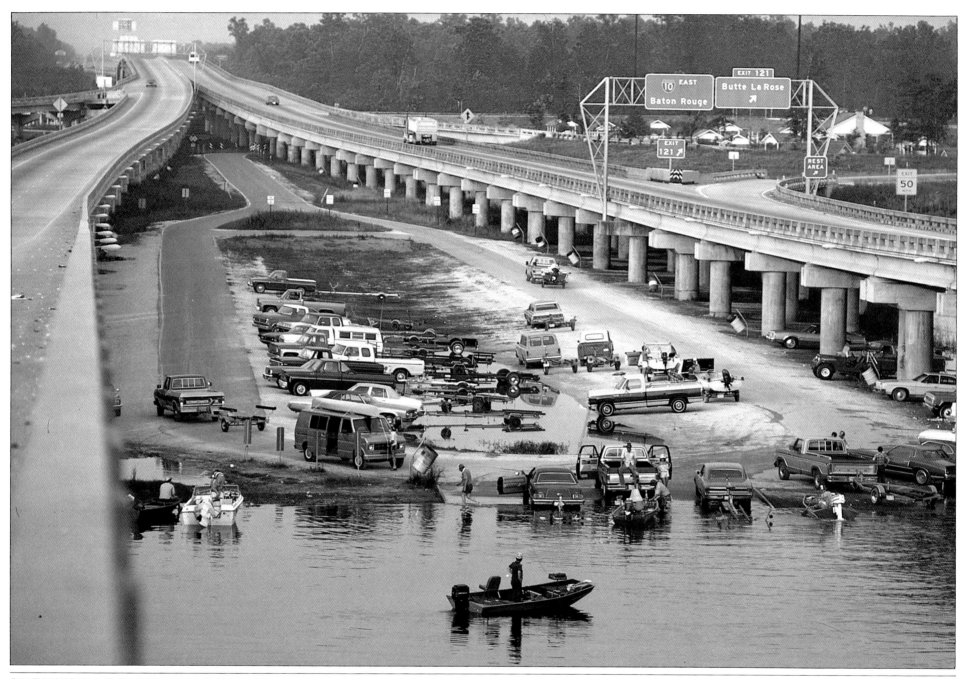

BOAT LANDING; *I-10 ON THE ATCHAFALAYA BASIN*

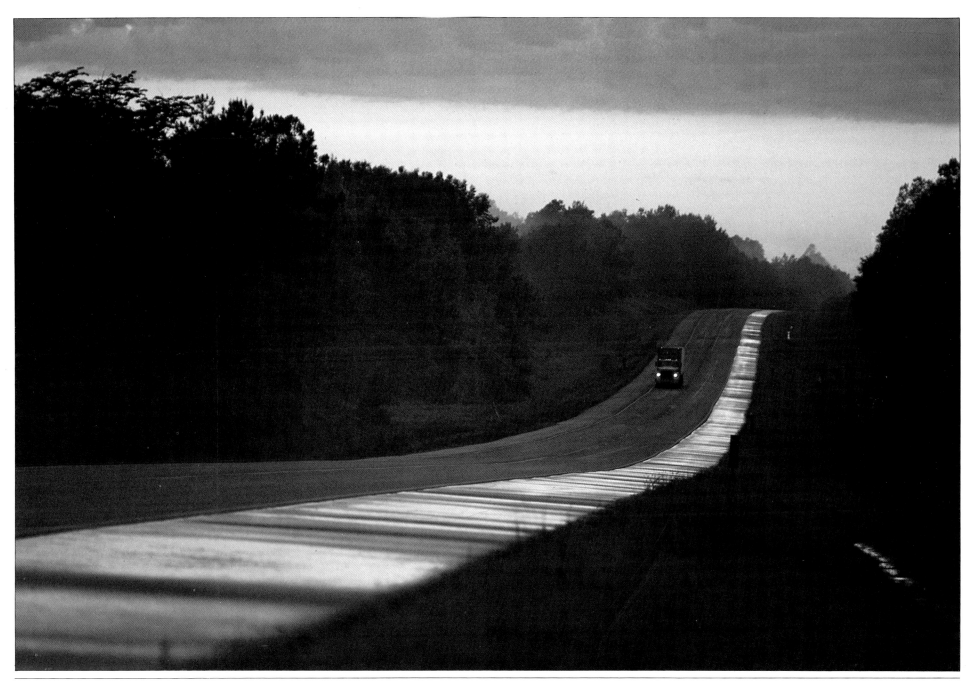

TWILIGHT OF RAINSTORM; *NEAR KISATCHIE NATIONAL FOREST*

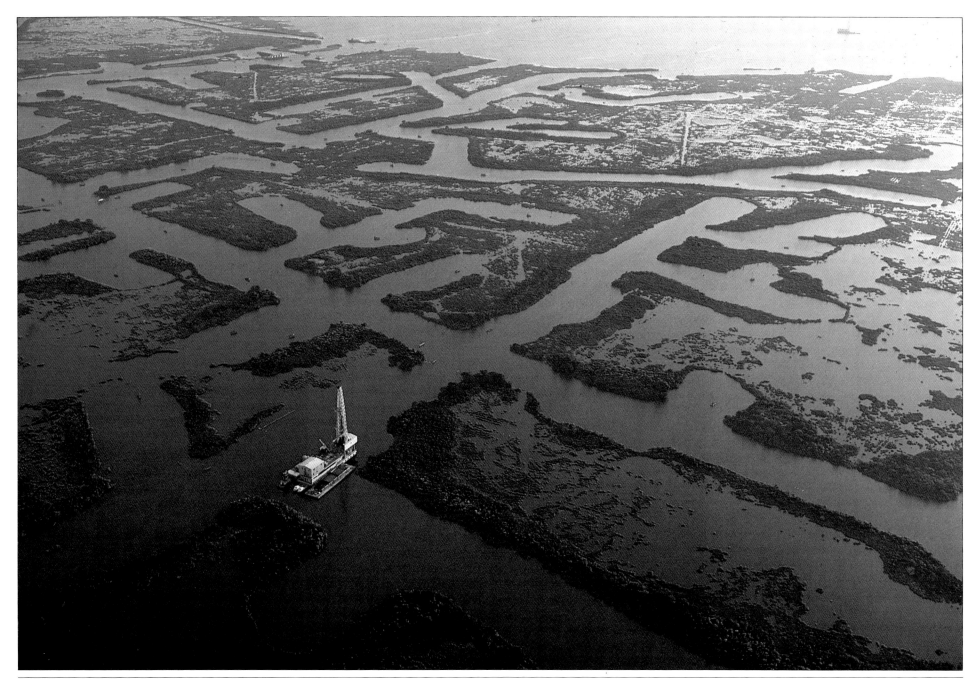

MARSH OIL FIELD; *LEEVILLE*

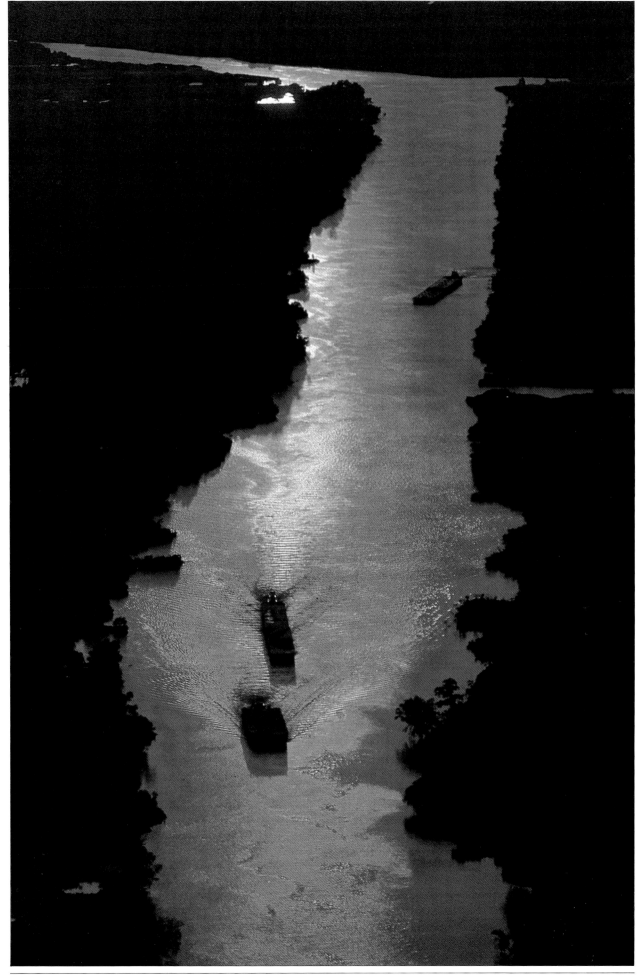

INTRACOASTAL CANAL; *HOUMA*

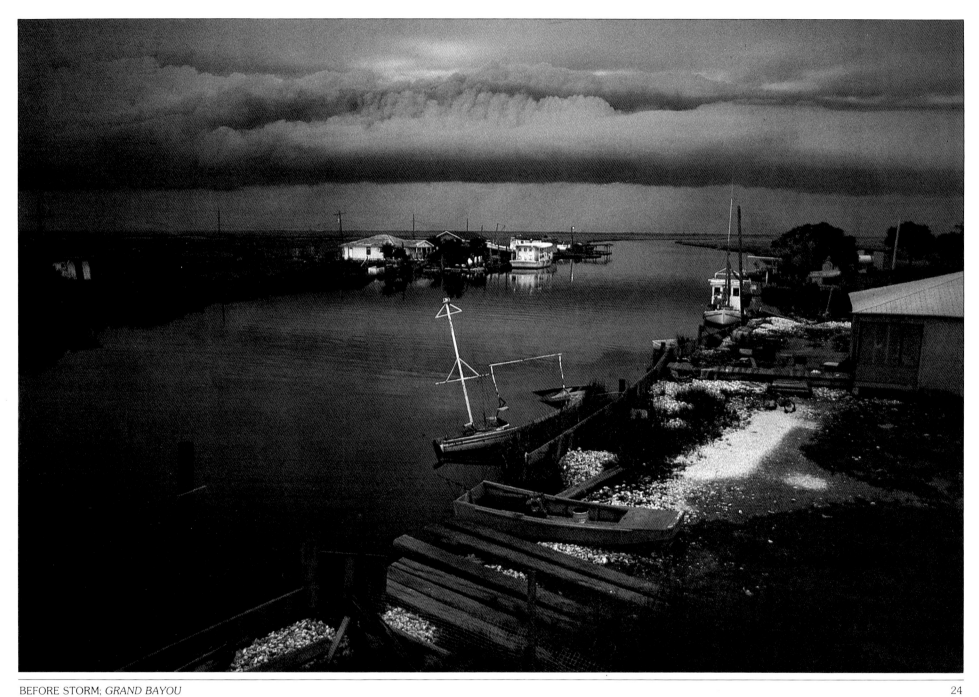

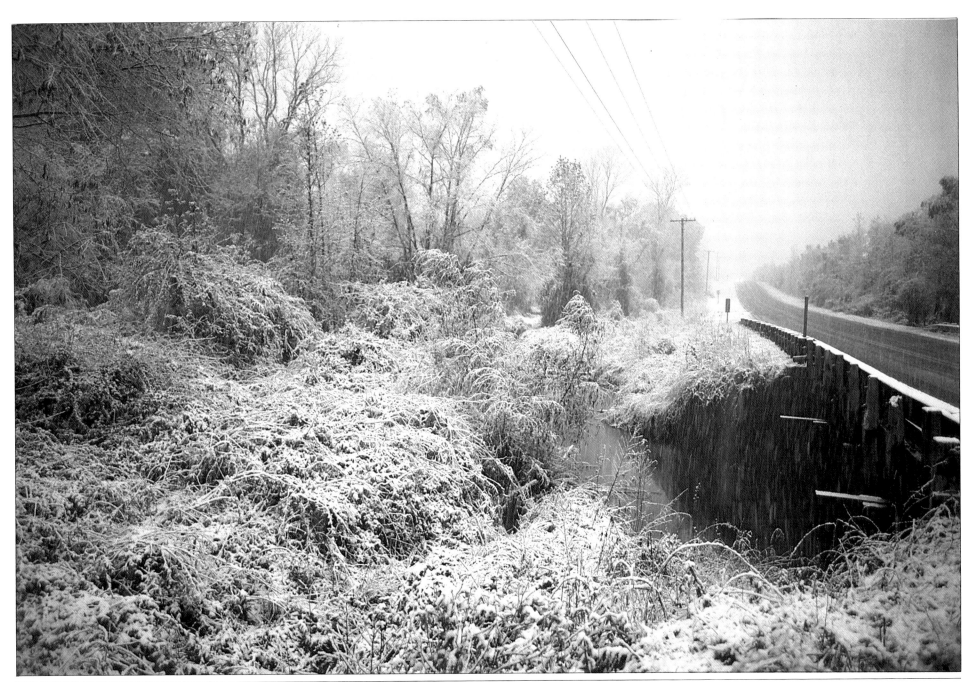

SNOWSTORM; *VIVIAN*

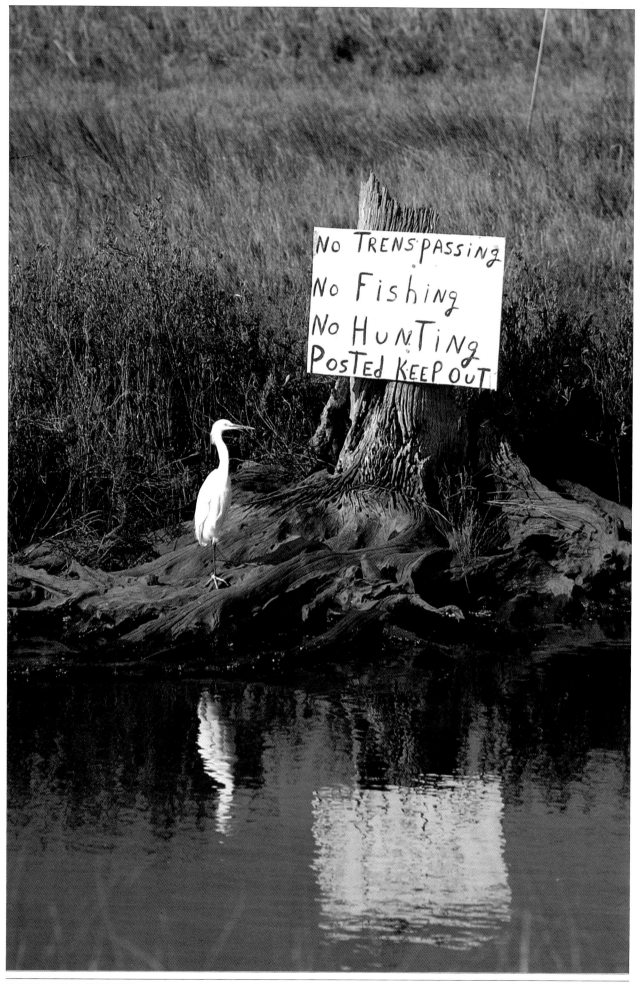

MARSH SIGN; *GRAND ISLE*

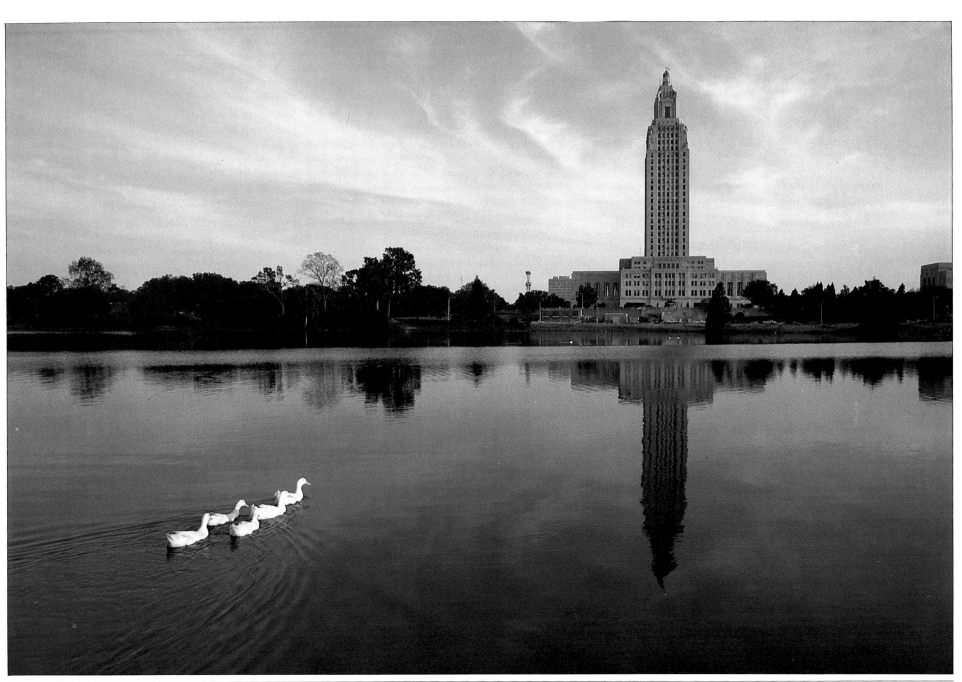

STATE CAPITOL; *BATON ROUGE*

VIRGIN MARY STATUE; *FORKED ISLAND*

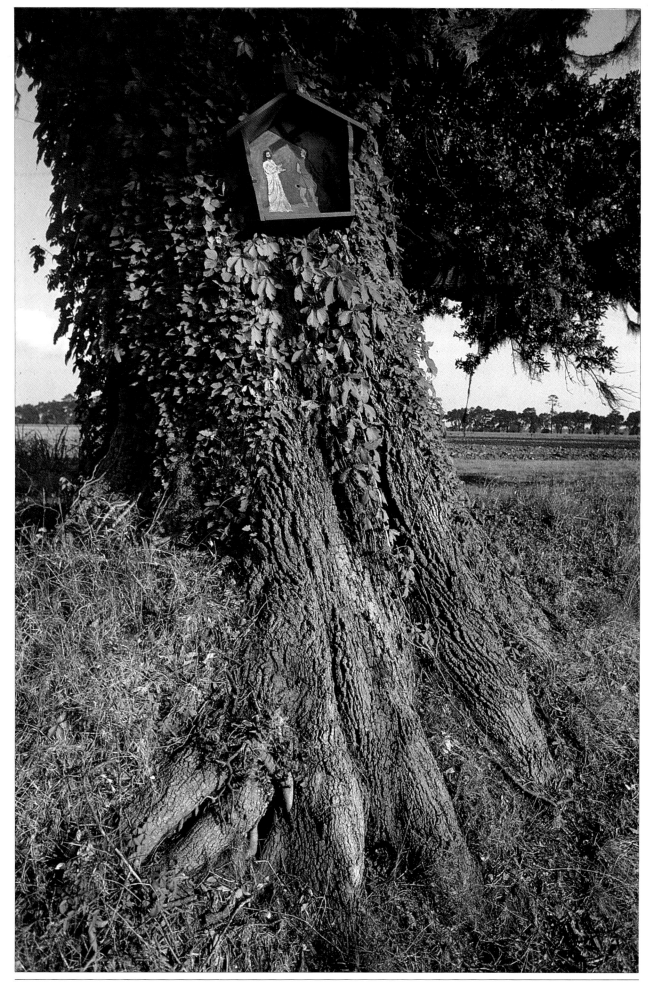

ROADSIDE STATION OF THE CROSS; *ST. MARTINVILLE*

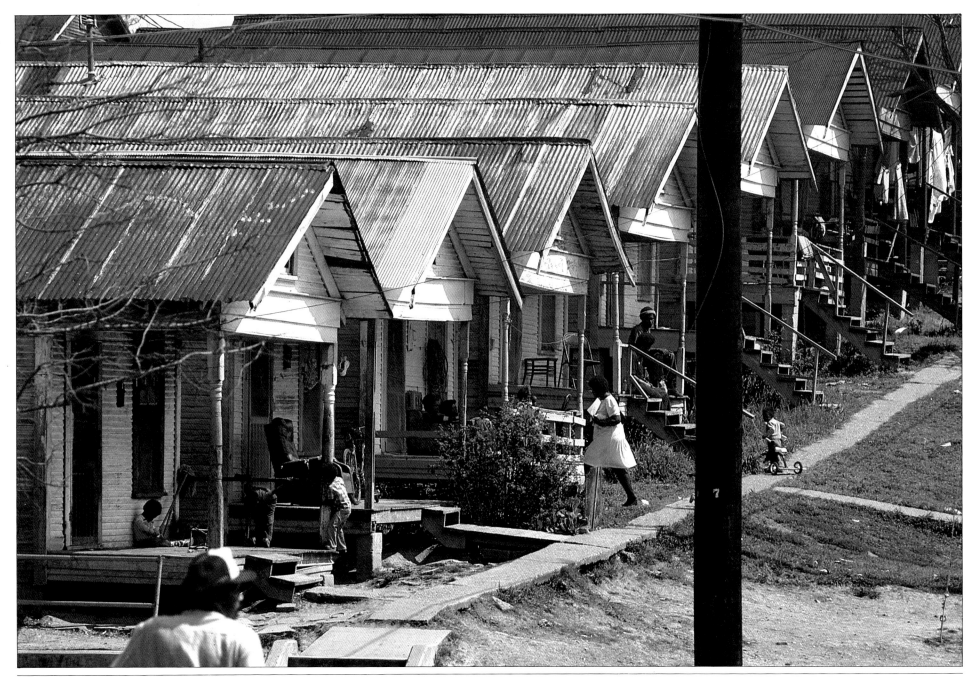

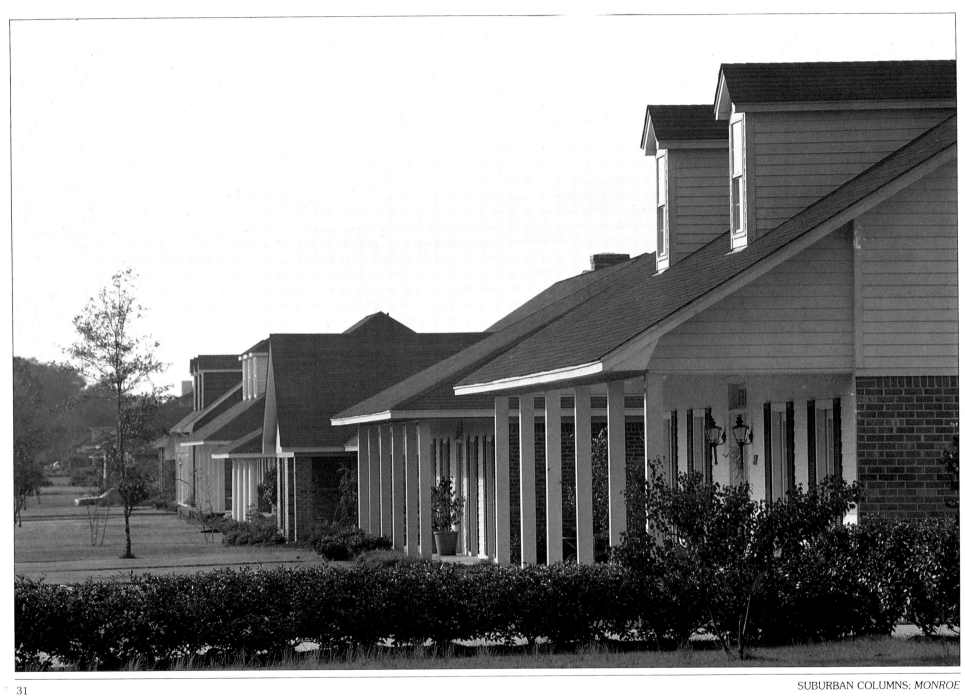

SUBURBAN COLUMNS; *MONROE*

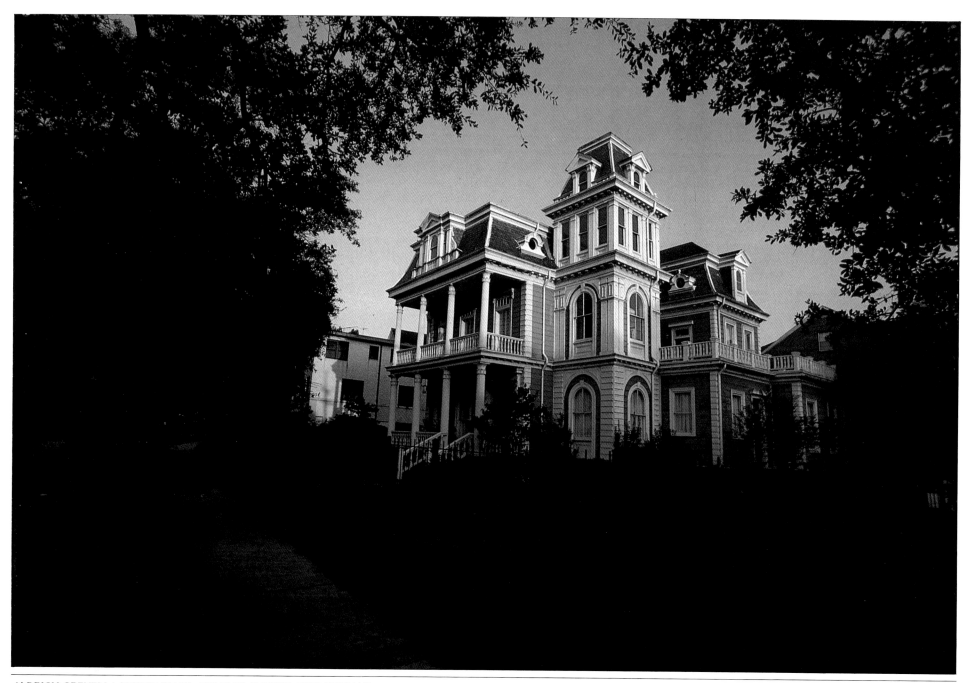

ALDRICH-GRENELLA HOUSE ON ST. CHARLES AVENUE; *NEW ORLEANS*

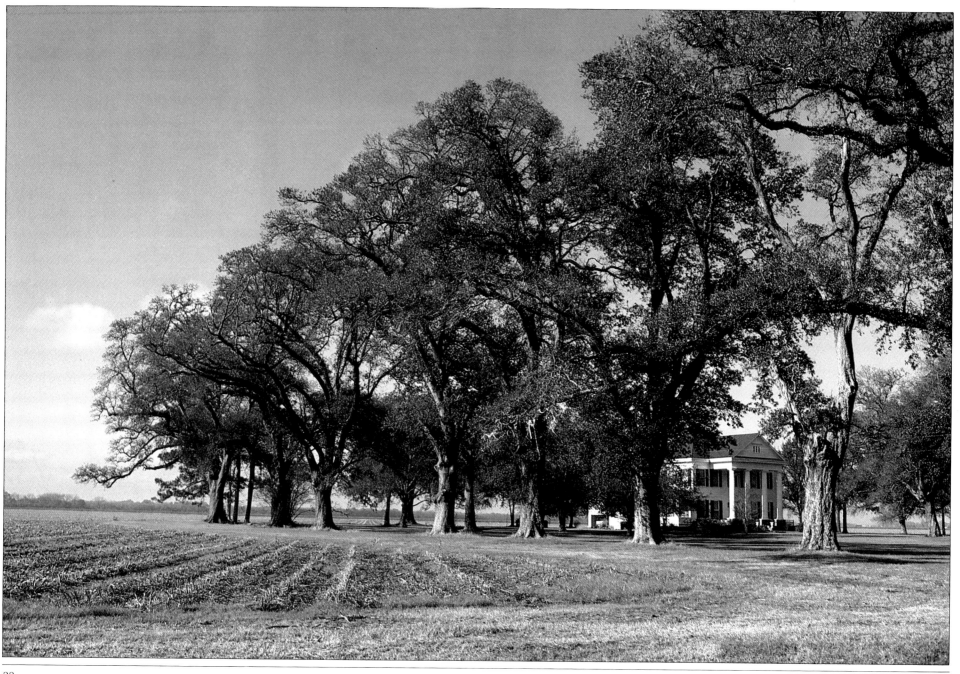

PLANTATION HOME; *BUNKIE*

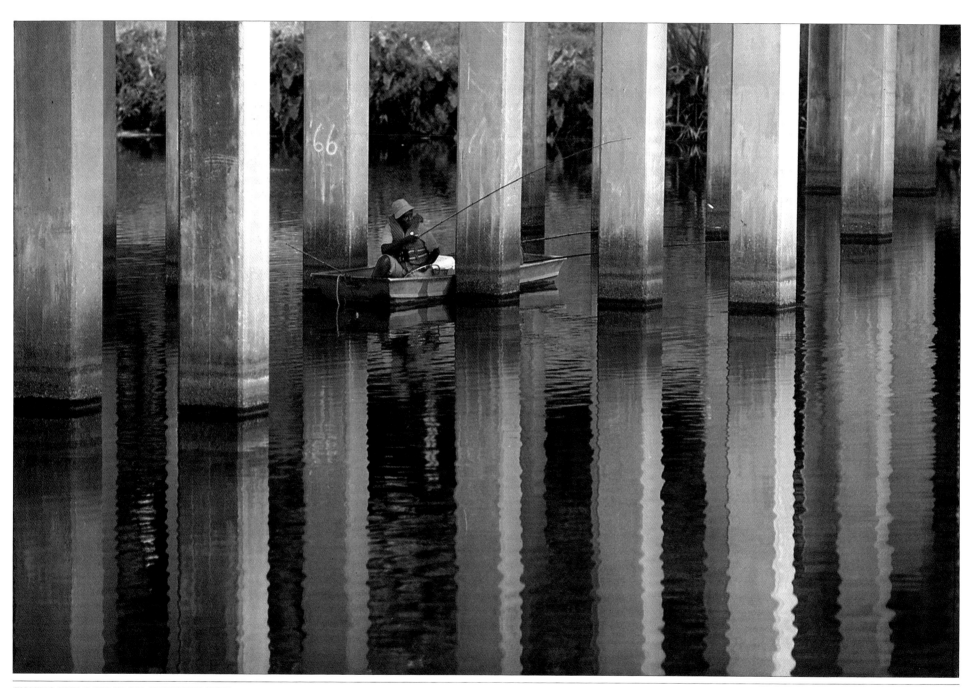

FISHING THE CANE RIVER; *NATCHITOCHES*

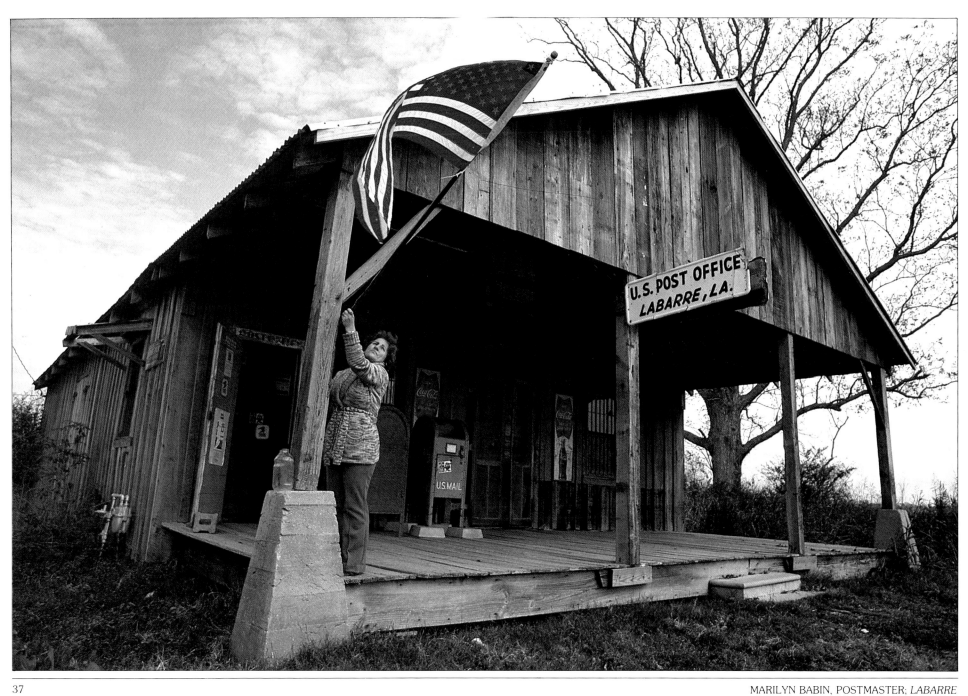

MARILYN BABIN, POSTMASTER; *LABARRE*

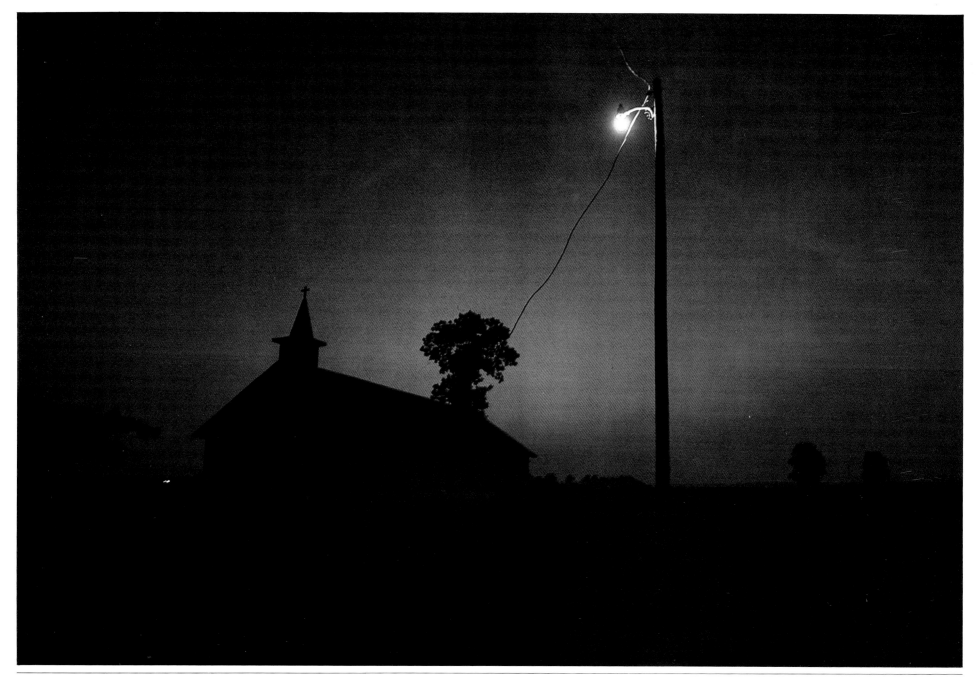

COUNTRY CHURCH; *NEAR VIDALIA*

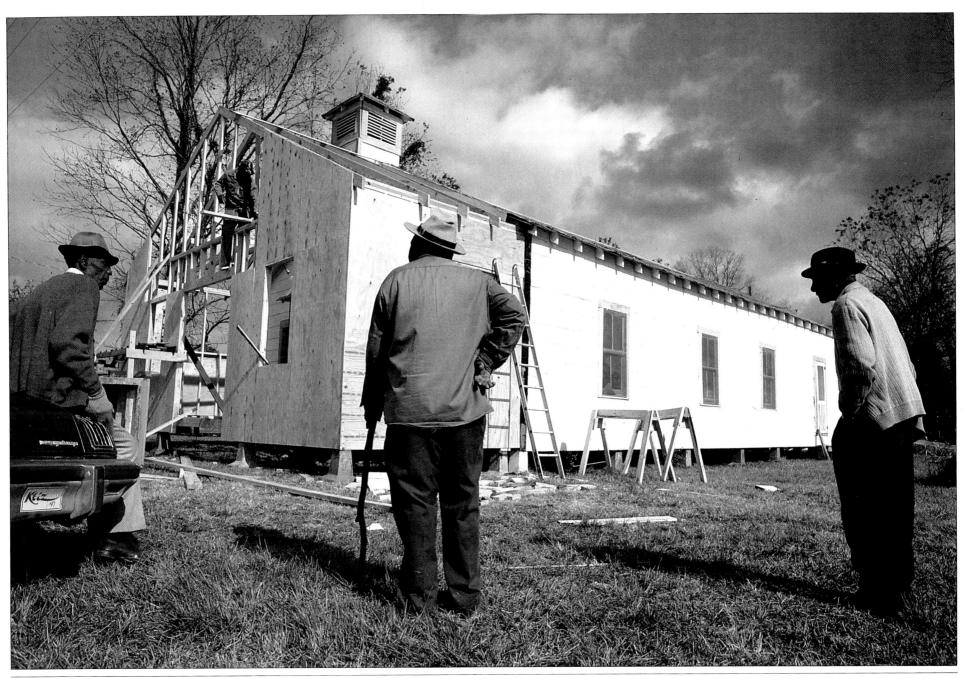

DEACONS OVERSEEING CHURCH CONSTRUCTION; *INNIS*

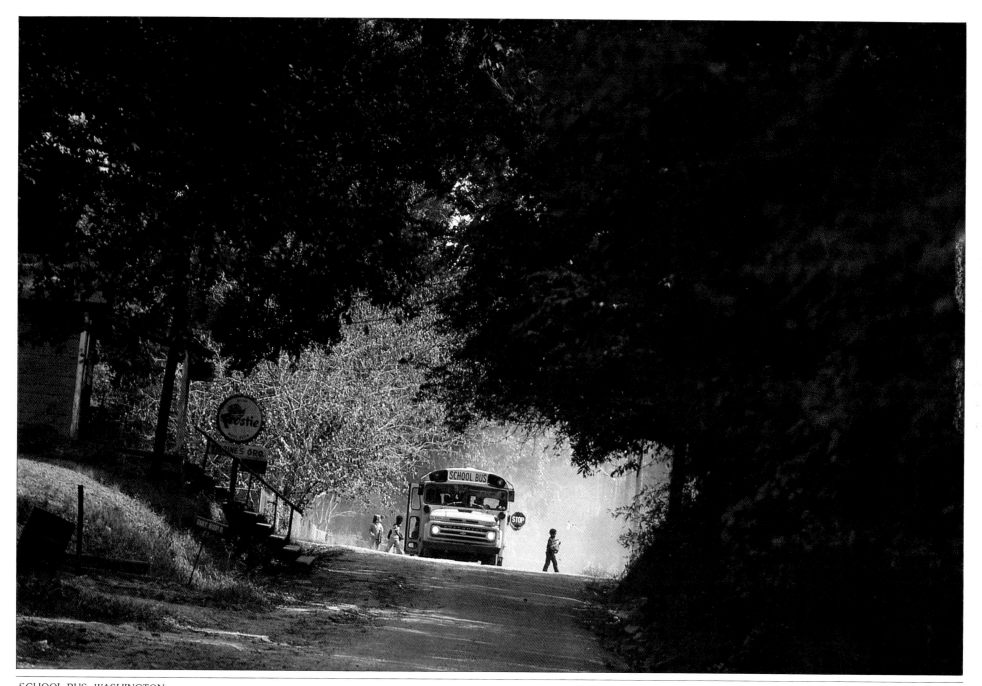

SCHOOL BUS; *WASHINGTON*

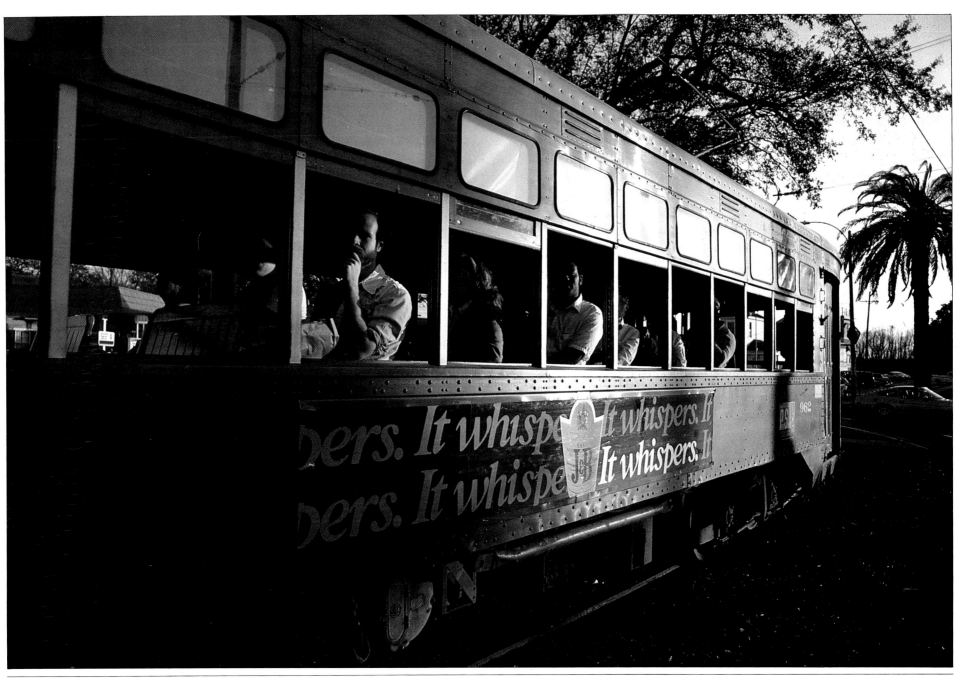

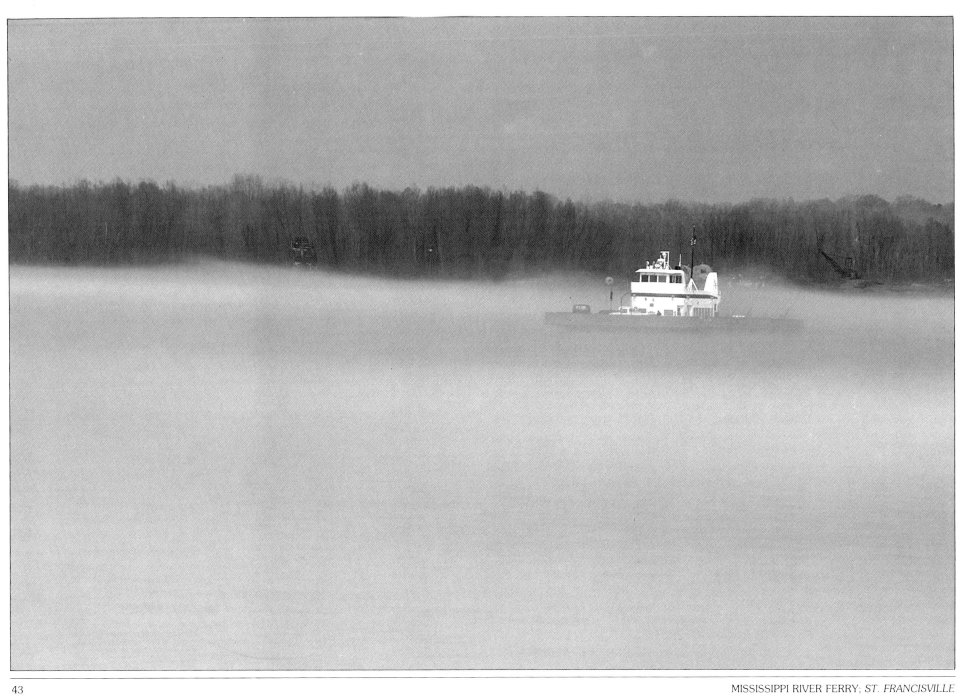

MISSISSIPPI RIVER FERRY; *ST. FRANCISVILLE*

THE PEOPLE

The faces of Louisiana's people present a composite portrait of the state's races, religions, regions and ethnic groups. They are Creole, Cajun, Coushatta, Anglo, black, Italian and Isleño. They reflect the earliest settlement by Native Americans to the latest arrival of Asian refugees. Louisiana's faces change as one travels across the state's varied landscape. In different regions the way people see themselves changes as well.

South Louisiana is well known for its traditions, but it is north Louisiana that is probably the most traditional, most culturally intact region in the state. Anthropologist Pete Gregory, a native of Vidalia, has called the cultural landscape of north Louisiana a "patchwork quilt." This is an apt metaphor since sewing circles of ladies—black and white alike in their respective homes—still gather to piece cotton patches (and now often polyester) into cloth bed coverings in remembrance of weddings, births and kinfolk. Though the finished quilt connotes continuity, it is also a series of strips that stand apart as they are pieced together in patterns like the Flower Garden, the Double Wedding Ring and the Log Cabin.

Diverse dialects of English reveal some of the variety in north Louisiana's social weave. The sons of yeoman farmers, who may have foresaken their stake in the red-clay hills for a mobile home, often speak with the timbre of the upland Southerner. The Shreveport banker may have the trace of a Texas drawl, given the proximity of Louisiana's second largest city to the Lone Star State. Plantation owners or their descendants who remain on the Cane, Red and Mississippi Rivers frequently add a genteel style to the area's repertoire of talk. Most rural people still speak in twangs, drawls and black bottomland dialects about church picnics, tent revivals, wrecks on the highway and family and friends. City people talk about similar things but in dialects smoothed by life in the suburbs and shopping malls. The terms "redneck" and "cracker" are still "smile when you say that" words for people—city or country—who have made the progression from buggy to pickup to Cadillac in the short span of a lifetime.

Anglo-Saxon and Scotch-Irish pioneers began to settle the area above the Red River in the 1700's. People also came from the upland South and the eastern Tidewater basin. These settlers—pioneers, planters, farmers and rivermen—were steeped in Protestant traditions and set the tone for the region ever since. The antebellum aristocracy in north Louisiana consisted of affluent planters who had come from Virginia and the Carolinas to settle the river plains, as well as a variety of mercantilists who traded on the rivers. Postbellum wealth was often acquired through timber and oil. Today's high society in cities like Shreveport, Monroe, Ruston and Alexandria moves in a circle of debutantes, country clubs, the First Baptist, Episcopal and Presbyterian churches, afternoon teas and garden clubbing.

The primary counterpoint to the dominance of white Southern society on the cultural pattern of north Louisiana is in the black communities. Though there is much cultural overlap in religion, foodways and even music—gospel and blues helped beget country and rockabilly—there is still social and cultural separation between working-class whites and blacks. Many blacks continue to live in current or former plantation areas, though over the years families have left seeking a better life upriver in northern cities like St. Louis, Memphis, Chicago and Detroit. Social and economic changes have allowed young people, who might otherwise have been forced to remain on the farm, to go off to college at Grambling and Southern or to work in Houston and California. The old folks stayed home and carried on and now that migratory trend has begun to change direction in recent years as blacks, along with other Americans, have sought the slower pace and rewards of a rural life and a revitalized South. Black communities, old and new, are especially strong in towns in or near the delta region such as Monroe and Vidalia.

Another contrast to the Anglo culture of north Louisiana is a French community along the Cane River south of Natchitoches who refer to themselves as Creoles of Color. The antiques may be crowded into one room of a once grand French house, the china may be cracked, but the pride remains among people who calmly insist, "*Les Américains peuvent pas comprendre que le sang mêlé, c'est plus fort* (Americans can't understand that mixed blood is stronger)." Devoutly Catholic, these people of color, as well as several white families, carry on the French tradition isolated from Cajun and Creole south Louisiana.

Not far west of Natchitoches is the old Spanish border with Texas, once a "no-man's-land" where Spanish and Choctaw people are still part of the cultural mix. Scattered elsewhere in north Louisiana are Chinese merchants in the delta, Italian communities in

Shreveport, Belgians near Many, Yugoslavs in Empire, Czechs in Libuse and Hungarians near Hammond.

Indians in north Louisiana—descendants of the first inhabitants of the region—include the Choctaws at Jena, Clifton and Baker. The Tunica tribe near Marksville and the Coushatta tribe in Elton both border French Louisiana. Remnants of Ofo, Appalache and Avoyel are mixed into the population as well. On the surface many Indians seem culturally like rural whites of an earlier period. For some, however, hide-tanning, tribal foodways and traditional agricultural and hunting techniques are still a part of daily life. The late Tunica chief, Joe Pierrite, said, "We have a promise from the sun: as long as there is a sun there will be Indian people in Louisiana." However, there is little doubt that many with Indian ancestry have melded into the larger black and white populations of the region as tribal identity has weakened.

Taken as a whole, all the people of north Louisiana—from Catahoula Lake catfishermen and market hunters to river planters, Shreveport stockbrokers and Florida Parish strawberry growers to delta sharecroppers and Monroe bankers—identify with the basic cultural fabric of the region. As such, north Louisiana's Indian, pioneer and plantation past, embodied in the peoples and cultures of the hills, bottomlands, piney woods, open ranges and urban centers continues to influence the present.

If the prevailing metaphor for north Louisiana is a patchwork quilt, "gumbo" is the oft-cited cultural recipe for south Louisiana—described by folklorist C. Paige Gutierrez as "south of the South." South Louisiana is Catholic with a thick mix of Cajun, Creole, Italian, Spanish, German, Dalmatian, African and Asian cultures. Its society is linked to the Caribbean by its history as well as its semi-tropical climate and former Creole lifestyles.

Not everyone in south Louisiana is Cajun, not all Cajuns speak French, and not all people of French descent are Cajuns—nevertheless, the predominant cultural accent in rural south Louisiana is Cajun. Initial Cajun settlements were on the Acadian Coast along the Mississippi below Baton Rouge and in the Attakapas military outpost along Bayou Teche. Settlers eventually ventured out to populate the prairies, to build towns along railroad lines and later along highways.

The Acadian migrants to these formerly isolated points and *anses* (coves) had large enough communities around them to maintain the French language, music and lifestyle in a manner less culturally mixed than their ancestral kinfolk in the river parishes of Ascension, Assumption, St. Charles and St. James or the lower bayou parishes

of Lafourche and Terrebonne to the southeast. Still, over the years prairie Cajuns in Mamou, Basile, Duson and Church Point welcomed and absorbed Germans and Anglos into their culture. Today one finds many a French-speaking *jolie blonde* with a name like Schexnayder or Johnson living in Midwestern-style towns like Crowley and Jennings. Cowboy hats, cattle brands and Texas culture have also left their marks on Louisiana's southwest prairies. The Lone Star influence is perhaps most intriguing in the remote grazing reaches of Cameron Parish where Cajun cowboys wear spurs on their rubber boots during cattle roundups in the marsh.

In Lake Charles the oil and chemical industries have intensified and accelerated the Cajuns' mix with Texas. Something of a cultural border town, "Lac Charl'," as people say in French, is fiercely proud, in both a gritty and a refined way, of its boomtown ambiance as well as its ballet companies.

Lafayette, seventy miles east, has also grown at a blinding speed, fueled by the oil industry. The premier Cajun city in Louisiana, Lafayette is home of USL's Ragin' Cajuns, the Council for the Development of French in Louisiana, as well as oil executives, French speaking black Creoles, old Lebanese families, Jewish merchants, Italian politicians, and plenty of restaurateurs and Cajun dancehall operators.

To the north of Cajun Lafayette are Evangeline and Avoyelles Parishes, settled by French royalists and military outcasts during the nineteenth century, which are more Old World French than Cajun. Along the upper Bayou Teche, a glimmer of Spanish and French Creole plantation society is still evident in the grandeur of old homes and families with names like St. Cyr and Delahoussaye who prominently display the retouched tintypes of their ancestors.

In St. Mary Parish on the lower Teche, old Anglo families predominate in towns like Centerville and Franklin with their prominent Presbyterian and Episcopal churches and eastern Tidewater-style architecture. There the people who built the sugar cane industry along Bayou Teche speak with a broad southern dialect. The area is Protestant in a strongly Catholic region. The looming sugar mill smokestacks and plantation/shack communities speak more of the Old South than of French Louisiana.

Along upper Bayou Lafourche, American and French Creole planters have blended with Cajun culture in towns like Paincourtville and Napoleonville. In the backwaters nearby, tiny Pierre Part, one of the only true remaining swamp towns, is filled with dark-haired, dark-eyed Cajuns who move about easily in boats on the bayous that lace the town. A few miles away into the swamp is what little remains of the legendary Bayou Chêne community of

Anglo-American lumbermen, planters and small farmers. Once an English-speaking island in the "sea" of French culture around, it is now an inland Atlantis. Not even the old church steeple breaks the water line since the high water of 1973. Many of those who lived there now make their homes in Bayou Sorrel along the Atchafalaya Basin's eastern ring levee. The accent in this town is piney-woods American, the churches are Baptist and the name Hébert is pronounced "Hee-bert."

South of Houma, the oil town known as "Venice of south Louisiana," one finds the Houma tribe. Pushed by the French and Spanish long ago from their land near the fabled red stick (Baton Rouge), they often speak an old style French and can tell you about medieval traditions like *loups-garous* (werewolves). Among the wooden boat builders of Lafourche and Terrebonne Parishes, Houma tribesmen and their Cajun neighbors are considered masters. Located to the west in Charenton, the Chitimacha Indian tribe is less mixed with the French culture than the Houmas, though they too have long been fishermen and trappers.

Some say that lower Bayou Lafourche was largely populated by Jean Lafitte's crews based long ago on Grand Terre Island and the Barataria region. The French accents of the area are not flat like those of the prairie Cajuns, and the feeling in workboat and shrimping towns like Galliano and Larose is Mediterranean. In lower Jefferson Parish, southeast of New Orleans, are a few descendants of Chinese and Filipinos who worked the shrimp platforms in Barataria Bay into the mid-twentieth century. The Berthude Cemetery in Lafitte summarizes well the complex history of southeast Louisiana. It contains a large Indian mound covered with shells and layers of French, Italian and Spanish tombs along with well-rooted oak trees. Its jumbled slopes are a literal pile of south Louisiana's peoples.

Closer to the Mississippi River, German settlers mixed with French on the "German Coast" between Hahnville and Convent, and families named Zweig became LaBranche while Achtsigers became Quatre-vingts. Nowadays the "Petrochemical Gold Coast" has fragmented the older settlements as company towns like Norco and Good Hope have moved next door to plantations like Oak Alley and Evergreen and old river landing towns like Vacherie, Plaquemine and Welcome.

Downriver from New Orleans, Spaniards, Cajuns, Italians, Creoles and blacks settled mineral-rich Plaquemines Parish. They were joined by Slavonians who brought oyster harvesting practices (tongs and luggerboats) from the Dalmatian coast of Yugoslavia to build hard-working, tradition-minded communities in Empire and Buras. As one "Tacko" (Dalmatian) elder said recently, "My heart still beats for the mother country."

In St. Bernard Parish, Isleño fishermen and trappers share a culture descended from Canary Islanders who came in the late eighteenth century to what was then Spanish Louisiana. Today the older Isleños (Islanders) speak a Spanish which is somewhere between the New and Old World and sing *décimas,* fifteenth-century ballads recounting exploits during the Crusades as well as more recent encounters with alligators and the parish sheriff. The Isleños have worked for over 200 years *entre patos y ratos* (among ducks and muskrats) as trappers and fishermen in isolated villages such as Delacroix Island and Shell Beach.

Long before an ad agency thought up the logo "Louisiana, a Dream State," New Orleans was called "The Land of Dreams" in the song "Basin Street Blues." The allure of the Crescent City to Louisiana country boys, tourists and native New Orleanians is undeniable. Distilled within the city-state's political wards, neighborhoods and aged nineteenth-century grid of streets, are many of the cultures of Louisiana.

Some call New Orleans a Creole city to allude to its elite European forbears born in the French and Spanish colony. Creole also speaks of the descendents of the antebellum *gens libres de couleur* (free people of color), today known as Creoles of Color. Most broadly, creolization refers to the social mixing process that led to the united but diverse population in New Orleans today.

New Orleanians are also known by the once derisive term "Yat," for the accent "Hey where y'at? . . Awrite." To working people of New Orleans the term has become a source of bemused pride. To the outsider this New Orleans accent resembles Brooklyn more than the South. Generally, "Yat" has some attachment to places like the Irish Channel or the lower 9th Ward and a working class esprit de corps among people who know the Crescent City is the only place where they would dream of living.

Historically New Orleans is the natural and economic gateway for all of central North America and the Caribbean. The city has thus taken in tides of immigrants from the dispossessed Acadians to the Creole planters, freemen and slaves seeking refuge from the Haitian revolution, to the nineteenth-century Germans, Irish and Italians. Now people from the Spanish Caribbean Basin, South America and Southeast Asia continue to flood the city and simmer into its ethnic stew. The Vietnamese waiter serving French-style dark-roast coffee to an Italian from the Irish Channel at the Café du Monde confirms that New Orleans' cultural eclecticism is not a thing

of the past. Blacks marching as Indians on the Catholic festival days of Mardi Gras and St. Joseph's remind us that ethnic, racial and cultural identity are much more negotiable or at least performable in New Orleans and south Louisiana than elsewhere in America.

The human element of New Orleans is all too often missed by romantic commentators on the city who choose to focus on creations such as music, architecture and food and who forget that New Orleans people are the creators of these attributes. The mingling of African-American folk musicians with popular and elite European musical performers gave birth of jazz. The city's people also perform gospel music, rhythm-and-blues and street cries. People create and consume the food at K-Paul's, Galatoire's and the Hummingbird Grill. People built the landmarks and neighborhoods from Esplanade Ridge to Bucktown, from Jackson Square to the Garden District. In many shades, but similar accents, New Orleanians participate in a creolized culture that is different from any other urban area in North America. It makes the "Big Easy" more akin to Port-of-Spain, Caracas and Rio than Chicago, San Francisco or New York.

New Orleans is best known for its rites of spring, including Mardi Gras and the newer tradition of the Jazz and Heritage Festival. In the latter, the whole city structure of rich and poor, black, white and in-between, native and tourist opens in a ritual display of everyday social masks. The coexistence of gentility and funkiness in the same city, neighborhood and street has long intrigued visitors to New Orleans. The quizzical couple from Topeka knows this isn't Kansas anymore, but is still not sure what to make of the freewheeling ambiance in the French Quarter, of Creole blacks, of the "gatorland" preppies who stalk tree-lined St. Charles Avenue. Natives don't seem as worried about describing the amazing diversity of this urban "cultural wetland" as just getting through it all in style, while sitting on stoops, going to Catholic school, catching and throwing Mardi Gras beads and living with high water, tourists and all those songs: "Way down yonder in. . . ," "Do you know what it means to miss . . ." or "This time I'm walking to. . . ."

If there is one arena in which the peoples and cultures of Louisiana come together, it is the competitive contact sport of politics. Louisiana politics with its bossmen, banana-republic, populist, Dixiecrat, Sunbelt neo-conservative and progressive elements, is fueled by oratory and strategies as diverse as the people in the state. In Louisiana, where the biggest sin for a governor is to be boring, politics oftens resembles cock fights, horse races and sting operations as much as democracy. The legendary names abound: Huey, Earl and Russell Long, Leander Perez, Jimmie Davis, "Sixty" Rayburn, "Shady" Wall, Dudley LeBlanc, "Cat" Doucet and Edwin Edwards. They have run for governor, Senate or House, sheriff, even alligator control officer. They have run, and voters have cheered and complained as these knights in tarnished armor do ignoble battle to get their opponents indicted or at least investigated just before elections. They have seen more money spent on single campaigns in the Bayou State than is spent on all political races in other states.

Politics in Louisiana is a cyclical ritual and festival made even more fascinating by the faces, families and rival city groups that do battle on the gubernatorial, legislative and police jury levels. These arcane elective dramas reach their audience of voters with a plastering of yard signs, placards and bumperstickers, in French and English, and devastating television spots slickened with a bit of Madison Avenue and caked with lots of Louisiana mud. Politics is the symbolic battleground of a diverse people who fight together and stand apart.

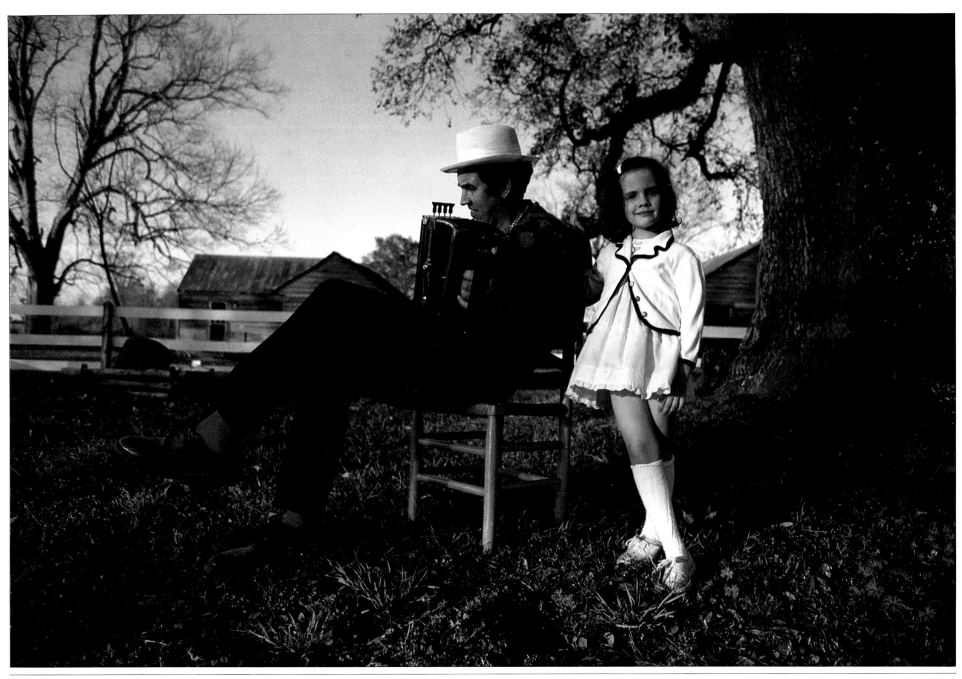

ACCORDIONIST MARC SAVOY AND DAUGHTER SARAH; *EUNICE*

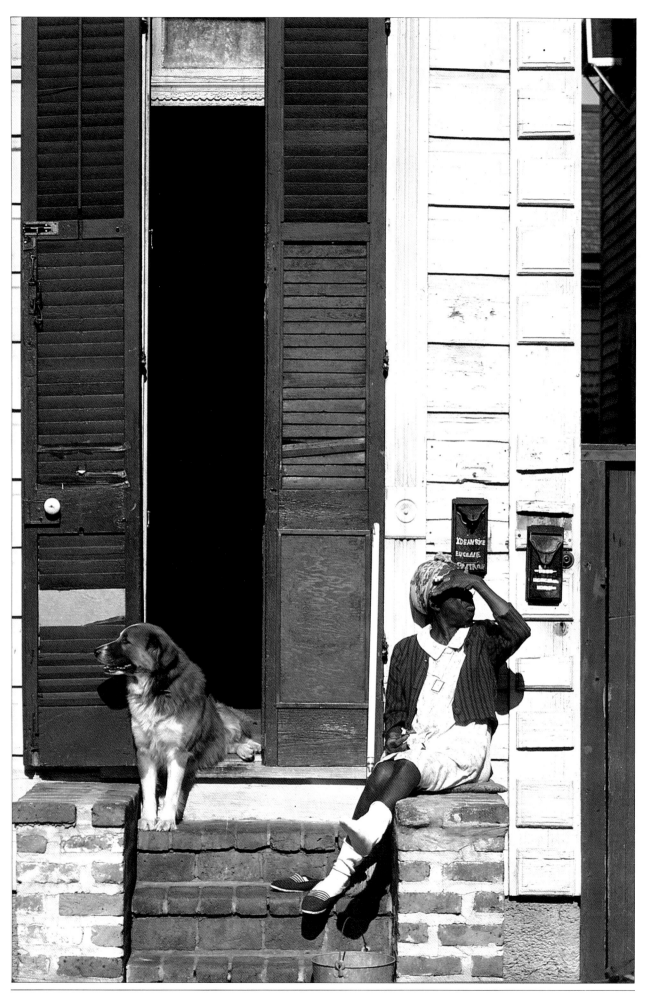

CHECKING OUT THE FRENCH QUARTER; *NEW ORLEANS*

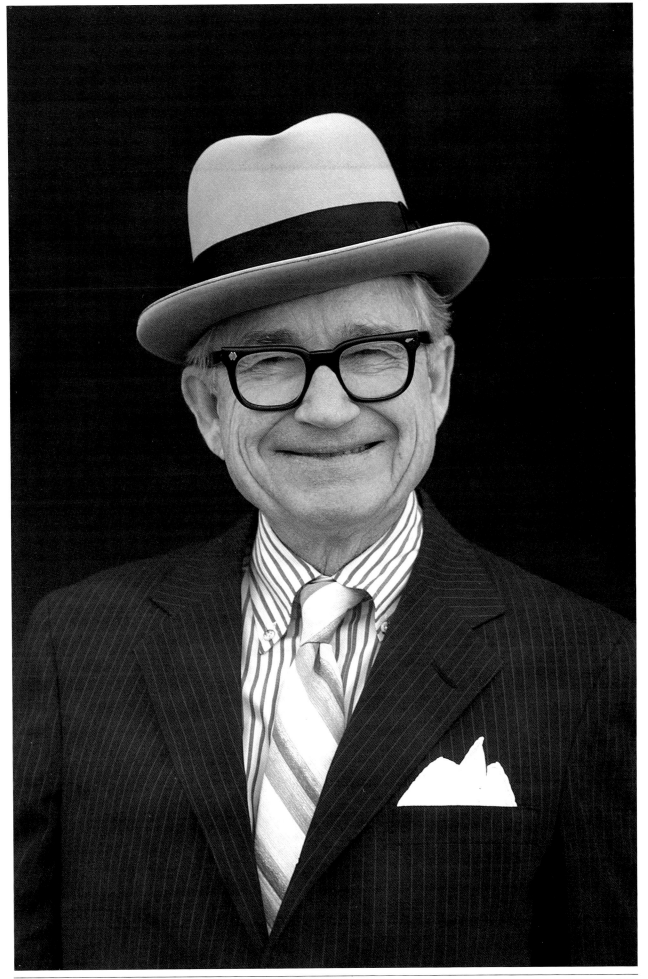

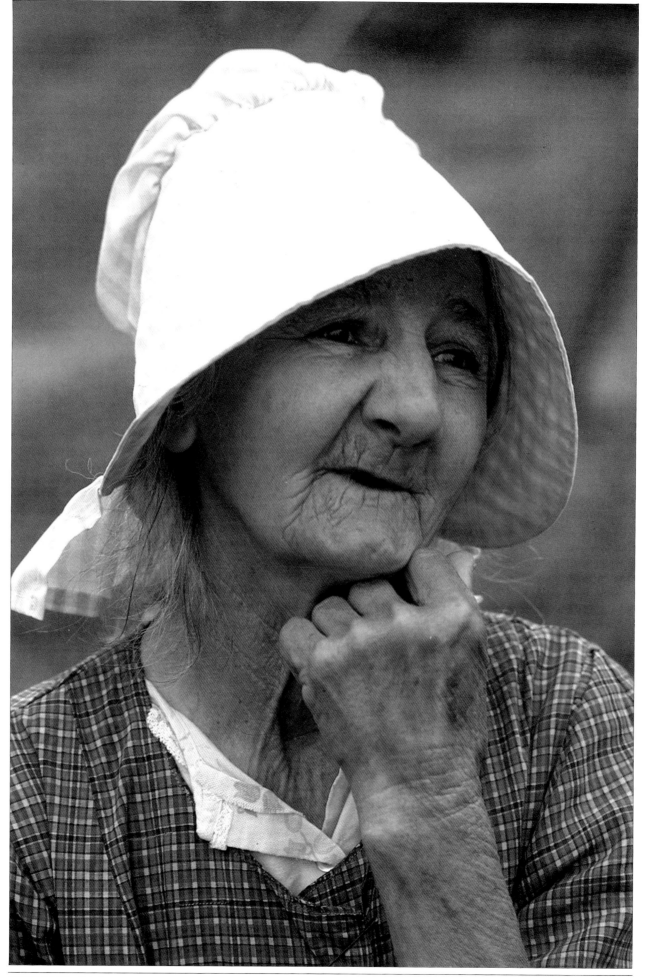

PETIT DAVID; *FALSE RIVER*

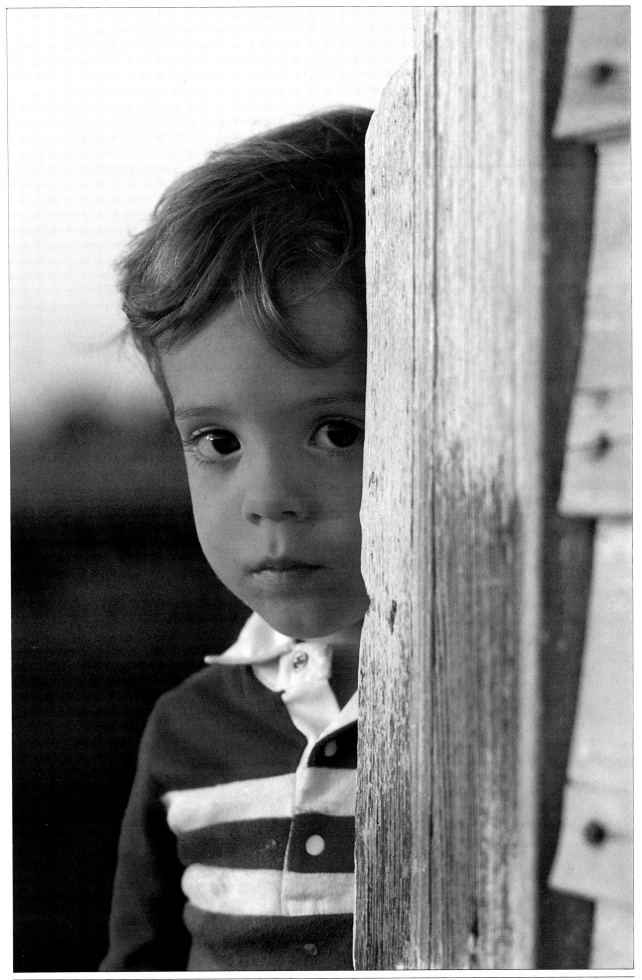

JEAN ANCELET AT HOME; *OSSUN*

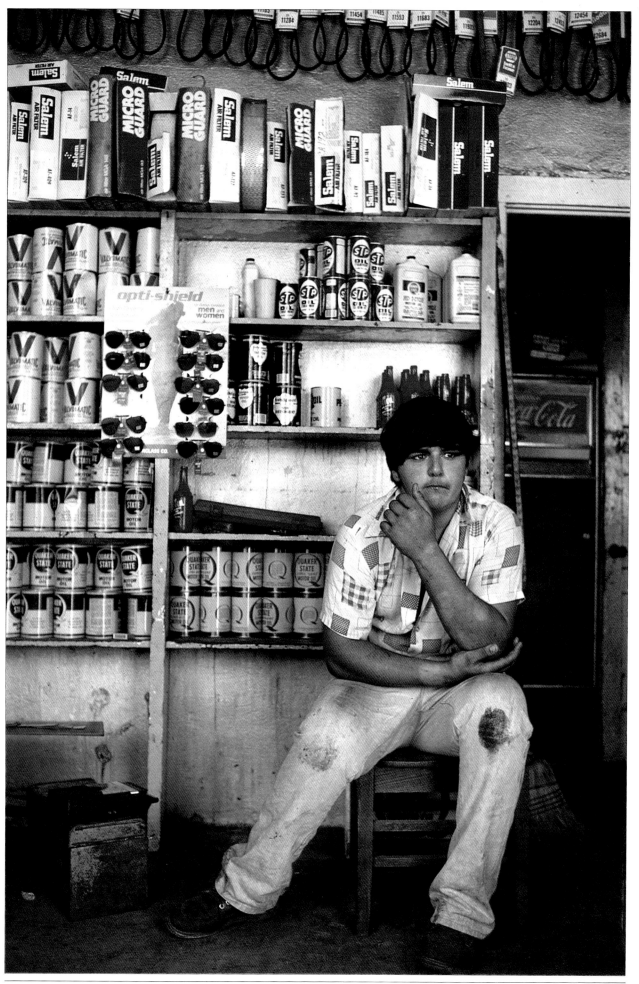

GAS STATION ATTENDANT; *CLOUTIERVILLE*

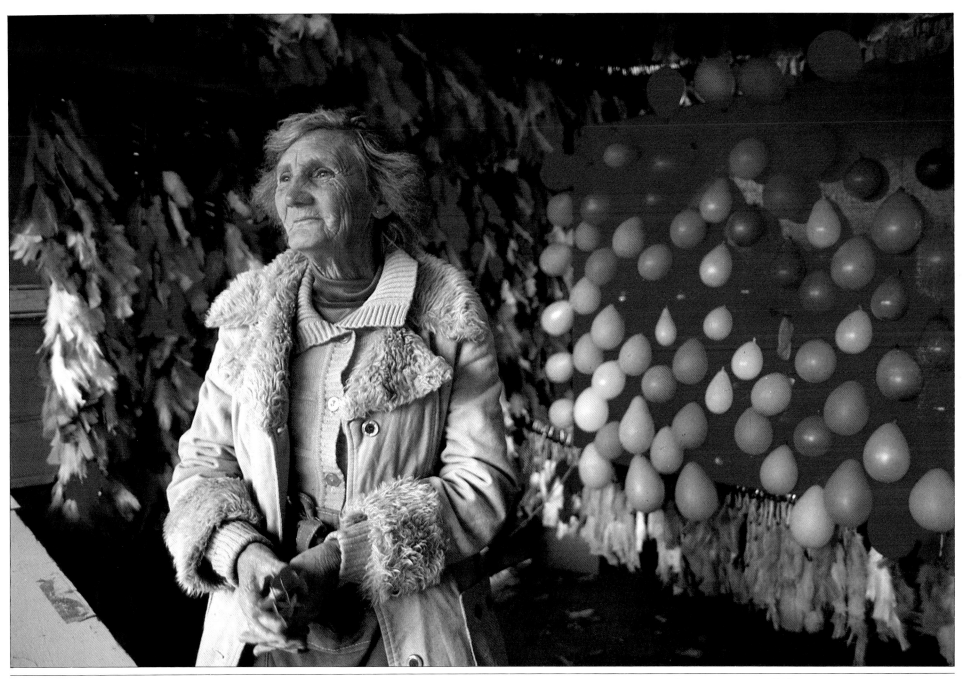

ANNIE PUTNAM WORKING THE STATE FAIR; *SHREVEPORT*

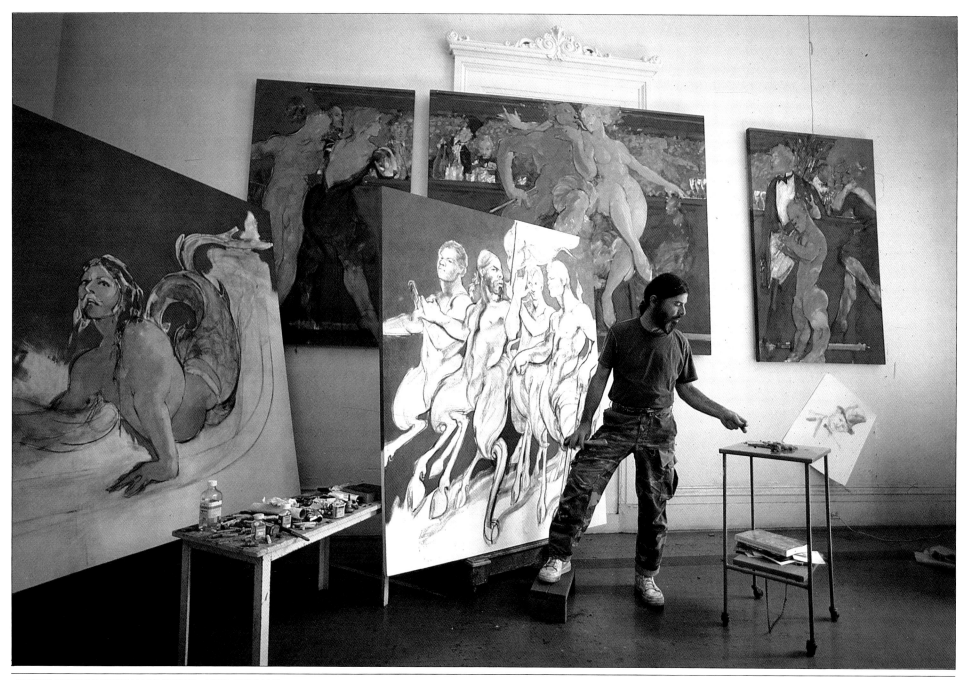

ARTIST GEORGE DUREAU IN STUDIO; *NEW ORLEANS*

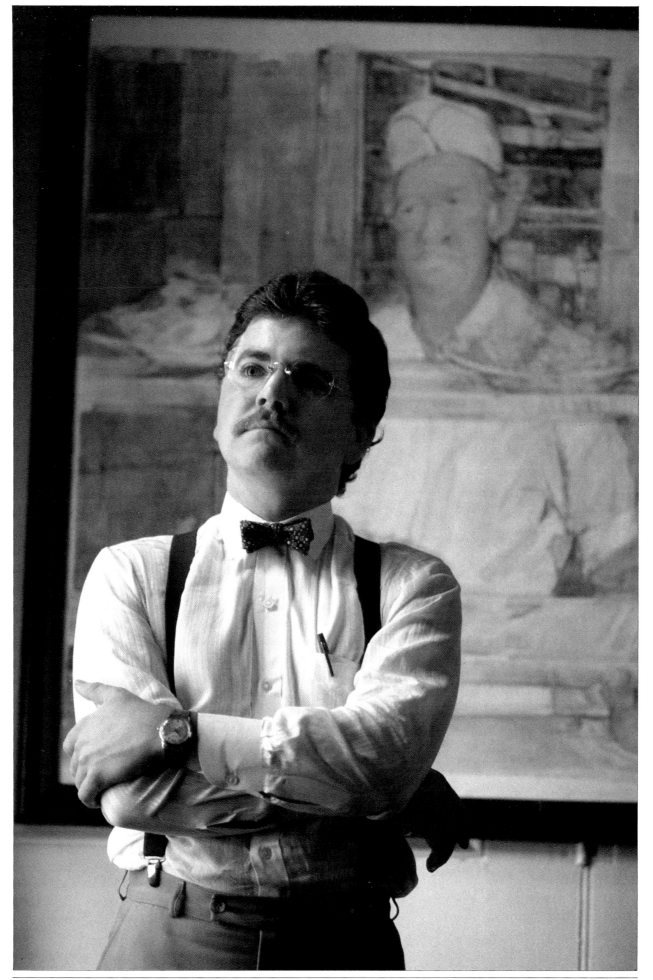

ROY GUSTE, JR., RESTAURANT PROPRIETOR; *NEW ORLEANS*

CIGAR SMOKER; *COLFAX*

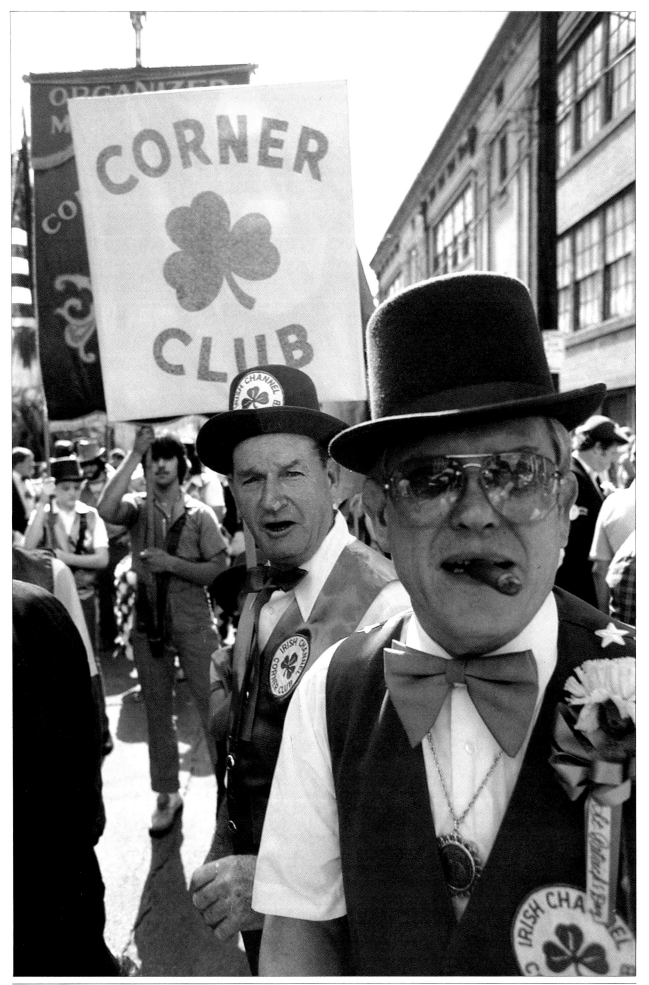

ST. PATRICK'S DAY; *NEW ORLEANS*

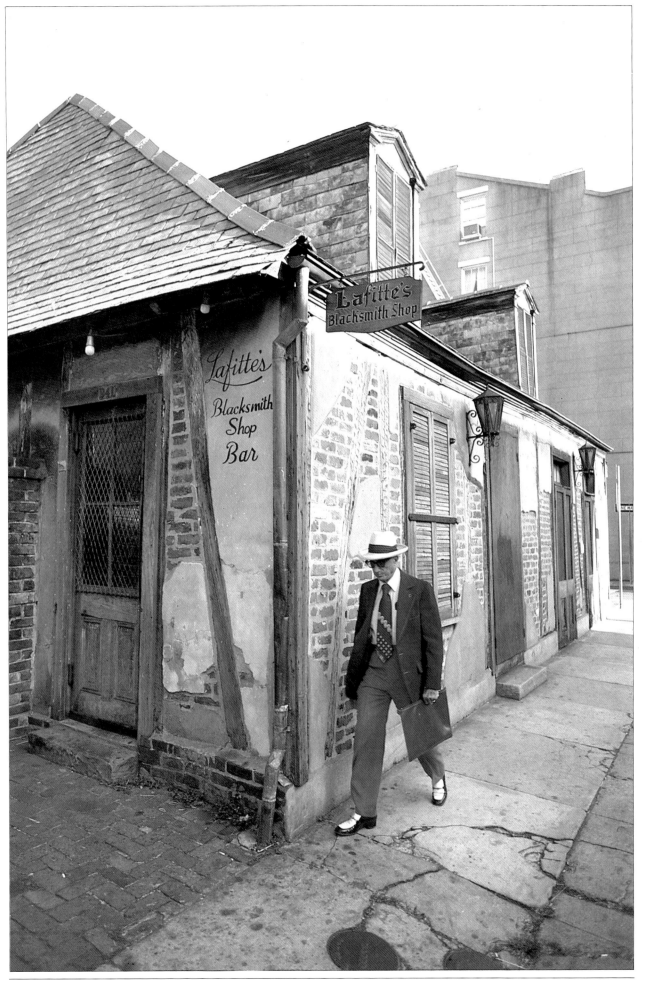

LAFITTE'S BLACKSMITH SHOP; *NEW ORLEANS*

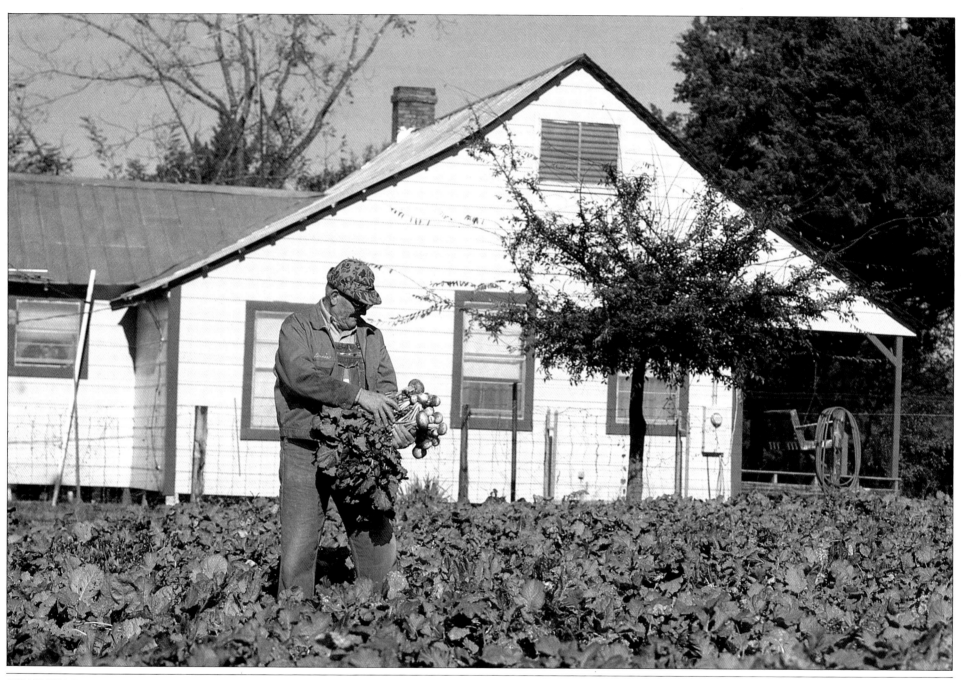

WILLIE MILLS PICKING GARDEN TURNIPS; *COLUMBIA*

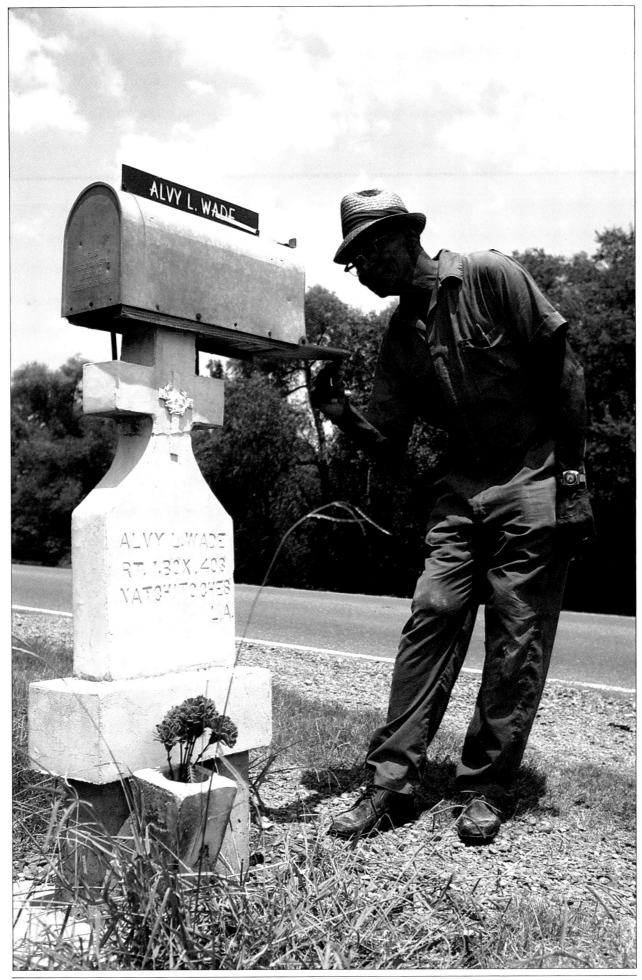

ALVY WADE, GRAVESTONE MAKER; *NATCHEZ*

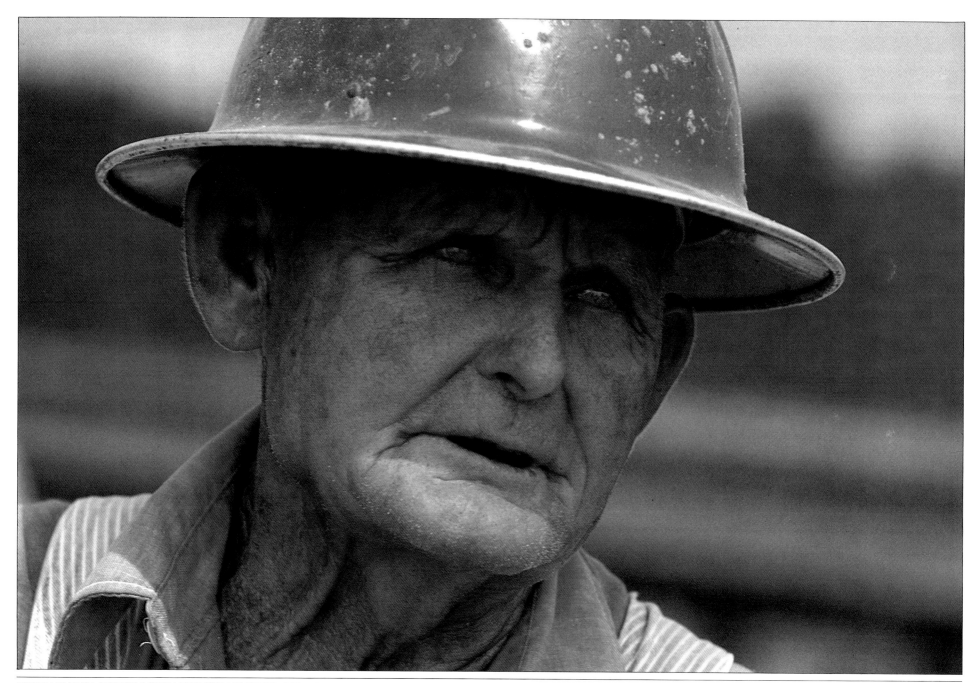

GRADY FANNIN, NORTH-SOUTH HIGHWAY WORKER; *INTERSTATE 49*

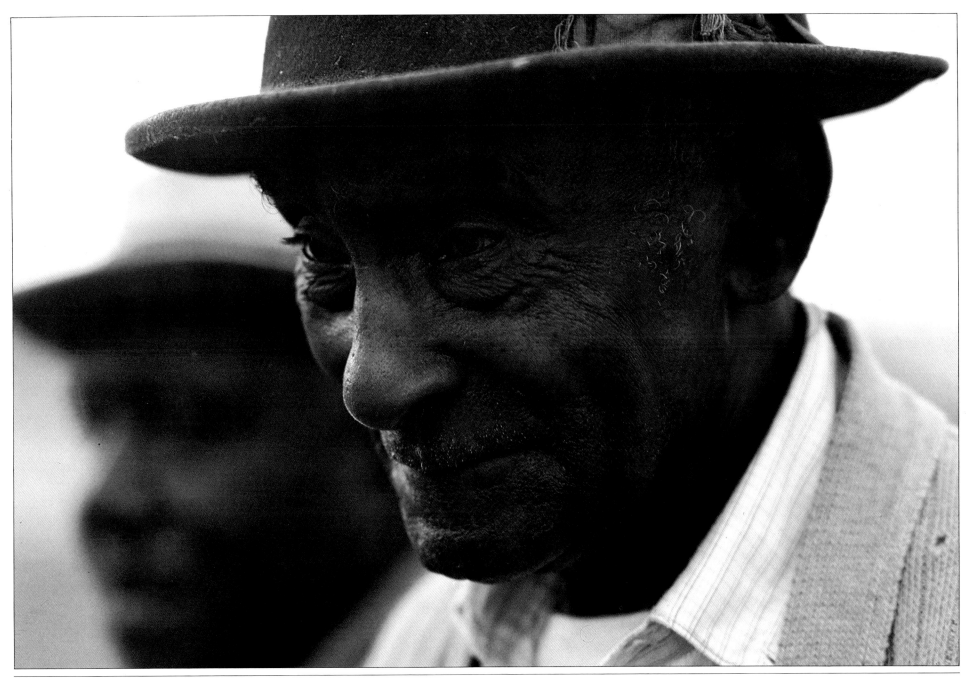

CHURCH DEACON; *INNIS*

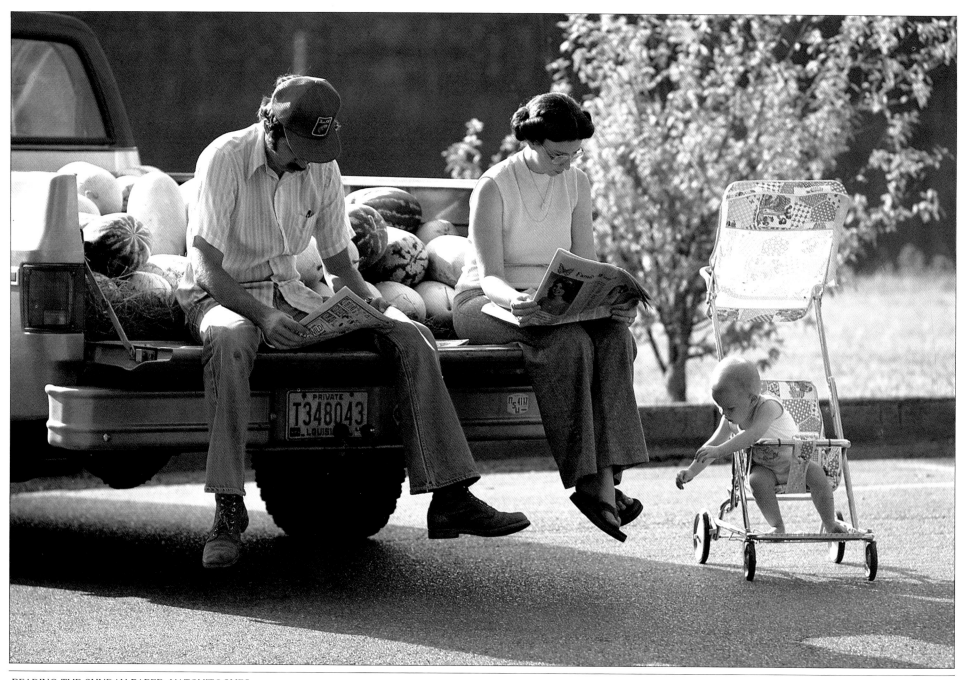

READING THE SUNDAY PAPER; *NATCHITOCHES*

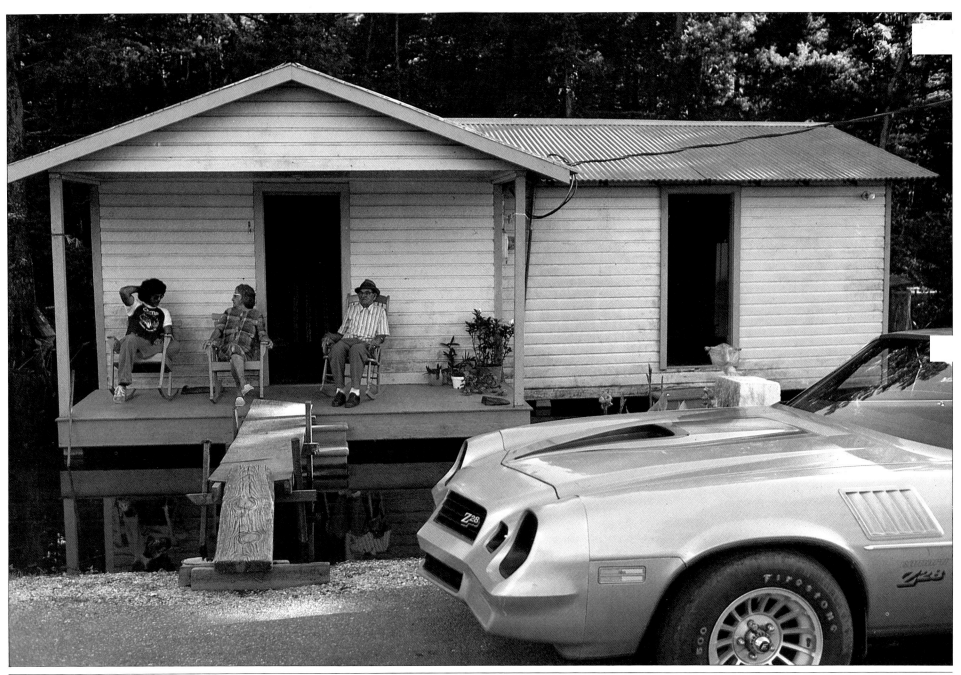

VISITING THE GRANDPARENTS WHO RAISED HIM; *PIERRE PART*

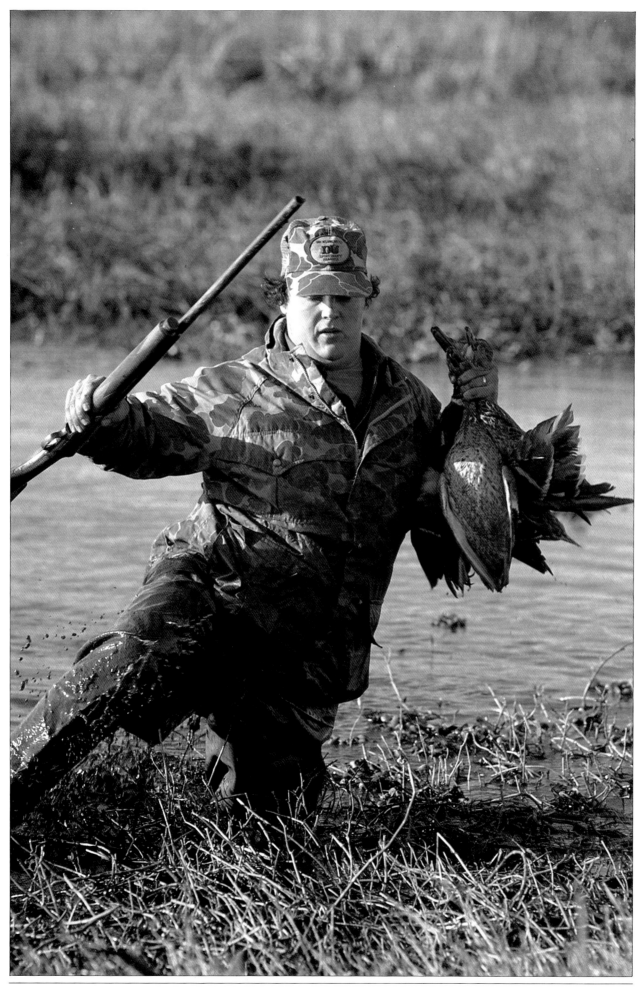

ERIC WHITE, DUCK HUNTER; *ST. MARY PARISH MARSH*

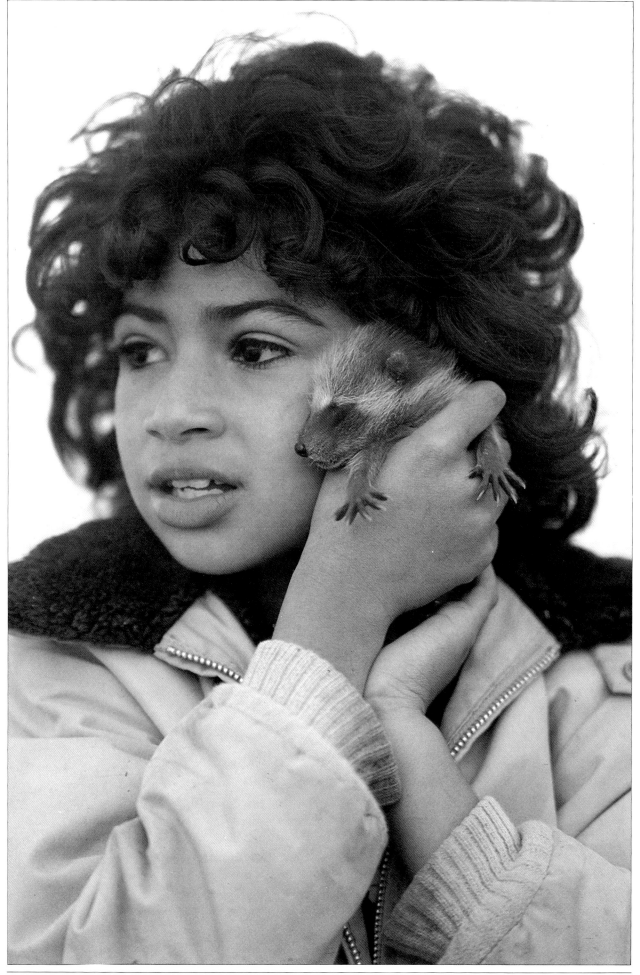

TIFFANY MACADO WITH PET RACCOON; *GRAND BAYOU*

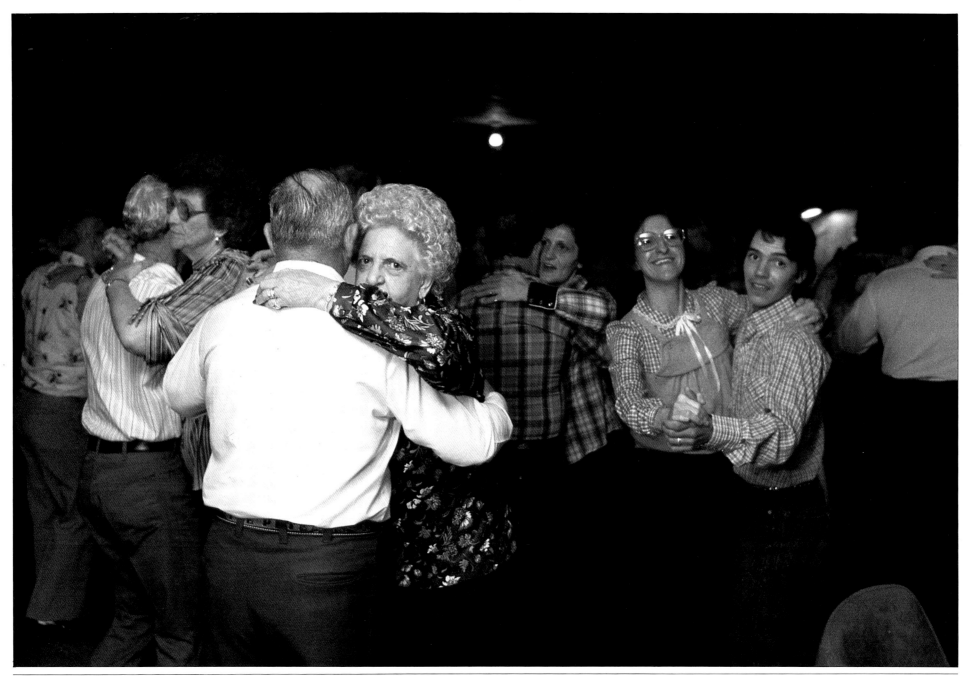

RED'S CAJUN CLUB; *KAPLAN*

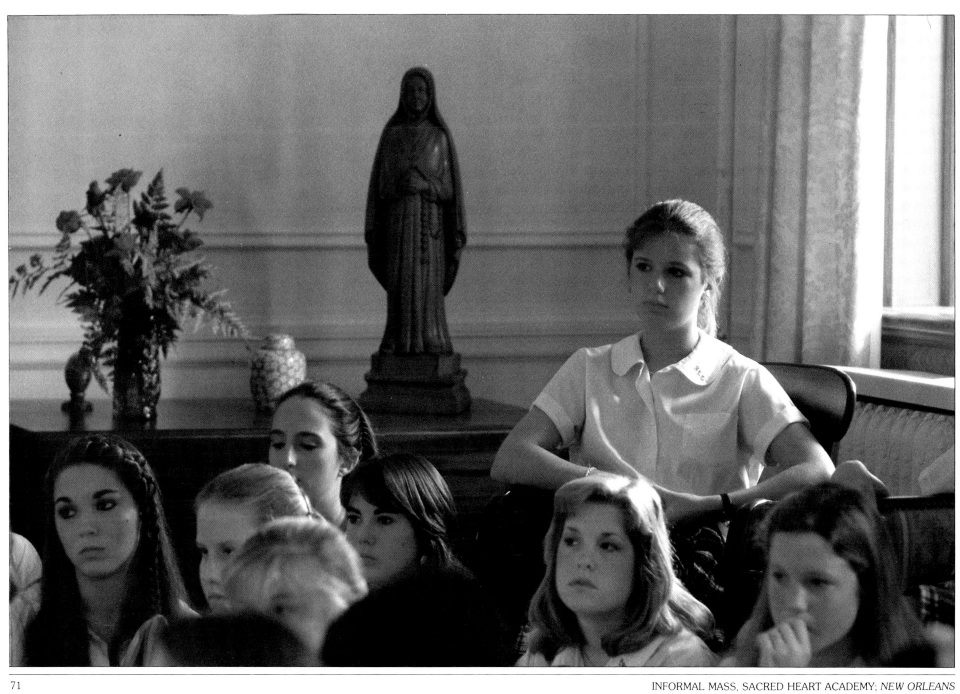

INFORMAL MASS, SACRED HEART ACADEMY; *NEW ORLEANS*

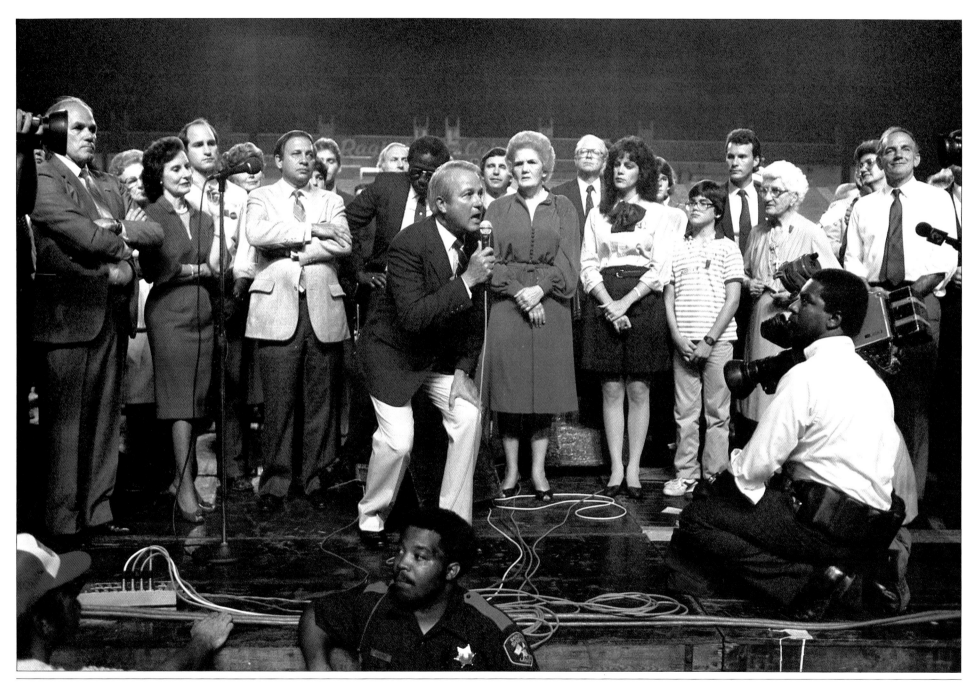

GOVERNOR EDWIN EDWARDS AT LAST APPEARANCE BEFORE HIS 1983 REELECTION; *LAFAYETTE*

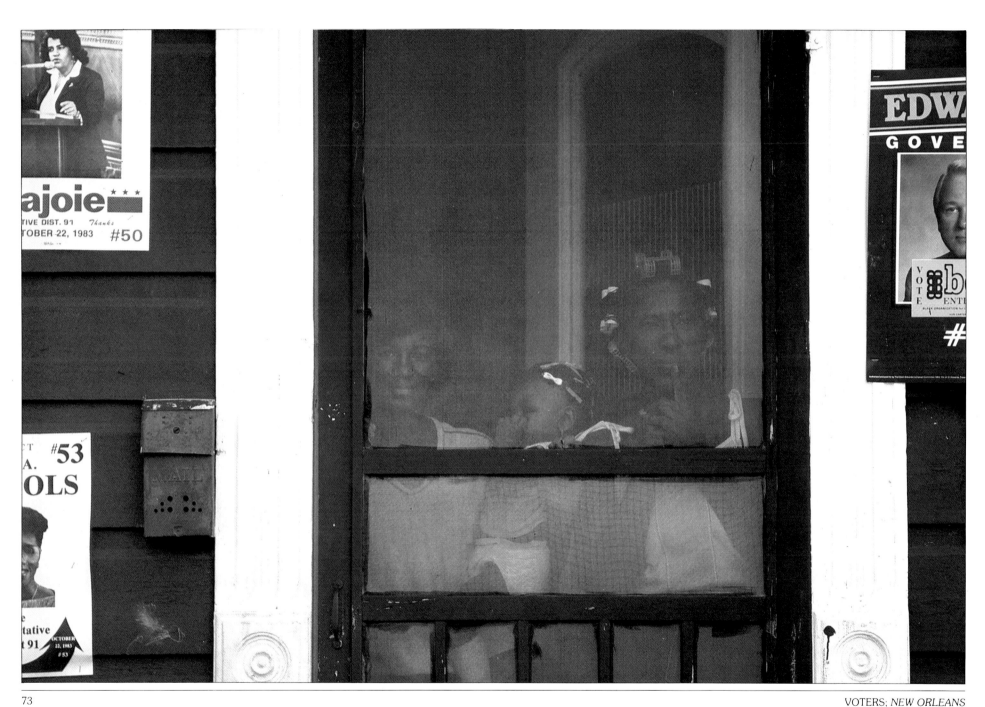

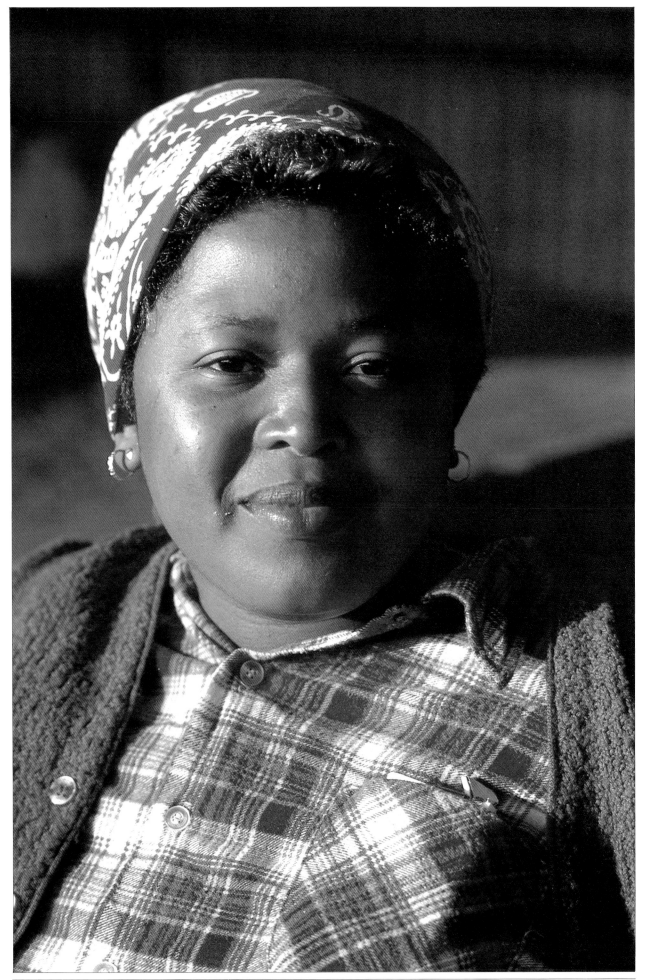

SUGAR CANE MILL WORKER; *BALDWIN*

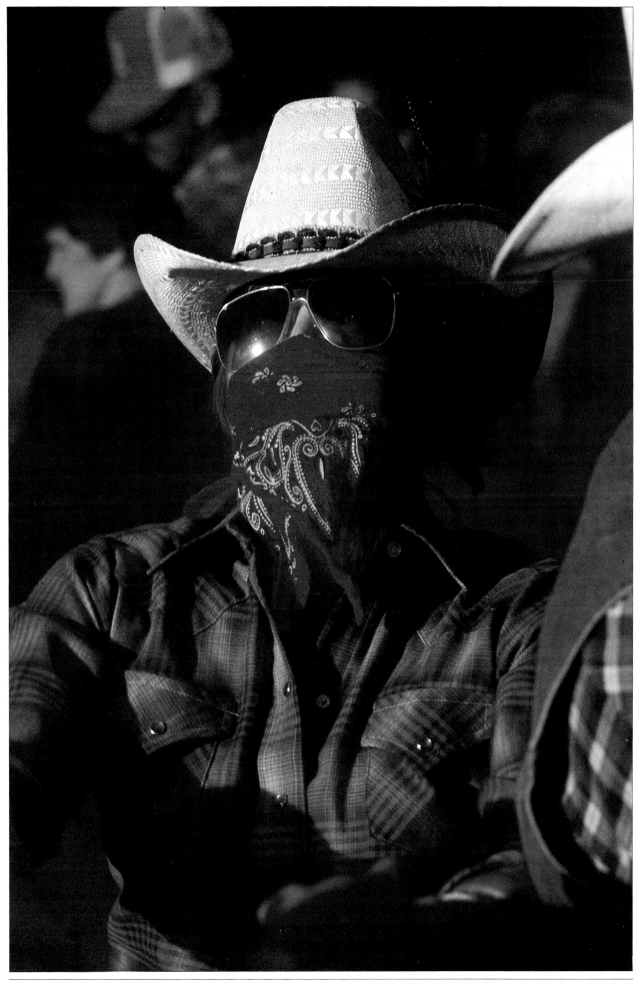

AVOIDING DUST AT CAJUN MUSIC FESTIVAL; *LAFAYETTE*

WORKING

Louisiana's diversity of people and environments has produced a wide variety of occupations unique to the state. In rural areas people historically fished, foraged and farmed the land for a living. In port cities and railroad towns they provided the backbone and muscle for commerce, shipping products throughout America and the world. In recent years Louisiana has industrialized to process its natural and agricultural wealth in timber, oil, gas, fish, soybeans and sugar. This rapid industrialization has diminished many traditional vocations, particularly in small-scale agriculture, fishing and trapping. Yet subsistence lifestyles are still common in the Bayou State where many have learned to supplement their annual rounds of fishing and foraging with work in oilfields and factories.

Urban centers have always had masons, carpenters, plasterers, cobblers and other craftsmen. Looking over their work are the bankers, merchants, shippers and traders who underwrote ventures first involving concessionaires and slaves, and later sharecroppers, stevedores and salesmen. In recent times the middlemen — tool pushers, regional distributors, franchise operators — have become all-important. But in Louisiana it helps if the middleman knows his way around the north Louisiana hills, speaks French in south Louisiana or masters the art of cutting a deal in New Orleans.

The most basic rural workplace remains the household, where the labors of men and women include gardening and ranching, hunting and fishing, clearing, planting and harvesting, cooking and cleaning, quilting and sewing. Today most subsistence occupations based on the needs of the household have merged into the cash economy. Flooded prairie rice fields now yield crawfish for cash. Cane and cotton fields have increasingly given way to lush rows of bush soybeans. Sharecroppers' homes are now surrounded by mechanical harvesters that resemble spaceships. Moss pickers, cypress sawyers, muskrat trappers and alligator hunters watch their environments and livelihoods shrink as the demand for some products declines while others become scarce and expensive.

Yet attitudes toward some kinds of work have changed little. Men still occasionally come together in north Louisiana to raise a barn. Ladies in the region often gather to quilt or to put up preserves. In Cajun country the *ramasserie* survives as neighbors aid one another at harvest time. *Coups de main* (literally "strokes of the hand") help members of the community who are sick or in need.

Many occupational crafts in Louisiana remain remarkably strong because they have made the transition to serve the needs of the modern world. Coastal and swamp areas continue to demand construction of wooden boats like the Lafitte skiffs, *bateaux,* Creole skiffs, *chalands* and shrimp boats. The traditional wooden boat building skills among Cajuns and coastal Indians have merged into construction of aluminum, fiberglass and steel craft which serve the oil and fishing industries alike. Products of bayou boatmakers rival those in Atlantic and Pacific coastal states in their diversity and quality, from the elegantly simple cypress-lined plank pirogue to the elaborate steel-hulled crew boat.

Boat building was initially a response to needs in transportation across bayous and swamps, as well as in fishing and trapping. Louisiana currently leads the nation's fisheries accounting for 22 percent of the country's catch with 1.4 billion pounds of shrimp, oysters, redfish, crabs and menhaden pulled annually from our waters. Louisiana also leads the nation in commercial trapping with an $18 million-a-year industry in nutria, muskrat, mink and alligator. The Bayou State produces more hides, pelts and meat than Alaska or Canada. With fishing and trapping becoming big business, water and marsh related skills such as net making and repair, trap and live box construction, trawl rigging and skinning have retained practical importance.

Smithing, now a fading enterprise, was once an important source for the tools needed for work on land. The job of the blacksmith, who is often portrayed shoeing a horse in a pastoral setting, is to take what he has on hand and make it work. Thus a tempered iron "tooth" from an abandoned hayrake can be reborn as a metal harness clip, an oil pipeline support strut or a Cajun musician's triangle. Blacksmiths have responded to the fading demand for horseshoes and buggy springs by providing a wide range of old and new services such as blade sharpening, corn meal grinding and especially oil field welding.

Louisiana's timber industry also joins traditional lifestyles and skills with modern machinery. Forests were used by the first settlers to make houses, boats, furniture, fencing, plank roads and coffins. Much of the best wood, especially cypress, was cut in the nineteenth and early twentieth centuries. Lumber camps with pull barges and skidding operations were isolated swamp communities unto themselves. In the north Louisiana hills, men working at the "front" to cut pine forests lived in nearby company towns. Though truck and tractor have replaced ox and steam power for pulling logs out of the forest, the work continues to mingle sweat and sawdust. The paper

mills are still partly supplied by two- and three-man skidding teams that truck out massive piles of second- and third-generation pine on single flatbed trucks. A few backyard sawmills remain that cut prize cypress (when they can get it), as well as oak and pine for local carpenters and boatbuilders.

A different occupation in overgrown terrain involves skills and lore of the Louisiana "woods cowboy." Louisiana has long had a range cattle industry in its northern hills, coastal prairies and Florida Parishes. The people who drive cattle still depend on the Catahoula hound dog which, when teamed with a mounted rider, can turn and circle a herd on voice command. Old cowboys in north Louisiana often boast, "The wild west ain't nothin'. . . . Try duckin' branches all day on horseback." Modern "cowboys" often drive to work at fenced ranches in pickups, and many even work as truck drivers. Their high-riding trucks are outfitted with large flaps to accommodate the Louisiana mud. Cajun French and Redneck English crackle side by side on the CB as the truckers navigate two-lane asphalt strips through the Louisiana terrain. Truck drivers move pipe, mud and jack-up rigs from assembly yards to wellheads for the oil industry throughout the state.

The migration of workers from rice and cane fields to the oil fields is much of the story of twentieth-century Louisiana. Just as Slavonians brought their lugger-type boats to the oyster industry of Plaquemines Parish and Midwesterners brought wheat harvest technology to grow rice on the prairies, Texans and other outsiders brought the world of drilling rigs and pipelines to Louisiana. Cajuns and other south Louisianians in turn have taken oil technology first into the Gulf of Mexico and then worldwide to Saudi Arabia, Brazil and beyond. Today telephones dialed by Cajun workers on North Sea rigs ring local Lafayette exchanges. In a neat twist of history and technology, some Cajun oil workers have now returned to within view of their Acadian homeland on the Canadian Maritime coast as they work the oil fields of Georges Bank.

Oil exploration activities that produced 410 million barrels of crude in 1982 have affected occupations and the landscape of the entire state. Oil was discovered in Caddo Lake in 1906, five years after the initial find at the Evangeline oil field near Jennings. The Caddo field was later named Oil City, and the adjoining fields in Caddo and Bossier Parishes have often rivaled the production of Gulf Coast parishes. When natural gas and oil were discovered along the Tuscaloosa Trend during the 1970's, feverish speculation returned to the exploration for energy resources. Sudden wealth has sometimes made dreams come true for farmers and country people, while bringing with it a certain amount of social disruption.

In Louisiana hard work—from crop dusting to crop growing, from fishing camp to logging camp, from cotton patch to oil patch, from farmstead to factory, from plow pusher to paper pusher, from river pilots guiding ships up the Mississippi to B-52 pilots flying airborne fortresses from Barksdale Air Force Base—is matched in intensity only by hard play. Some traditional work has even become play as livelihoods have changed. People now skin nutria for prizes at the Cameron Fur and Wildlife Festival. Cowboys compete in parish-fair rodeos. People fish for food, but they also fish for fun and trophies with their families and friends. The camp, once associated with days away from home working in isolation, is now a weekend place for courtboullion, BBQ, beer and parties. Similarly, yesterday's tools are now recycled or romanticized. The big iron syrup boiling kettle has become an elaborate front yard bird bath. Cornshuck horse collars and spinning wheels from the "good ol' days" are now wall hangings and antiques in suburban homes.

Duck decoy carving now serves the sportsman and artisan alike. The common man who hunted duck for his family once went out with little more than a mud and moss "duck-head" on a pole to stick in the shallows for attracting a bevy of birds. The commercial market hunters used eight gauge shotguns—veritable hand-held cannons—and brought back their catches, sometimes as many as 400 birds a day, from marshes south of New Orleans and from the Catahoula Basin near Alexandria. They made axe-cut decoys of *Dos-gris,* Canvasbacks and *Poule-d'eau,* among others. The old working decoys were crude but effective. Most of today's finely carved birds sitting on the mantleplace would not be at home in the marsh. "In the old days we used to catch birds with our decoys, nowadays we catch people," says one carver in New Orleans.

In many ways the crawfish industry has become a microcosm of Louisiana's recent economic history. Crawfish, once the catch of individual, family-feeding fishermen, is now a multimillion dollar industry employing people throughout the state. The crustacean has also become the exalted symbol of Cajun cuisine and lifestyle as well as a major source of pleasure and protein. Once fished solely from the Atchafalaya Basin and roadside canals, crawfish now constitute a "crop" rotated with rice and soybeans and covering 92,000 acres in southwest Louisiana alone. Crawfishing has become a major industry with national implications as people in and out of Louisiana eat about 50 million pounds a year.

Even as the state moves toward the national fixation on high-tech, or more likely "bio-tech" industries, some of Louisiana's oldest work traditions continue to be useful. Others will be modified to serve future needs for food, shelter and clothing. Swampers now paddle aluminum pirogues, while crawfish "scientists" invent machines to catch and peel the crustaceans. And just when north Louisiana woodsmen were considered extinct, someone appears who still makes cowhide chairs or notched log smokehouses.

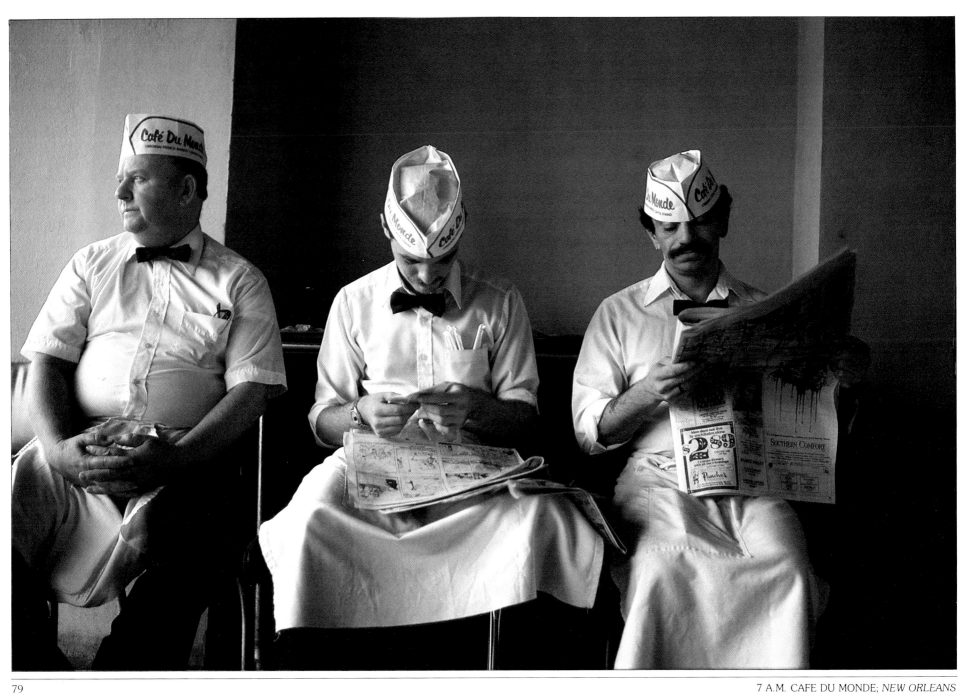

7 A.M. CAFE DU MONDE; *NEW ORLEANS*

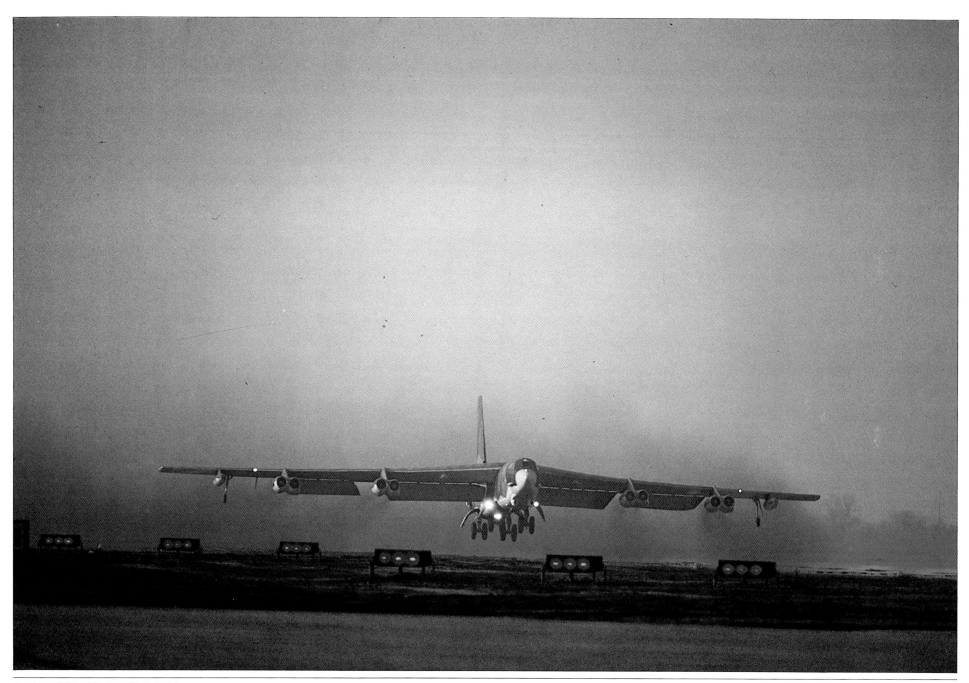

B-52 TAKING OFF; *BOSSIER CITY*

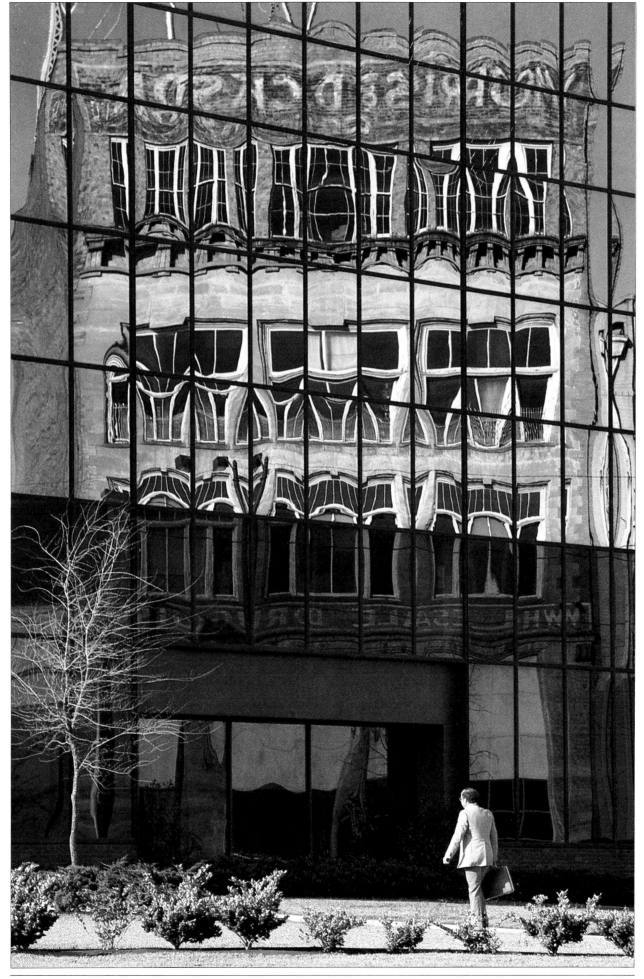

TWO GENERATIONS OF OFFICE BUILDINGS; *SHREVEPORT*

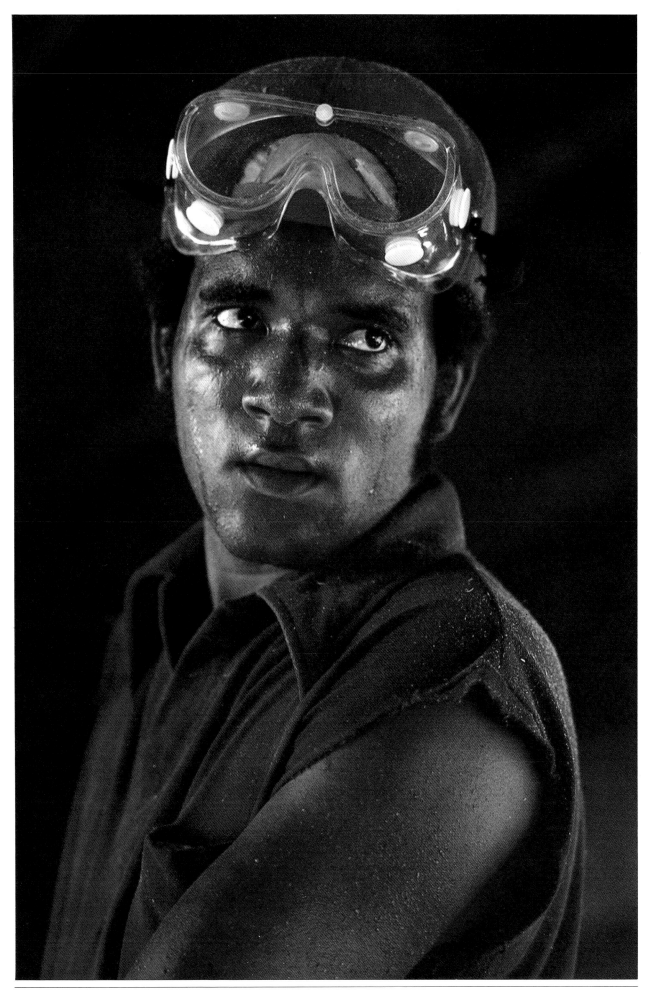

WADE BIBBIN, LUMBERMILL WORKER; *MARKSVILLE*

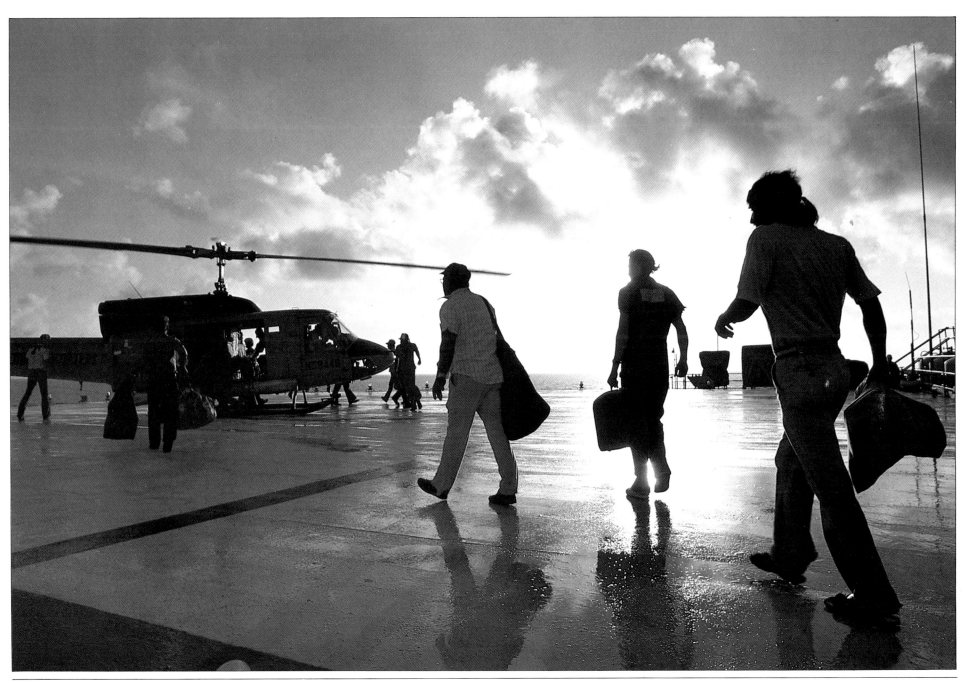

GETTING OFF WORK OFFSHORE; *GULF OF MEXICO*

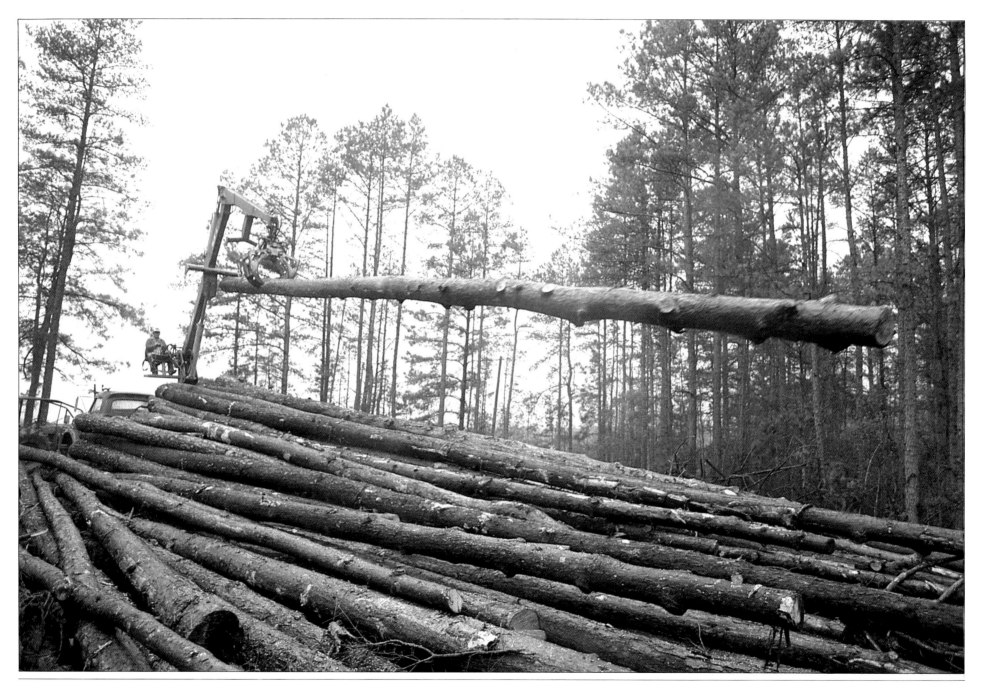

PROCESSING LUMBER; *CASTOR*

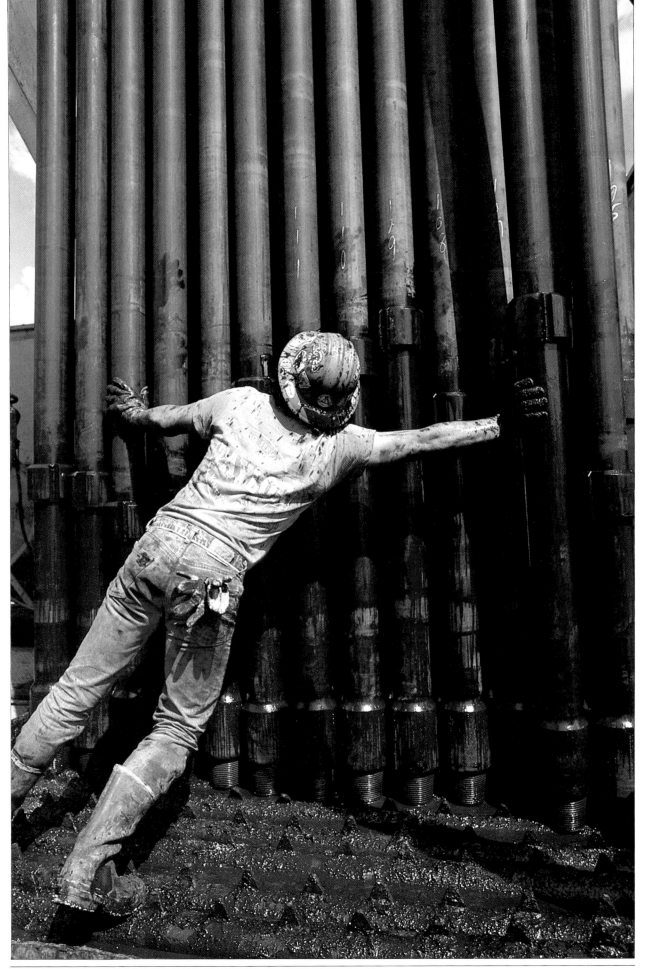

PUSHING PIPE ON THE TUSCALOOSA TREND; *DENHAM SPRINGS*

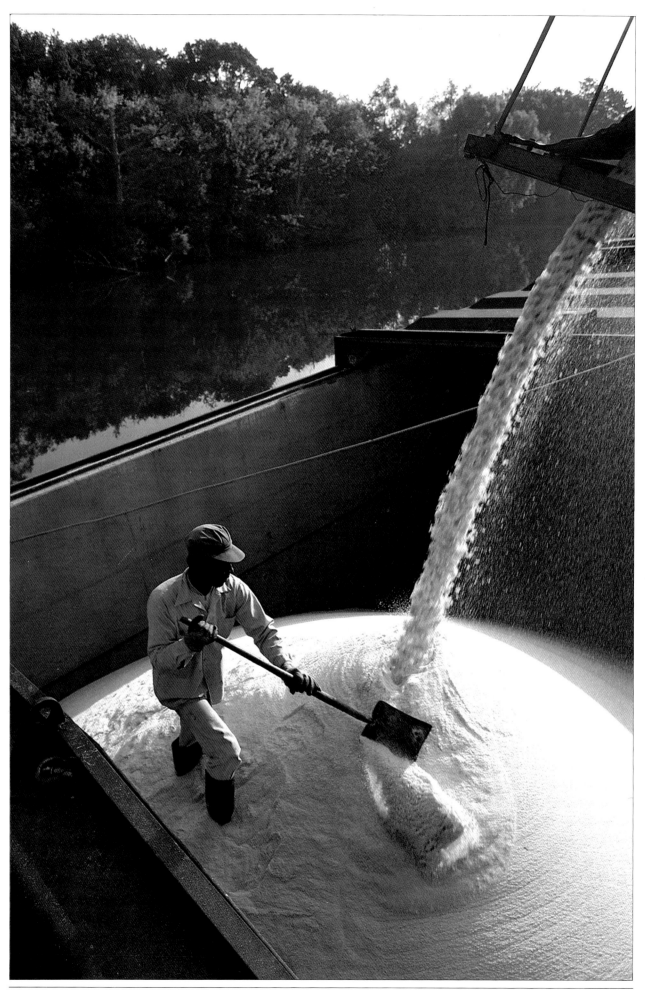

POURING REFINED SUGAR INTO A BARGE; *BALDWIN*

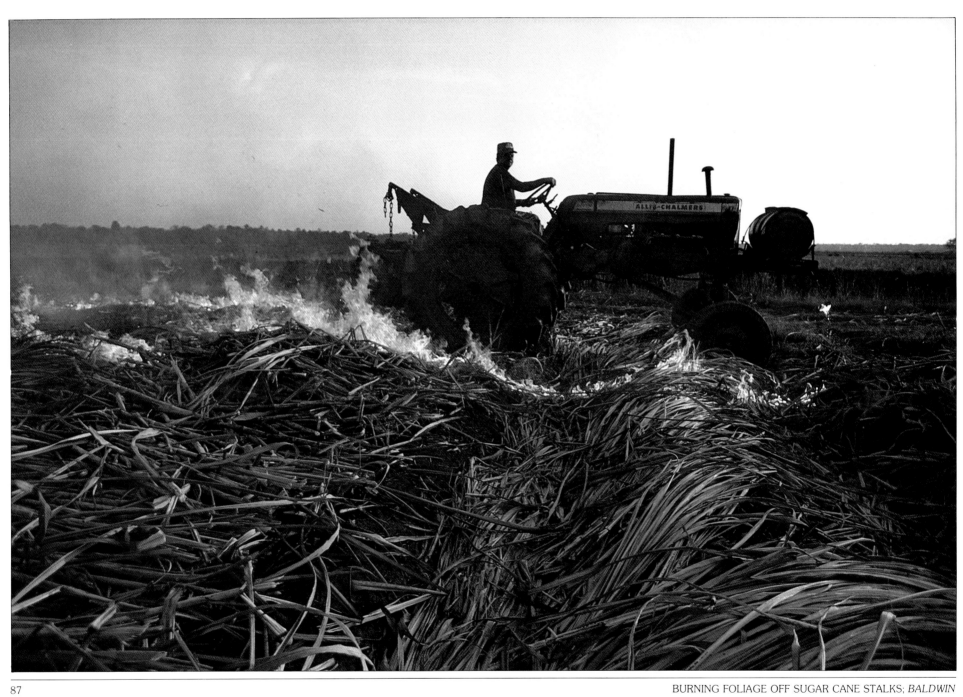

BURNING FOLIAGE OFF SUGAR CANE STALKS; *BALDWIN*

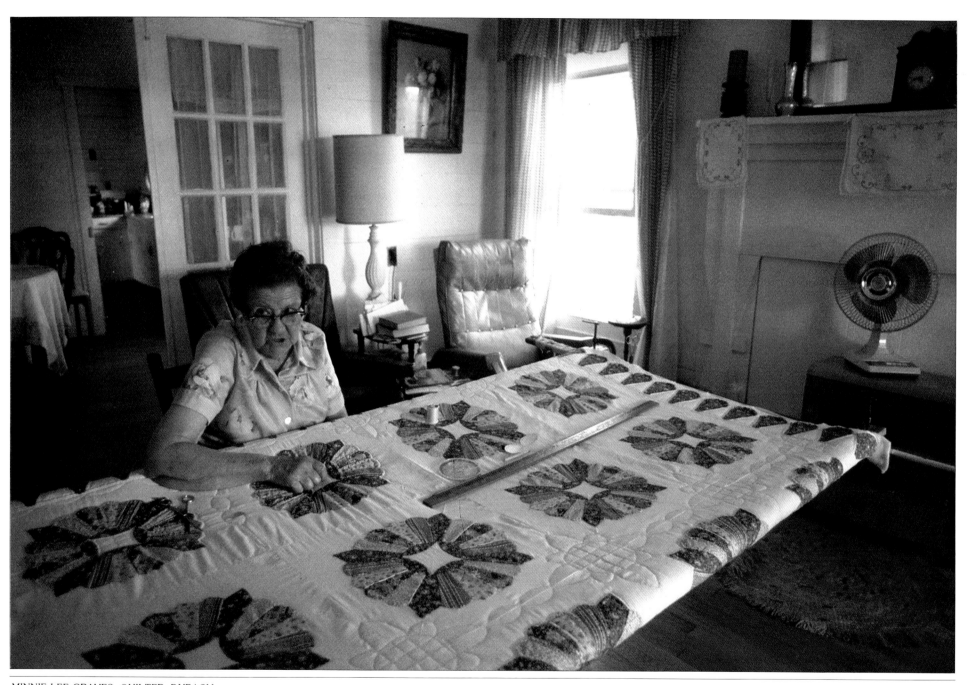

MINNIE LEE GRAVES, QUILTER; *DUBACH*

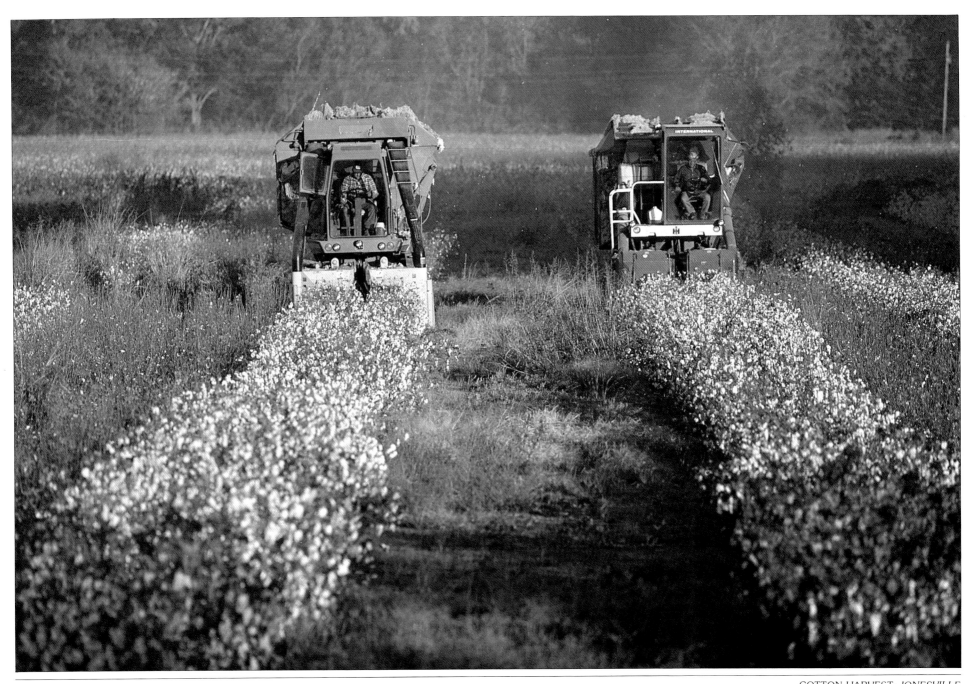

COTTON HARVEST; *JONESVILLE*

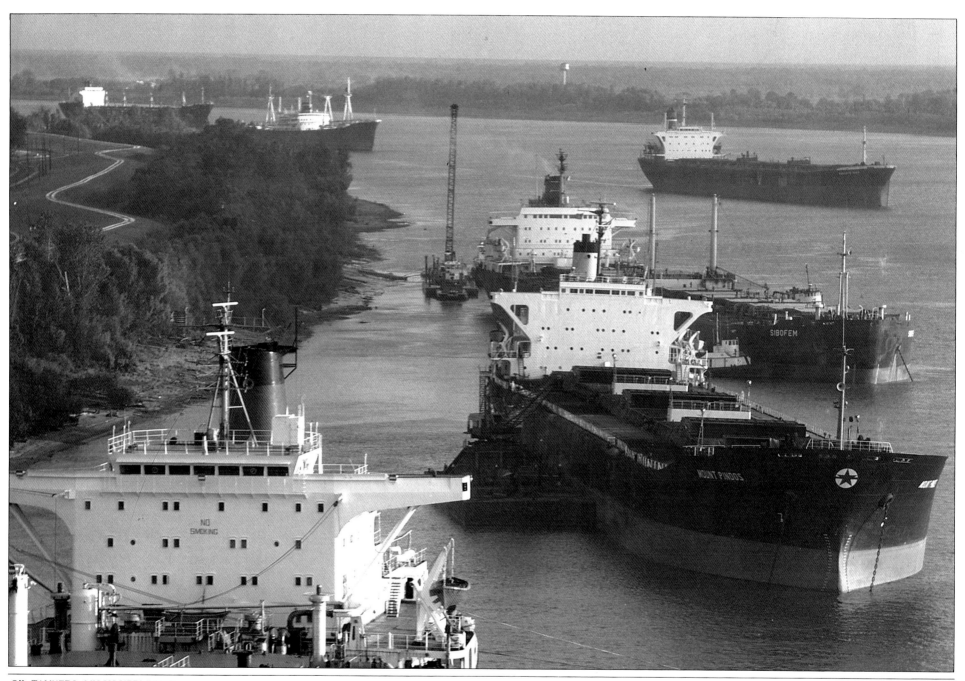

OIL TANKERS; *MISSISSIPPI RIVER*

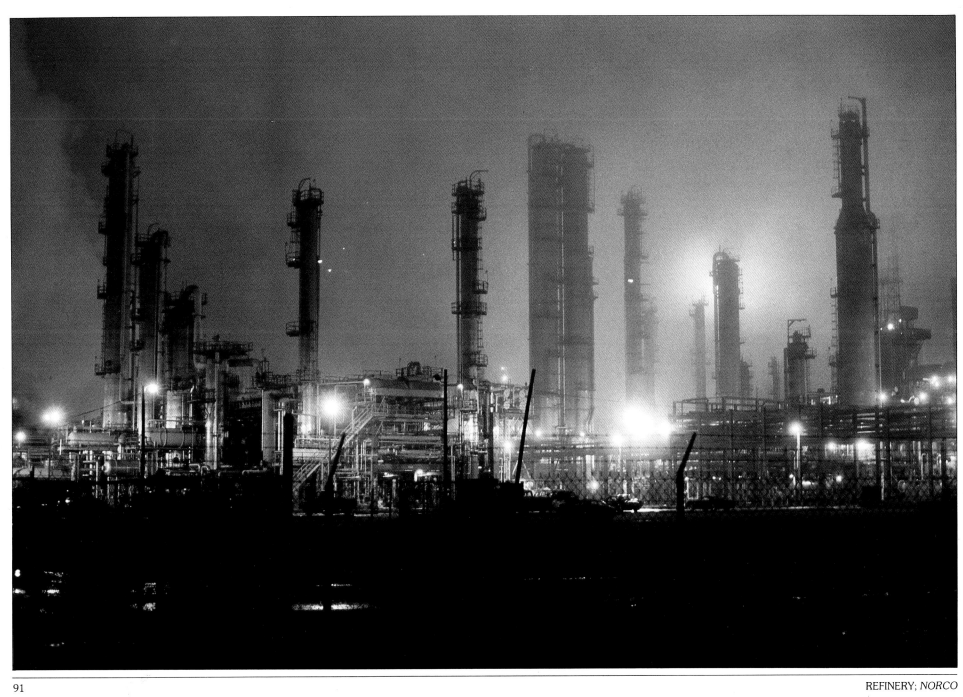

REFINERY; *NORCO*

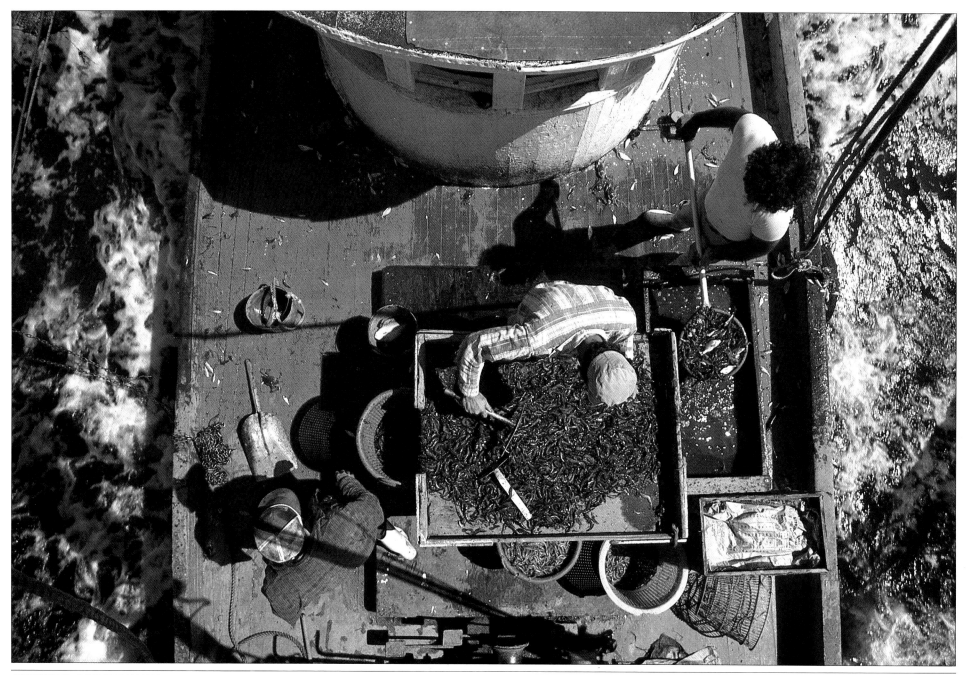

SHRIMPERS; *LOWER BAYOU LAFOURCHE*

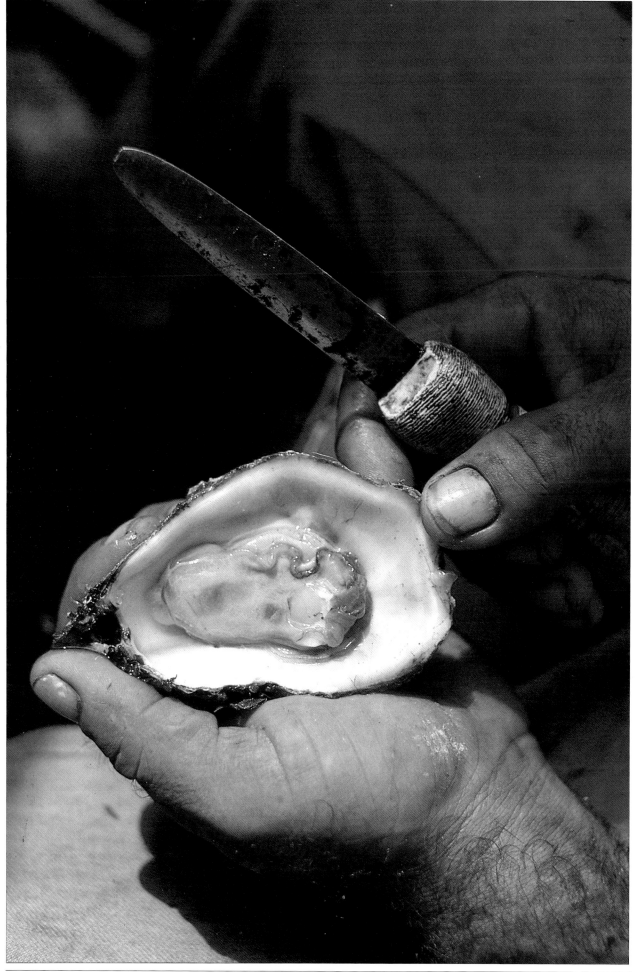

HANDS OF AN OYSTER FISHERMAN; *DELACROIX*

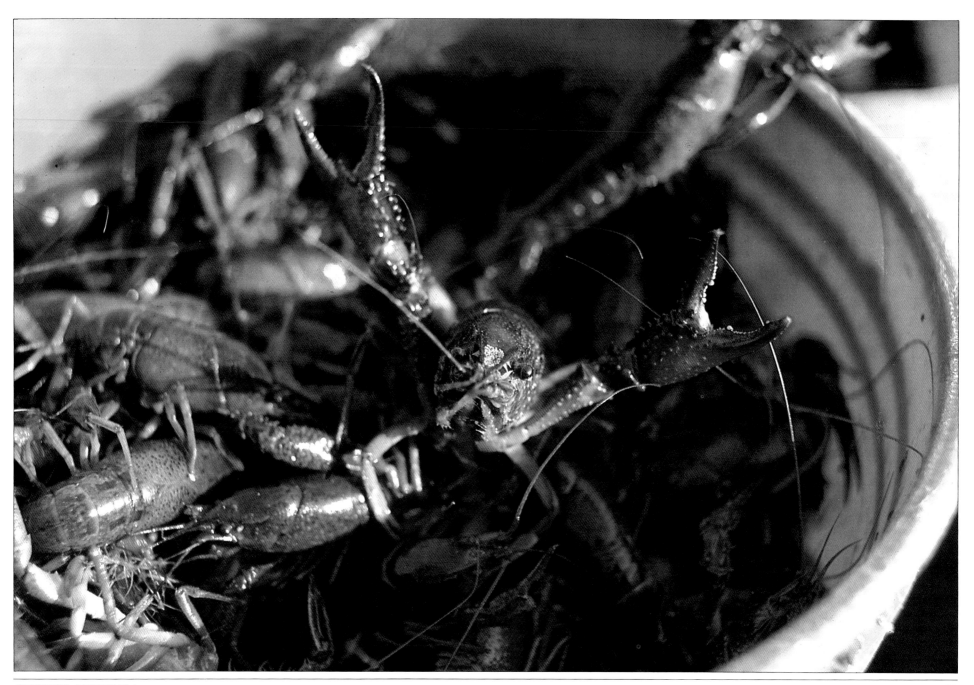

CRAWFISH; *CATAHOULA*

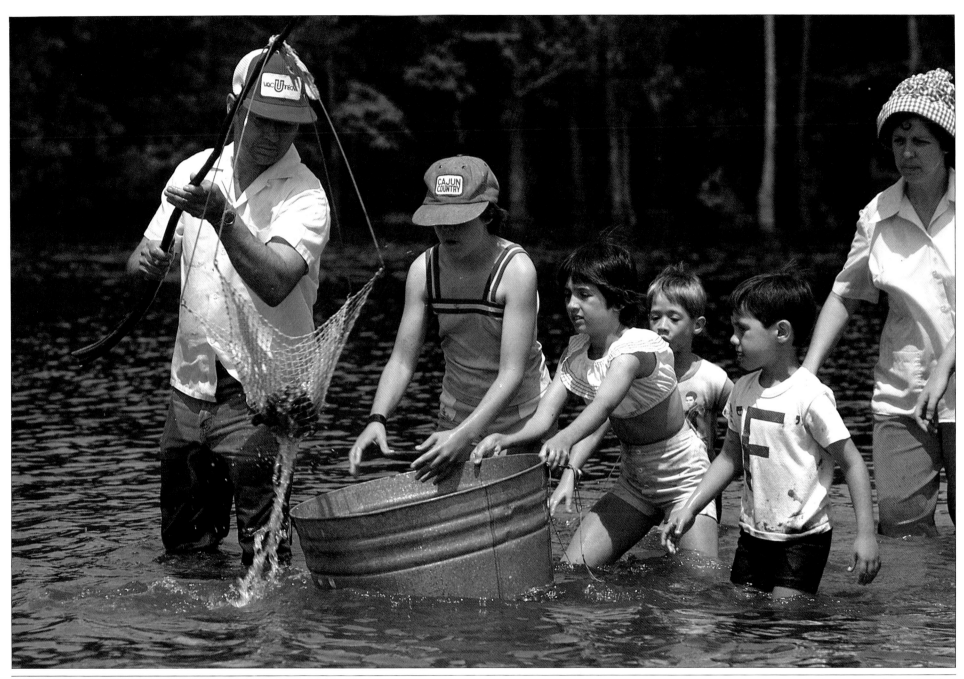

FAMILY CRAWFISHING; *ATCHAFALAYA BASIN*

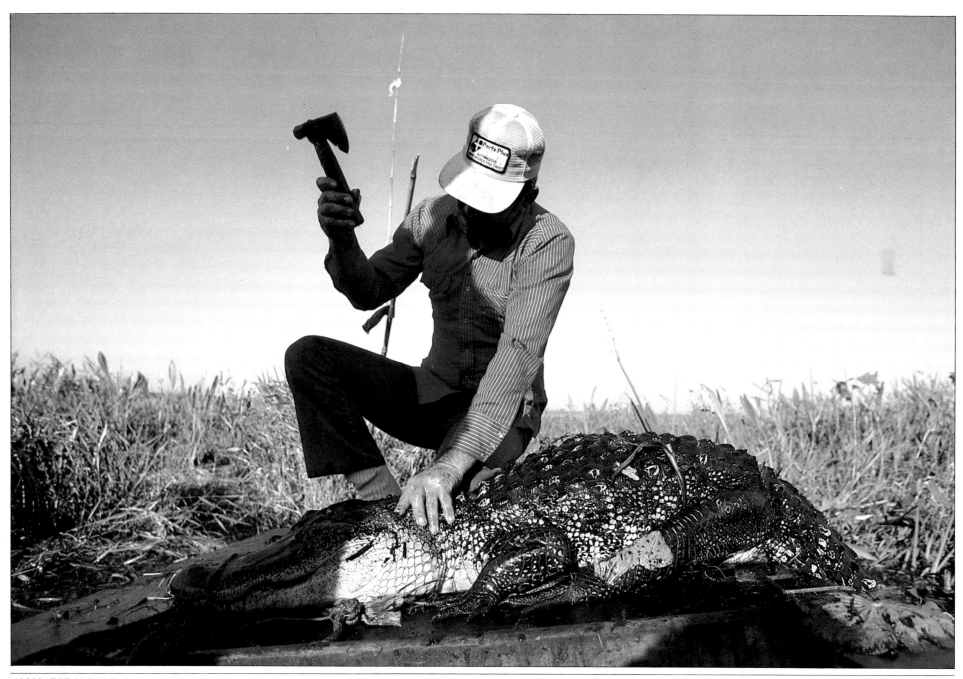

ALLIGATOR HUNTER; *LACCASSINE REFUGE*

CLIFTON MOLERO; *DELACROIX*

CELEBRATING LIFE

Ethnic groups, families and communities in Louisiana celebrate life on a variety of ritual and festival occasions that range from rural family reunions to elite Mardi Gras balls. Such occasions may be a solemn procession for a saint in New Orleans or a dance in the street at the Basile Swine Festival. People celebrate their friends and their culture when they go to Louisiana dance halls for zydeco, Cajun music, jazz, blues, country, rockabilly and rock 'n' roll. They celebrate the sporting life fishing at a camp near Pecan Island, water skiing on Lake Bistineau, betting on a cockfight or horse race near Lafayette, playing baseball on a rough country diamond near Delhi or waving a pennant at LSU's Tiger Stadium.

In Catholic south Louisiana many communal celebrations are associated with days held sacred. Mardi Gras excesses are followed by the penance of Ash Wednesday and the ensuing Lenten season. The public St. Joseph's parade occurs after elaborate altars are assembled in New Orleans churches and homes to honor the patron saint of Sicilian Italians. Homage to other saints, such as Amico and Rosalie, still calls for processions—sometimes barefoot—in Donaldsonville and Marrero. Festive celebration usually follows such rituals. However, in an increasingly secular world, the celebration itself often overwhelms the religious ritual that may have once been integral. For some, Ash Wednesday slips into post-Mardi Gras oblivion, as does the fact that the shrimp and sugar festivals were originally focused on blessings of fleets and fields.

One public celebration that retains the religious link by its timing is the lighting of the *feux de joie* bonfires along the old German Coast of the Mississippi River for Christmas Eve. People work for weeks beforehand cutting logs and building conical structures — and sometimes effigies of houses and pirate ships — reminiscent of ceremonies in medieval Europe. As the structures are set ablaze, people gather to celebrate Christmas and eat gumbo on the levee by the river communities of Vacherie, Garyville and Reserve. Another Christmas tradition with roots in Central Europe takes place in Robert's Cove, a German town in southwest Louisiana. There local priests, Santa Claus and a character called Little Black Peter visit homes on December 6, the feast of St. Nicholas. They tease and then reward the children for being good.

Family festivity often remains tied to religion in celebrating such milestone events as baptisms and weddings. In Louisiana these celebrations run the gamut from a high society Episcopalian affair in the shadows of neoclassical columns to a small Cajun Catholic ceremony followed by a *bal de noce* (wedding dance) at the Triangle Club in Scott. In north Louisiana reunions and homecomings are also popular occasions to celebrate the most basic social group whenever big families are separated by time and distance.

Since the 1930's many new public festivals have emerged in Louisiana. These festivals and fairs celebrate agricultural production, natural resources, hunting, fishing, food and cultural heritage. They also celebrate consumption in one form or another. These events are especially intense in south Louisiana where most festivals are saturated with music, food, bingo games, beer, beauty queens and politicians. Food eating contests consume the crowd's attention as hefty locals try to stuff more boudin, rice, crawfish or oysters into their mouths than their competitors. While few actually enter the competition, everybody ends up eating.

Some south Louisiana festivals focus on production and work skills. In Galliano oyster shuckers at the town's Oyster Festival move their blades deftly to split the shells held firmly in their palms. At the Fur and Wildlife Festival in Cameron, nutria skinners (men and women) make the fur fly under the measured click of the stopwatch. At pirogue races in Lafitte, Houma and Galliano, men demonstrate their prowess as paddlers in the most basic of Louisiana boats.

North Louisiana festivals, in keeping with Calvinist and Protestant rather than Latin Catholic values, seem to focus much more on production. On Sawmill Day the town of Fisher boasts a log-sawing contest, a variety of oxen, horse and tractor pulls, and a cornucopia of fruit, vegetable, pie, jam, jelly and relish preserve competitions. The ladies from Shongaloo, Dry Prong, Hico, Zwolle and other surrounding comunities show off the fruits of their labors each year to sated judges handing out ribbons at parish fairs. Nearly everyone gets a prize, from champion quilt piecer to the premier pickler of purple hull pea jelly. . . so goes the celebration of the work ethic in Louisiana's hill country.

Rural Florida Parish events like the Washington Parish Fair have grown from what was once a farmers' gathering day to a full-blown event with country music, cotton candy and the requisite old-time

costumes all in the midst of several nineteenth-century buildings. Many north Louisiana heritage festivals reenact events in local history such as fatal gunfights, crucial Civil War battles or the founding of a sawmill. Some go so far as to promise "authentic storefronts" in their zeal to recreate a past that they can only live in costumes and pageants of the present.

Other festivals such as Cajun Days in Mamou and Church Point, the Creole Festival in French Settlement or Chauvin's Lagniappe on the Bayou simply celebrate ethnic heritage for its own sake. In Delacroix Island, the Isleño Spanish Festival features singers who recount the events of the medieval-Crusades past and the shrimp-fishing present in complicated rhyming songs called *décimas*, named for their ten-line stanzas. Other ethnic festivals in the state celebrate the Italians in Independence, the Hungarians in Albany, and myriad ethnic groups including Irish, Vietnamese, Filipinos, Germans and Italians in New Orleans.

Perhaps the most interesting phenomenon in recent years has been the development of folk festivals that celebrate and interpret on-going music and craft traditions. Among the most successful of these festivals in presenting local greats are Lafayette's Cajun Music Festival, the New Orleans Jazz and Heritage Festival, the Baton Rouge Blues Festival and folk festivals in Natchitoches and Columbia. Today some of these events have become traditions unto themselves as they encourage perpetuation of folk cultures throughout Louisiana.

Festivals are but one place Louisianians enjoy traditional and popular regional music. The honky-tonk, juke-joint side of Saturday night offers hot Cajun and big beat zydeco sounds in clubs like the Blue Goose in Eunice and Slim's Y-Ki-Ki in Opelousas. Put your hand out for the stamp, get a plate of red beans and settle in for a "Blue Monday" night jam session at Tabby's Blues Box in Baton Rouge. Or take the old tunes off the shelf at Preservation Hall in New Orleans. Uptown in the Crescent City, clubs such as Tipitina's (named for a song by the late Professor Longhair) or the Maple Leaf Bar present Louisiana musical legends or legends-to-be from Kid Shiek to Beausoleil, Dewey Balfa, Johnny Rivers, Fats Domino, John Delafose and the Eunice Playboys, Clifton Chenier and the Neville Brothers. Other New Orleans venues range from friendly to formal in style: the Dream Palace, the Alhambra, the Blue Room, the Glass House and the Saenger.

East of the Anglo/French border town of Baton Rouge, the Old South Jamboree in Walker brings in aging rockabillies and falling country stars, as well as local bands like the Livingston Parish Deputy Sheriffs. Farther north, Louisiana nights get serious in juke joints like the African Queen in Ferriday and a string of other black blues, soul and disco clubs from Newlight to Lucky. The white north Louisiana saloons are equally intense with beer drinkin', tear jerkin' activity, steel guitars, jeans and cowboy boots. At the bar the conversation is often about the job, the family or the good-looking person at the end of the bar.

Alabaman Hank Williams, who played on the old "Louisiana Hayride" in 1948 and again in 1952, penned the classic song about Louisiana's Saturday night. "Jambalaya" neatly tied north and south together with its country instrumentation, nasal vocal style, Cajun melody and dance hall ambiance. "Jambalaya, crawfish pie, *filé* gumbo . . . 'cause tonight I'm gonna see *ma chère amie-o.*"

If anything symbolizes the celebratory spirit in Louisiana more than the song "Jambalaya," it is Mardi Gras . . . where every man can be a king, fool, clown, woman, beast or something in between. The old books speculate that Carnival originates in the Bacchanalia or Saturnalia or, earlier, a pageant to a pre-Roman goddess of fertility. Today New Orleanian antiquarians debate Mardi Gras' nineteenth-century origins on the Gulf Coast — the Crescent City or Mobile? In New Orleans the Carnival season begins on January 6, or Twelfth Night, the Feast of Kings, and vibrates forward within the liturgical cycle up to the Shrove Tuesday explosion (originally the time to be "shriven" of one's sins) just prior to the solemn penitential days of Lent.

People enjoy grabbing for the throws of the old-line krewes of Carnival such as Comus, Rex and Proteus. These krewes and their balls form the core of the old Anglo-Creole aristocratic social structure of the city. In the streets they parade as royalty throwing "valuables" to the masses. They are attended by a symbolic servant class holding their horses by day and carrying their *flambeaux* at night. Their private balls project the royal image with strict guest lists, formal rules, debutantes and *tableaux.*

Out on the street Mardi Gras is another story. Folks with Schwegmann's grocery bags full of beads, plastic cigars, doubloons and giant toothbrushes flaunt their role as symbolic proletarian consumers. The never-would-be royalty from some neighborhoods get their chance throwing beads from truck floats. In the French Quarter gays take the opportunity to costume competitively and elaborately. Perhaps the most humorously regal of all celebrants are the men and women of Zulu. This major black Carnival organization hilariously spoofs the formality of the white krewes while exploding black stereotypes in the costumed overstatement of "wooley wigs,"

grass skirts and ultra-black faces with white eyesockets. From their floats comes the ultimate Carnival throw—now handed out due to city ordinance—the gilded coconut.

All the "How to Survive Mardi Gras" handbooks in the world can't quite explain to amazed tourists just what Mardi Gras means about life in New Orleans. Furthermore, few natives venture to some parts of the Crescent City to add diverse aspects of Mardi Gras to their Carnival knowledge. Still mysterious to many Orleanians, for example, are the Mardi Gras "Indian tribes" from black neighborhoods that parade in stylized Plains Indians costumes. They dance and chant in Afro-Caribbean style as the tribe moves from bar to crossroads to bar under the leadership of a "Big Chief" aided by a "Spyboy" with an entourage of "second-liners" falling in behind. Like their cultural counterparts in Haiti, Trinidad and other West Indian islands, warriors engage in what are now mock battles. Throughout the day they show pride in brotherhood, neighborhood, costume and craftsmanship, while honoring the American Indian as a symbol of resistance to domination.

In rural French Louisiana, Mardi Gras takes on a different flavor. Rather than clustering in urban streets for doubloons and trinkets, horse-mounted riders form an entourage in small towns for a 15-20 mile tour through the countryside. The *capitaine,* a sober, gallant and unmasked leader, takes his band of *paillasses,* or clowns, from house to house seeking *charité.* They drink and ride the whole day, dancing with one another and chiding in French, "*Une poule par an c'est pas souvent*" (A chicken a year is not so much). At each house they wait for the moment when a live bird is offered so that a chase past gardens and trash piles, over fences and pigsties and out into the muddy rice fields can begin. Sometimes the provider turns the tables and throws a frozen chicken in jest at these beggar-outlaw-clowns. The masked men are undaunted in leaving as they sing, "*On vous invite pour un gros bal et gumbo ce soir*" (We invite you to a big dance and gumbo tonight).

The *capitaine* tries to keep the riders somewhat sober, but by the end of the day-long run, many are nearly prone on their mounts. Still they summon all their concentration, ride back into town to the jubilant, waiting crowd for gumbo, beer and boasting. At sundown the dance begins. Those who can make it, waltz and two-step until midnight when the fleshy excesses of Mardi Gras throughout the Latin world, from Mamou and Church Point to Rio de Janeiro and Rome, turn into the ashes of penitance. It is a festive death after a festive climax, but resurrection is not so far away.

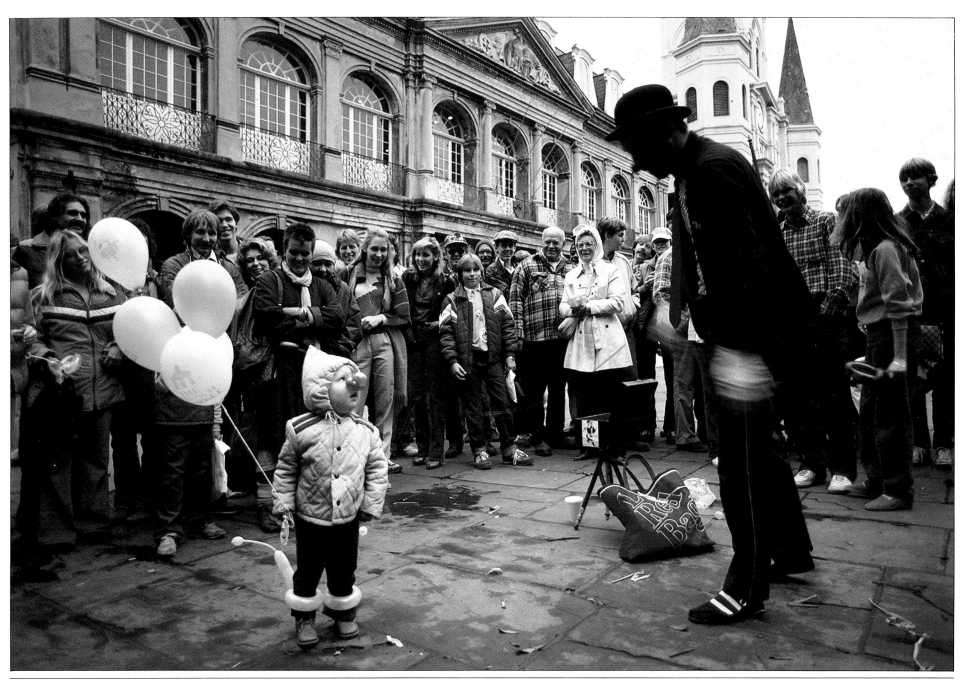

BALLOONS ON JACKSON SQUARE; *NEW ORLEANS*

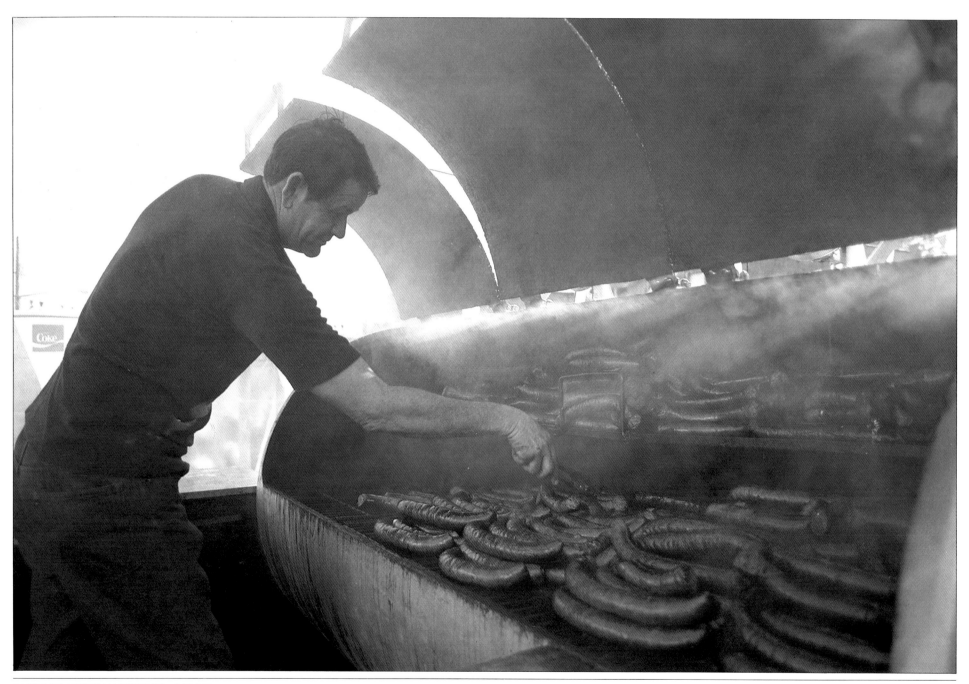

SAUSAGE AT PECAN FESTIVAL; *COLFAX*

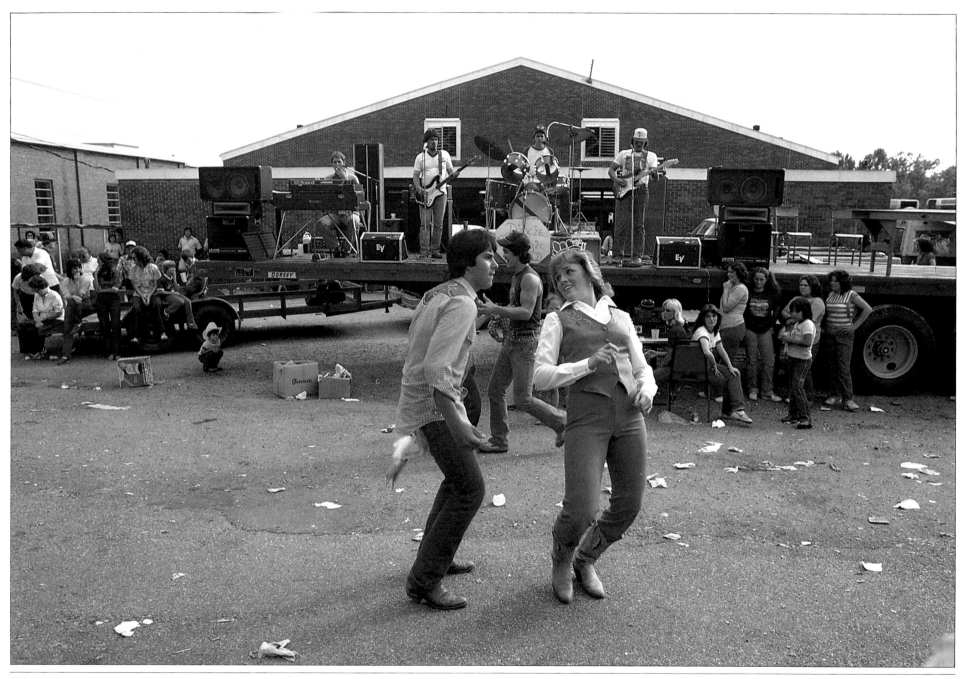

LAST DANCE FOR QUEEN OF TAMALE FESTIVAL; *ZWOLLE*

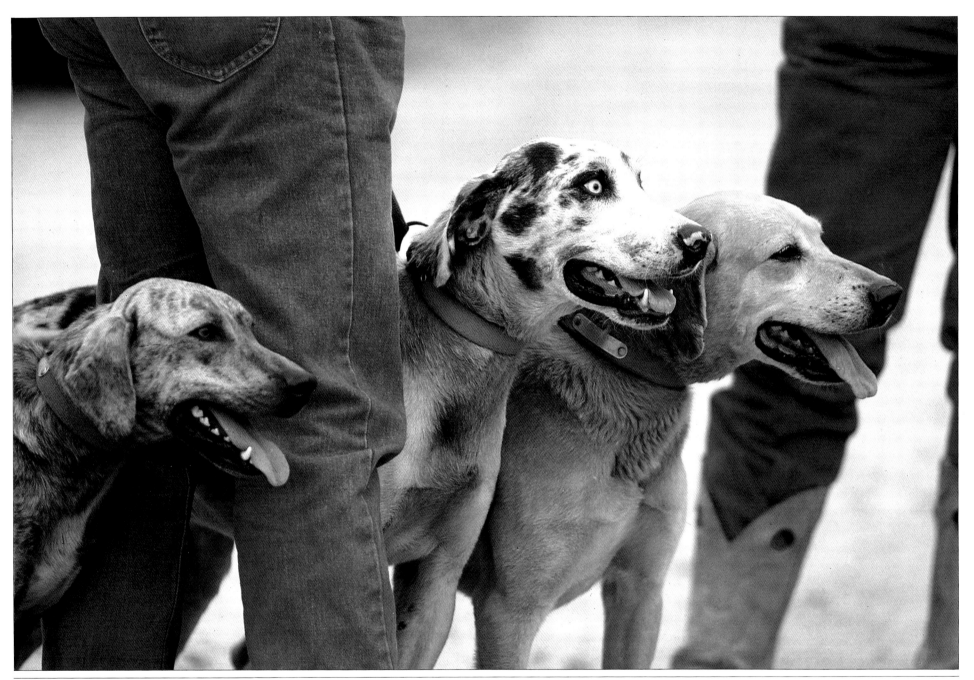

CATAHOULA COW DOGS; *DENHAM SPRINGS*

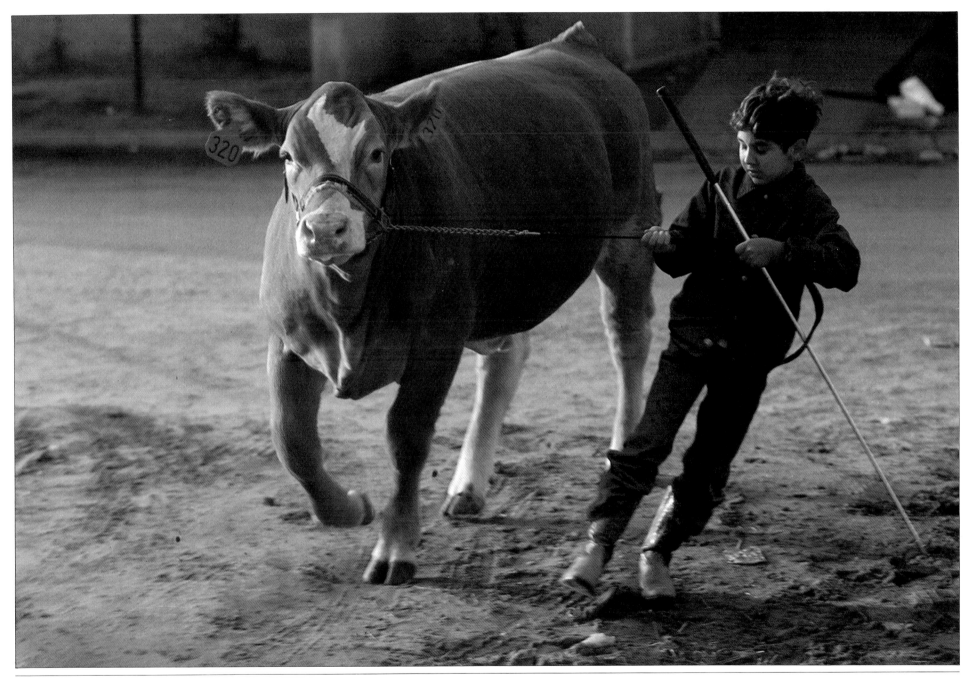

LEADING MASTER TO STATE FAIR CATTLE JUDGING; *SHREVEPORT*

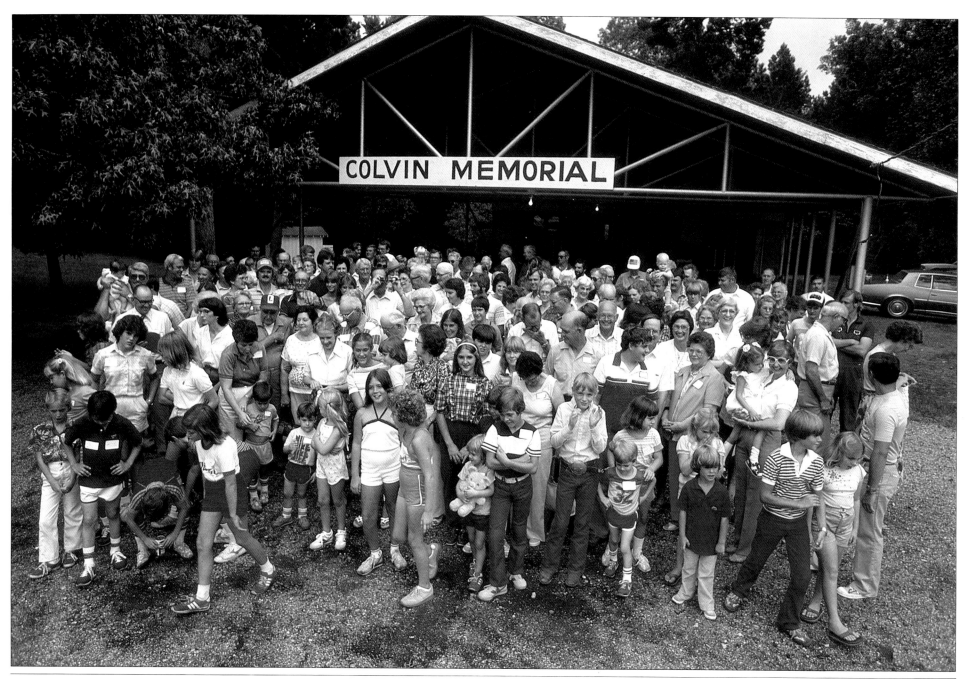

COLVIN FAMILY REUNION: *UNIONVILLE*

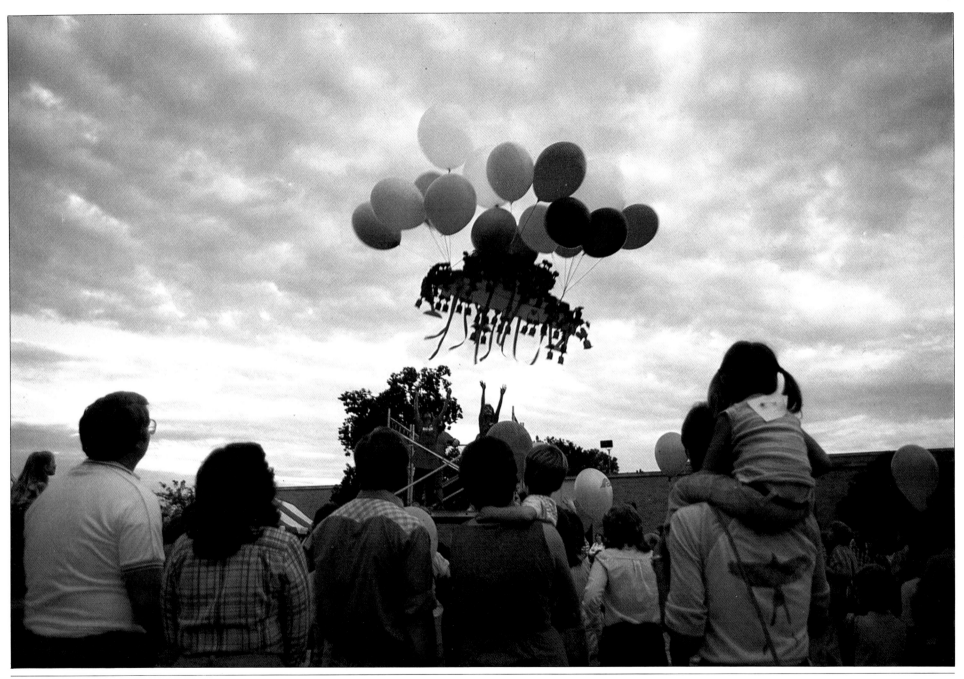

LAUNCHING OF SKY SCULPTURE, RED RIVER REVEL; *SHREVEPORT*

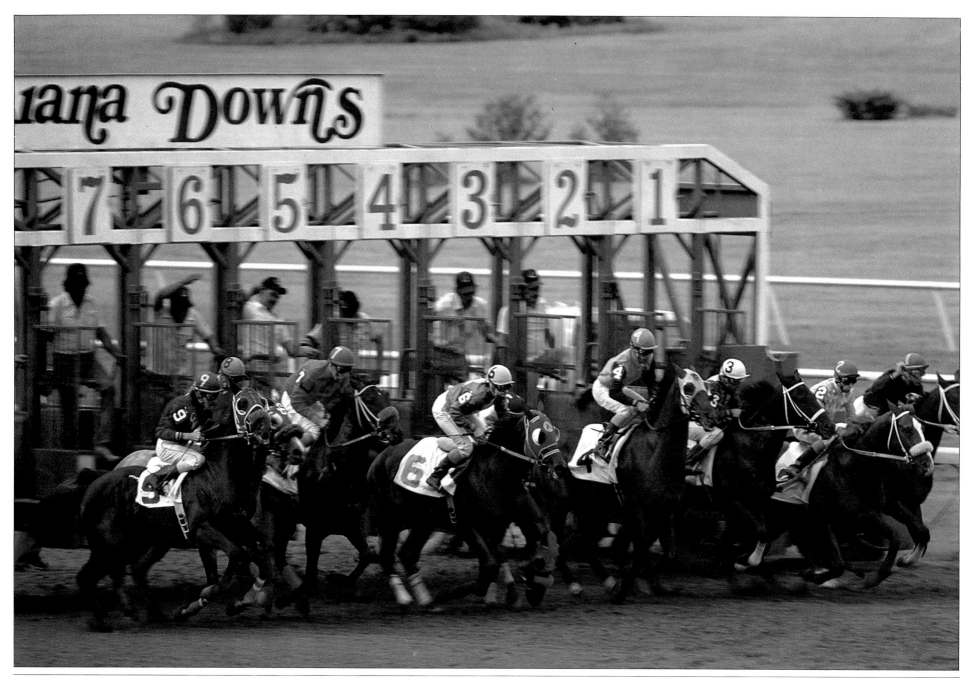

LOUISIANA DOWNS; *BOSSIER CITY*

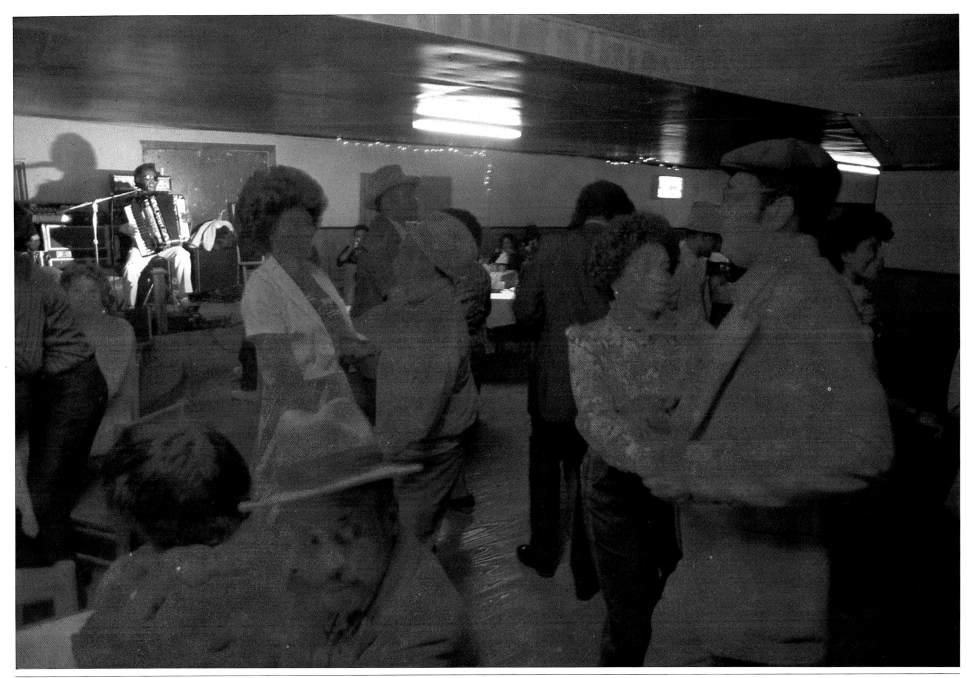

ZYDECO ACCORDIONIST CLIFTON CHENIER AT CASINO CLUB; *ST. MARTINVILLE*

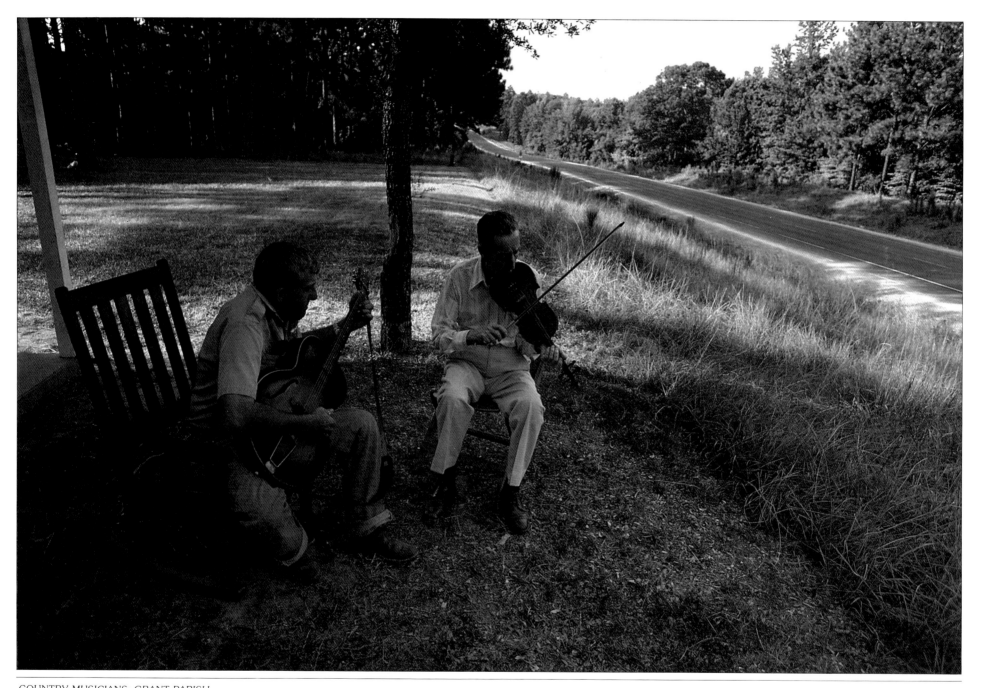

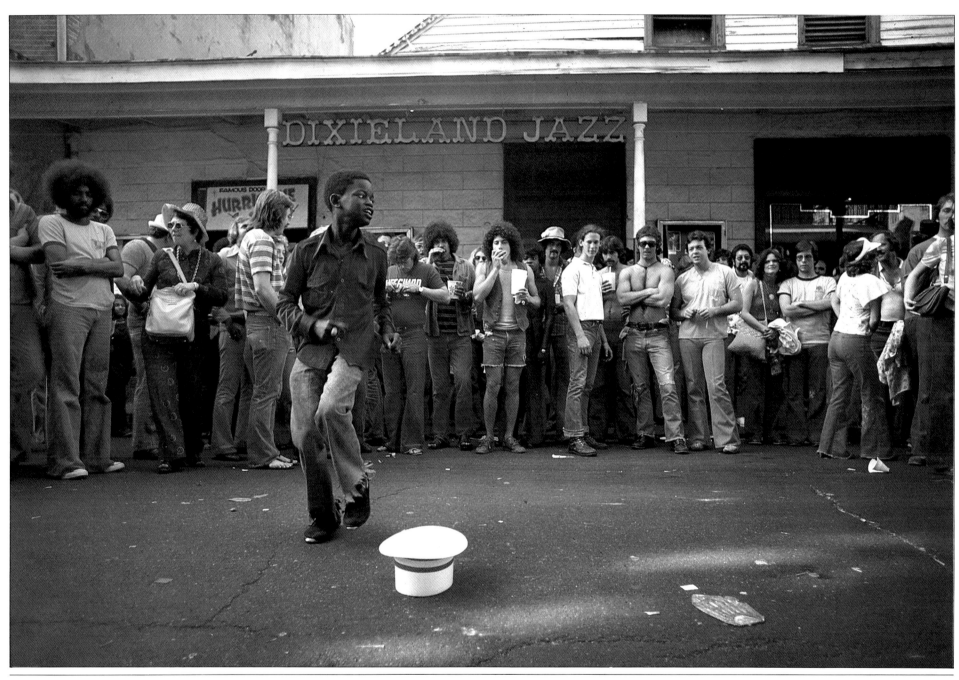

DANCING IN FRENCH QUARTER; *NEW ORLEANS*

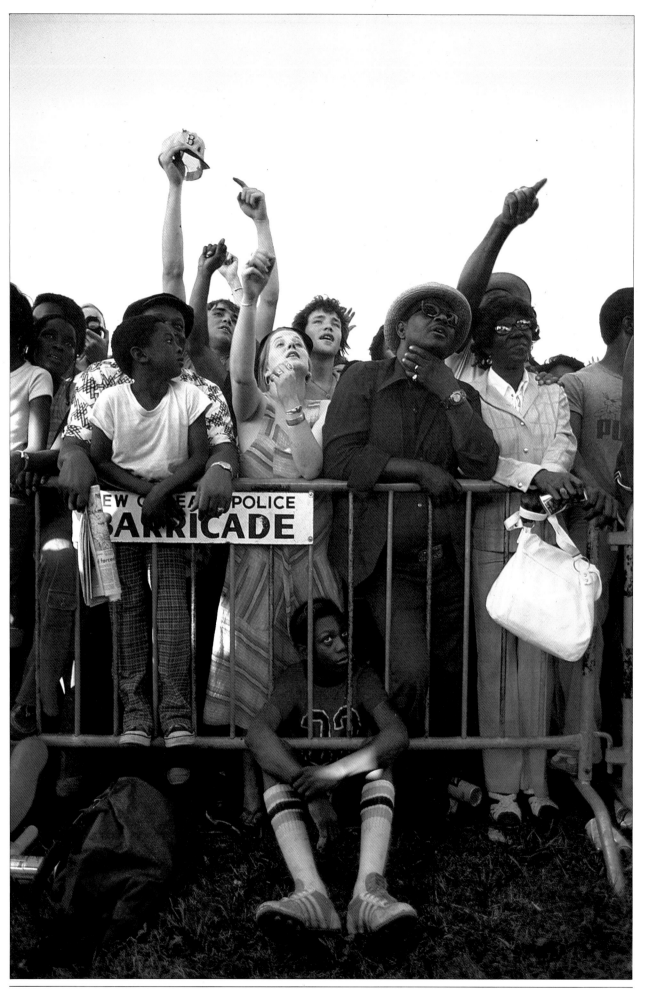

WATCHING B.B. KING AT JAZZ AND HERITAGE FESTIVAL; *NEW ORLEANS*

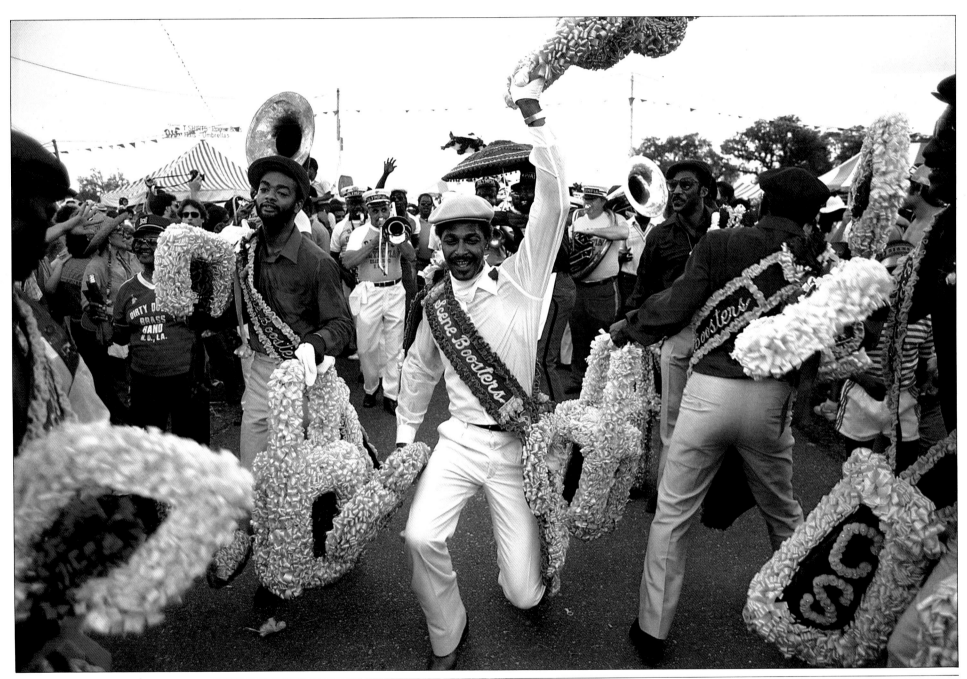

SCENE BOOSTERS AT JAZZ AND HERITAGE FESTIVAL; *NEW ORLEANS*

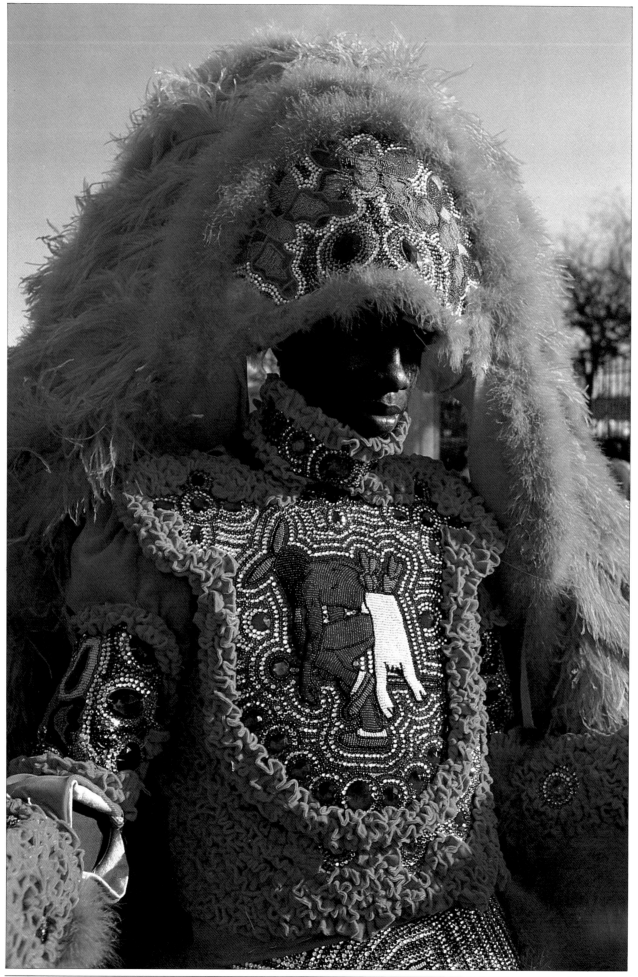

MARDI GRAS INDIAN; *NEW ORLEANS*

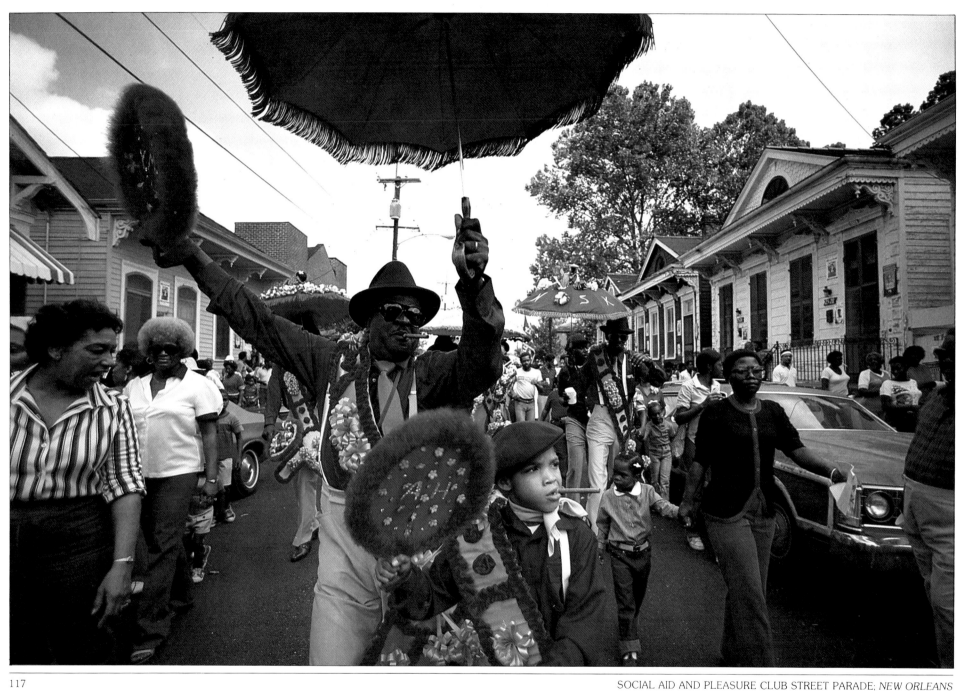

SOCIAL AID AND PLEASURE CLUB STREET PARADE; *NEW ORLEANS*

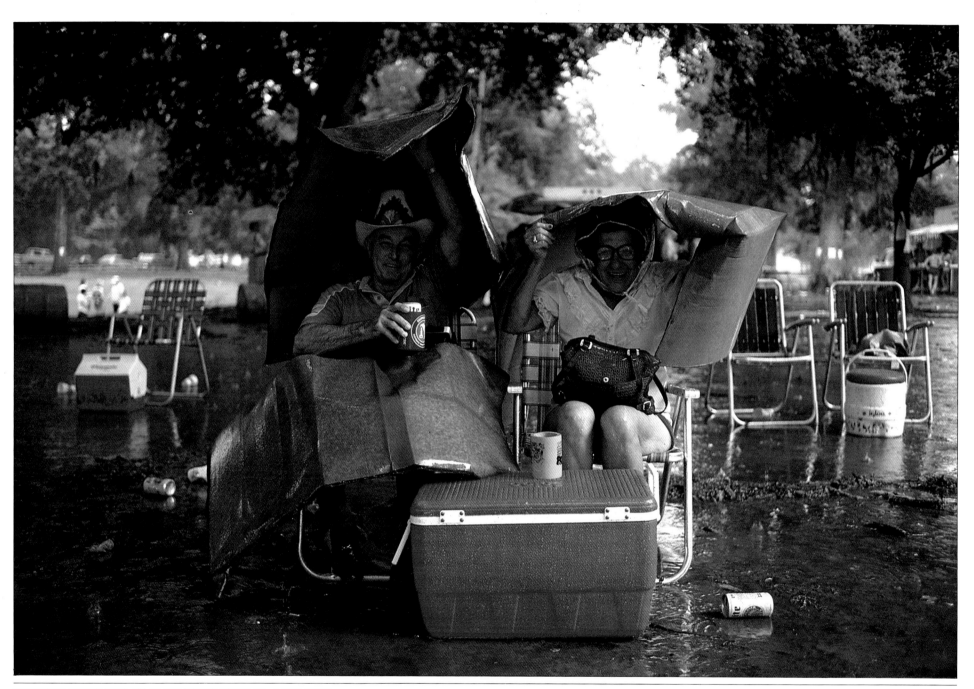

MONSOON SURVIVORS AT CAJUN MUSIC FESTIVAL; *LAFAYETTE*

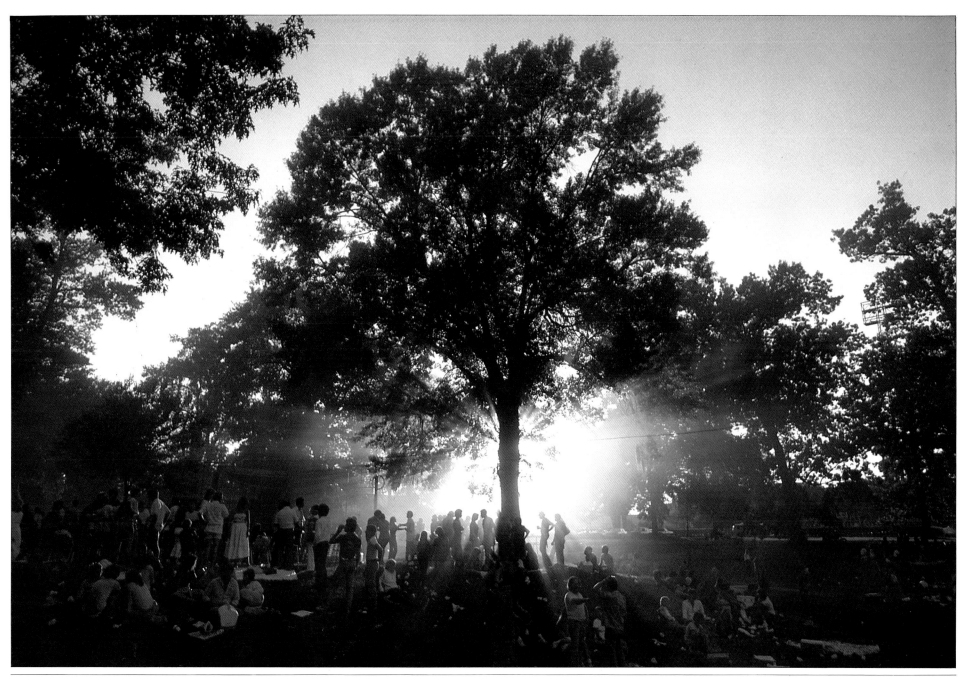

CAJUN MUSIC FESTIVAL; *LAFAYETTE*

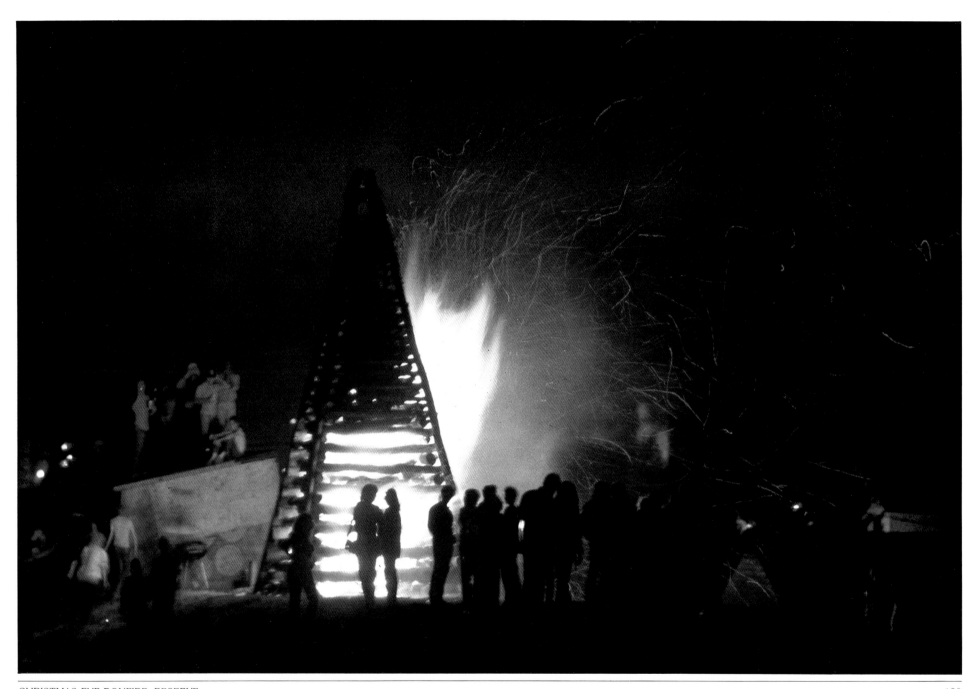

CHRISTMAS EVE BONFIRE; *RESERVE*

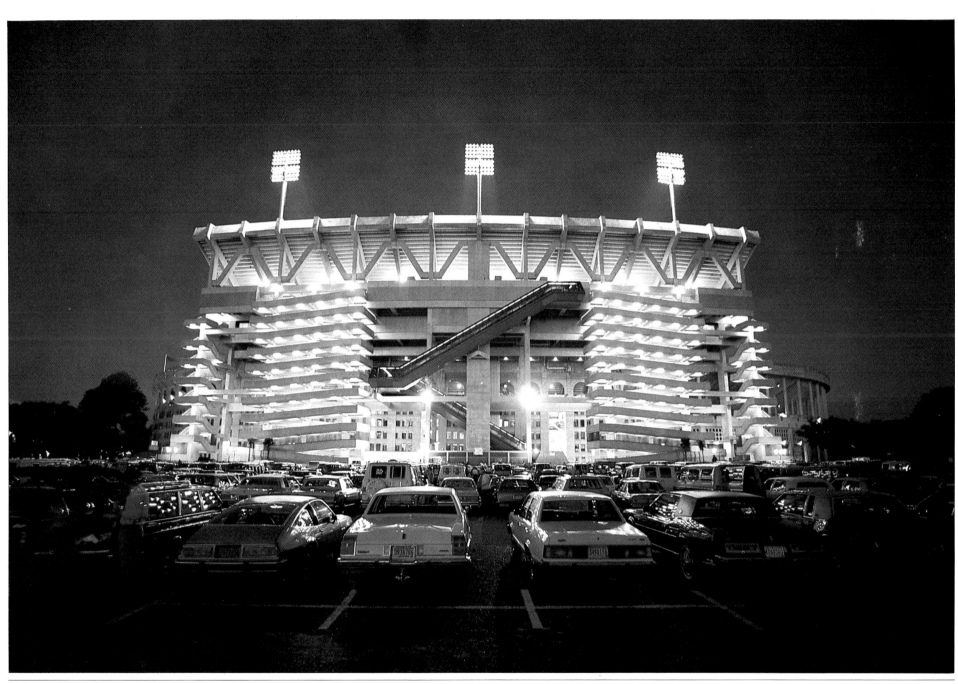

TIGER STADIUM, LSU; *BATON ROUGE*

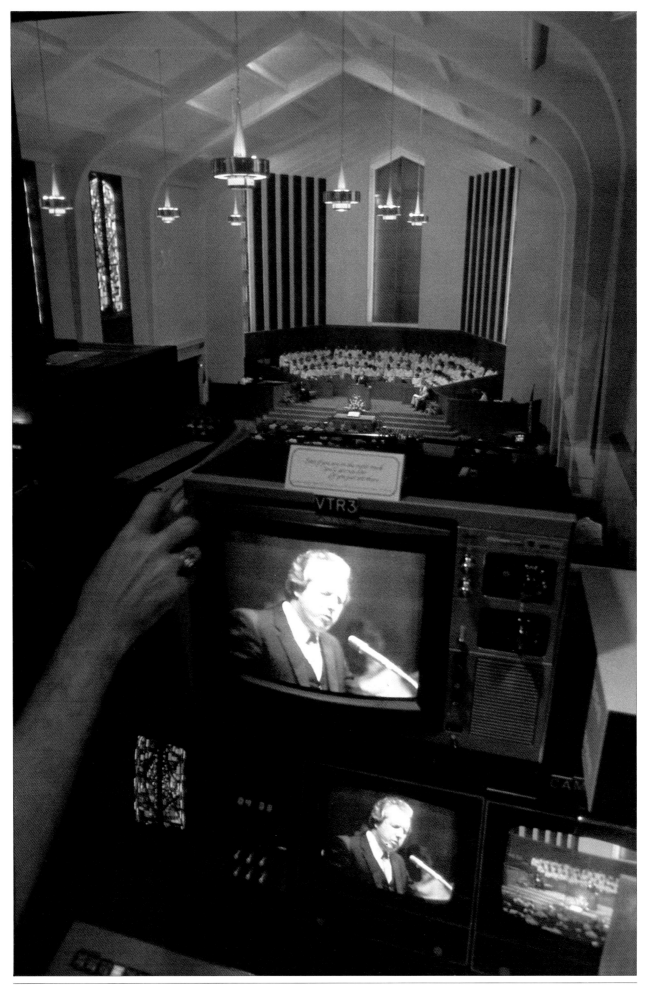

TELEVISED BAPTIST SERVICE; *SHREVEPORT*

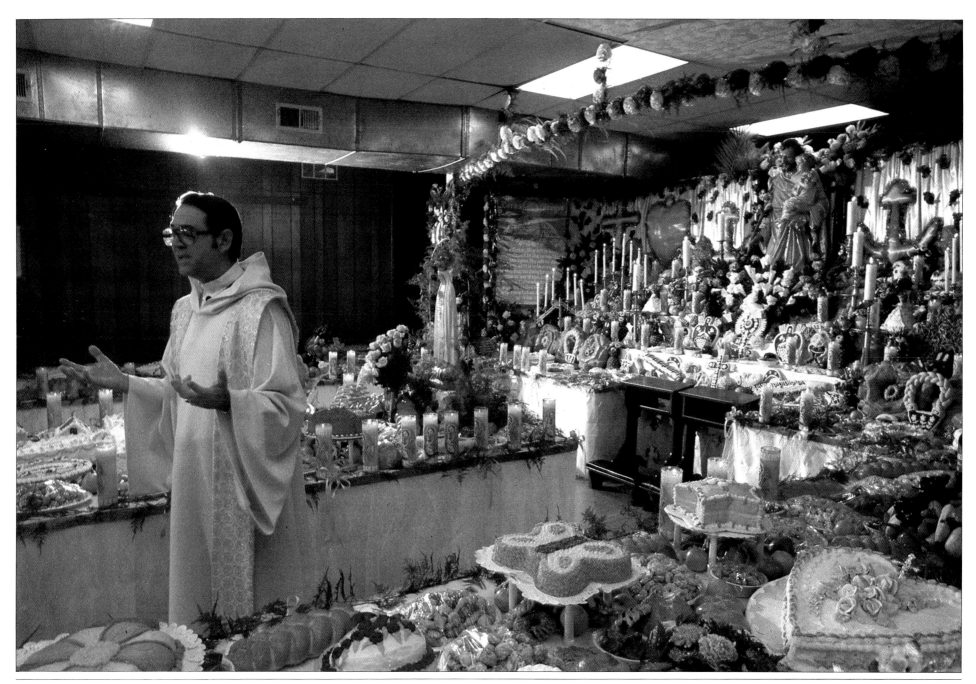

ST. JOSEPH'S ALTAR; *MARRERO*

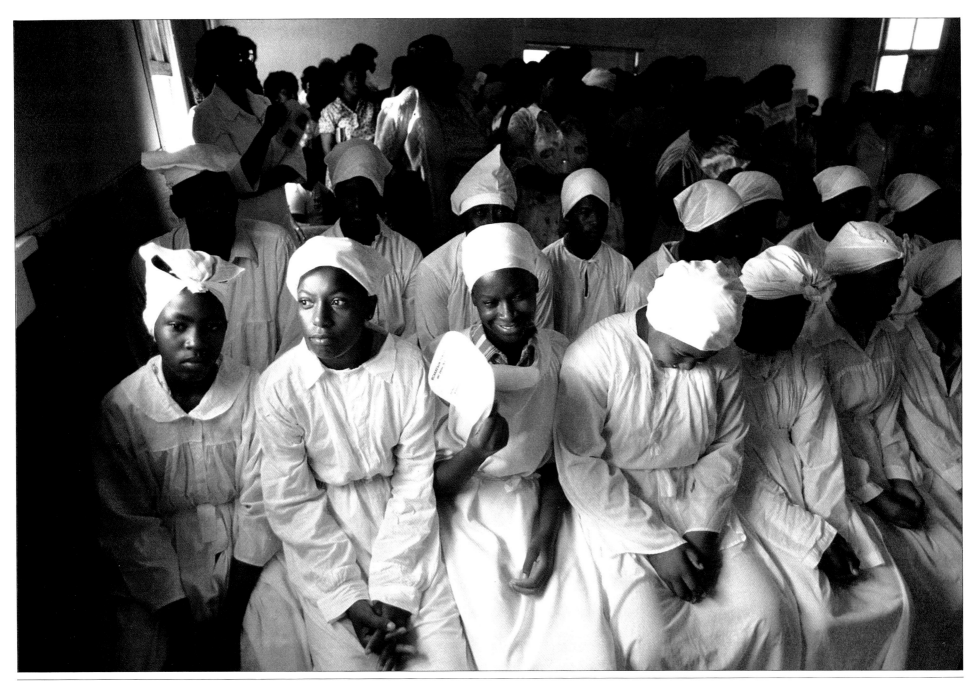

BAPTISMAL CANDIDATES; *NEWELTON*

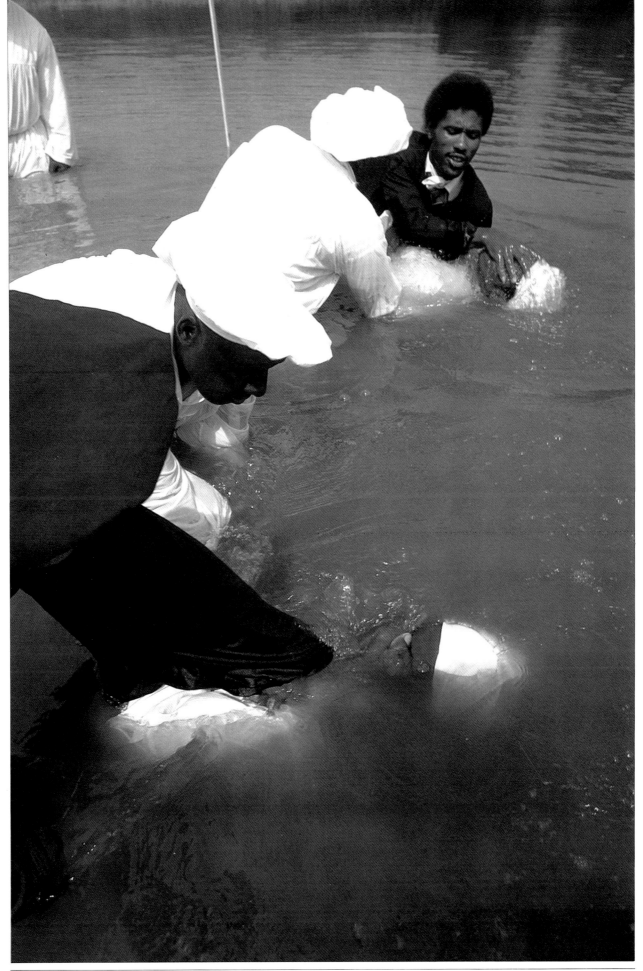

RIVER BAPTISM; *NEWELTON*

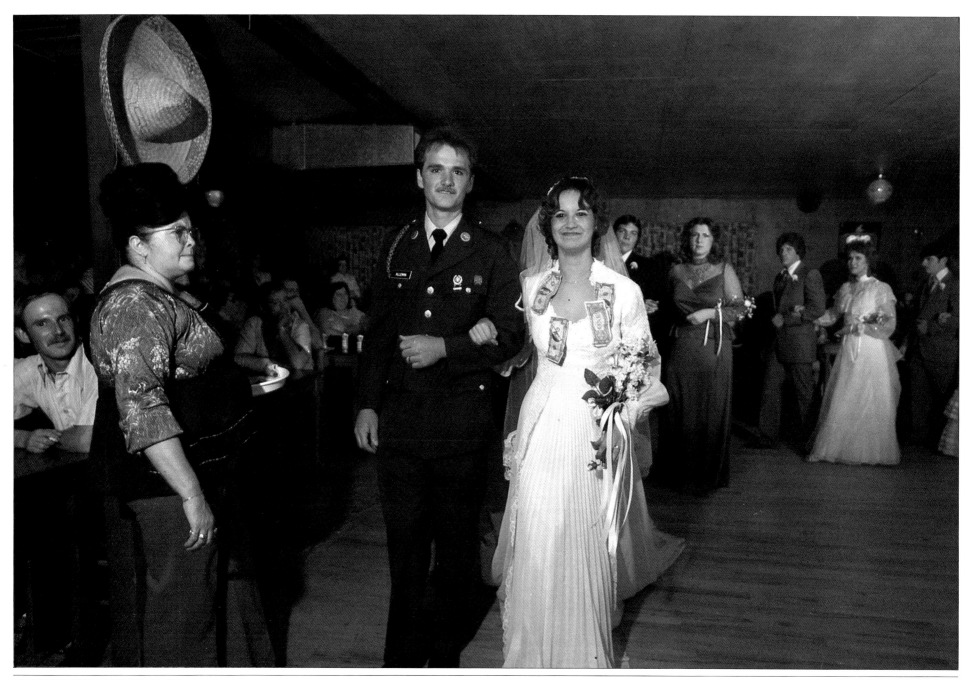

CAJUN WEDDING MARCH; *SCOTT*

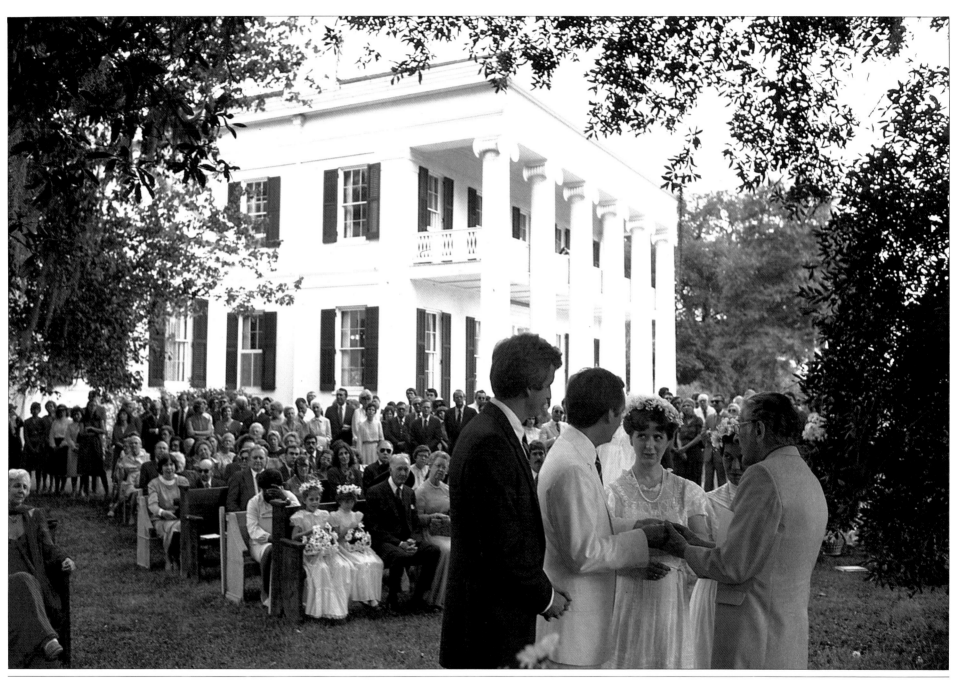

WEDDING AT MADEWOOD PLANTATION; *NAPOLEONVILLE*

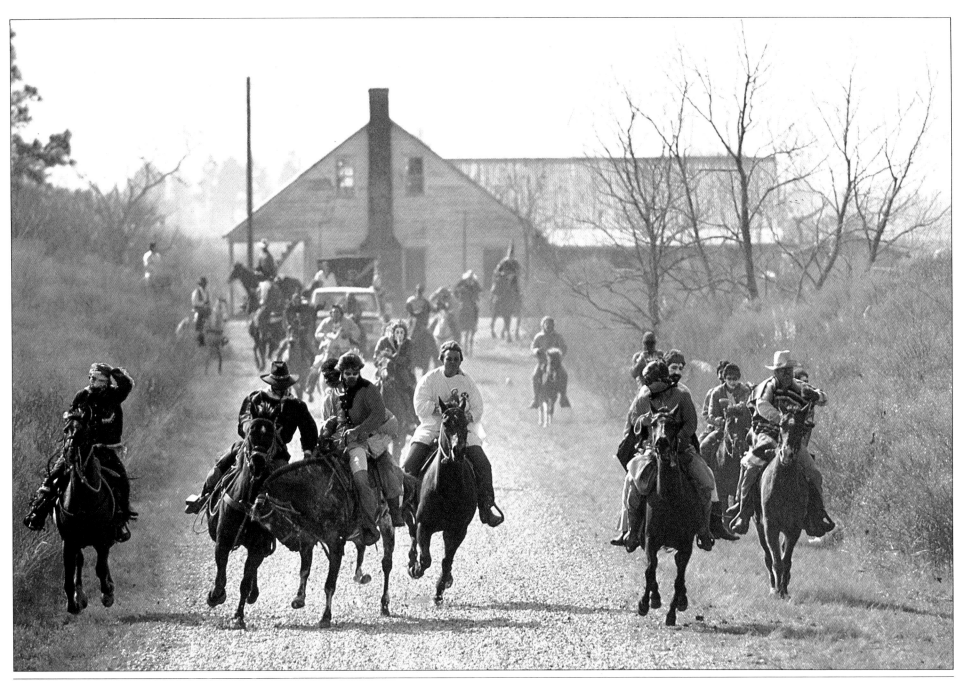

CAJUN MARDI GRAS RUN; *CHURCH POINT*

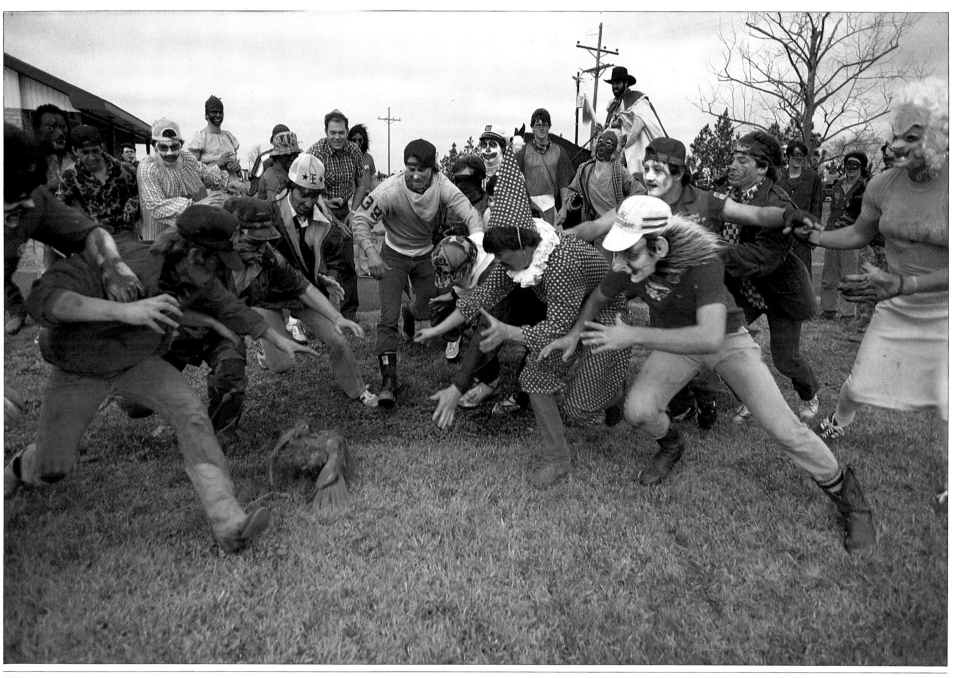

CHICKEN CHASE; *CHURCH POINT*

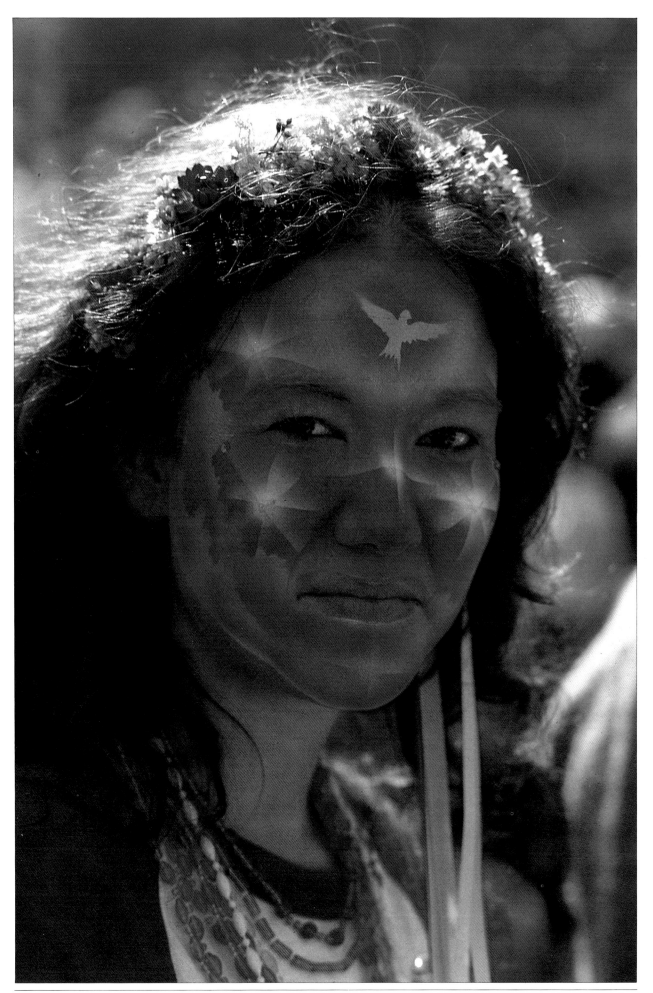

MARDI GRAS CELEBRANT; *NEW ORLEANS*

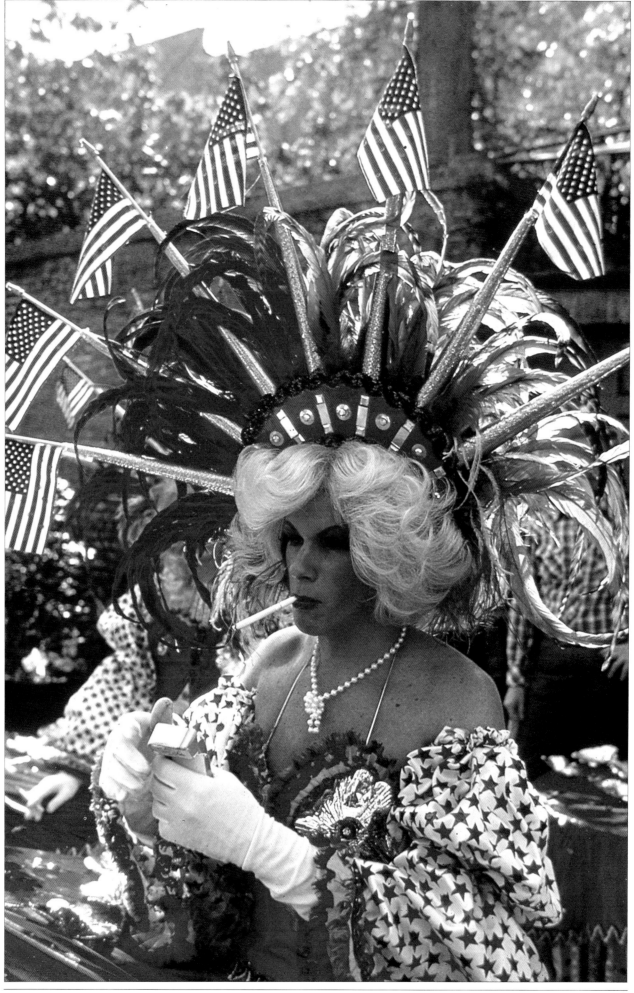

MARDI GRAS CELEBRANT: *NEW ORLEANS*

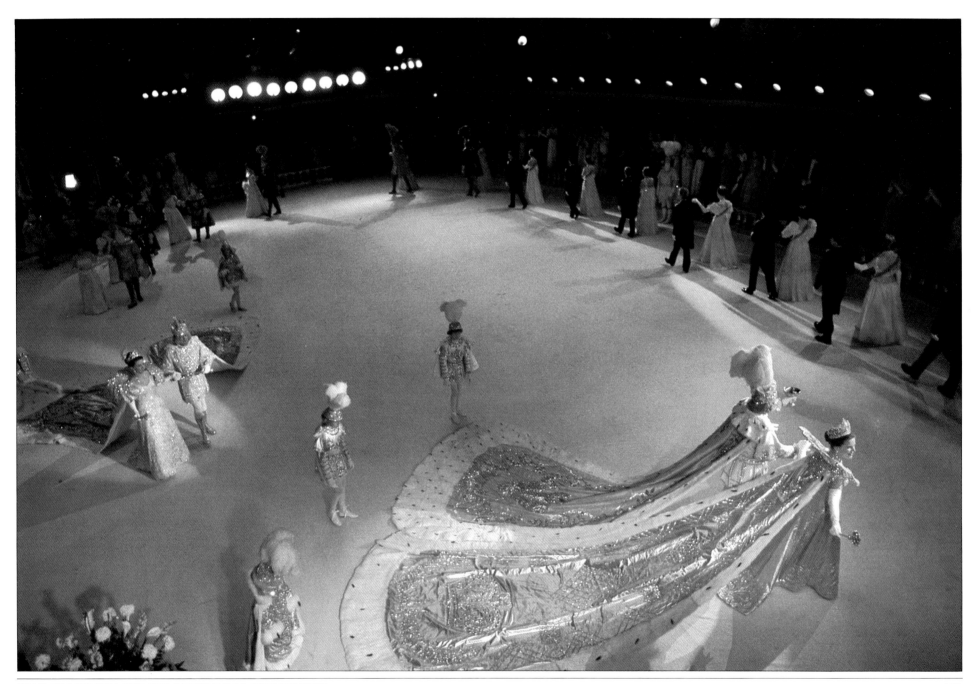

FINAL PROCESSION, REX AND COMUS BALLS; *NEW ORLEANS*

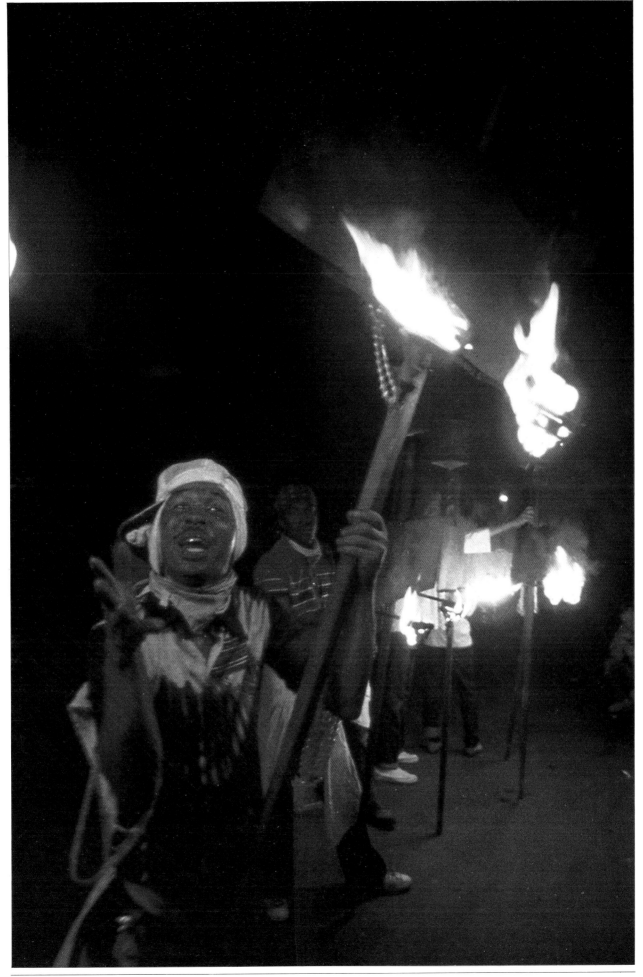

FLAMBEAUX CARRIER; *NEW ORLEANS*

AND DEATH

For Louisianians, like all people, fascination with death is often tied to the celebration of life. Attending to the death of others makes people come to grips with the certainty of their own end. Births unite people as they celebrate the perpetuation of mankind. So death brings together relatives, friends, even foes. Death evokes eternity and life in the hereafter. Death rituals often celebrate those who live as much as those who die.

A jazz funeral is a good example of death as celebration in Louisiana, drawing upon the West African tradition of heralding departure for the afterlife. When a New Orleans black musician or other luminary dies, a funeral parade is formed to honor him. Marching bands—Onward, Young Tuxedo, The Dirty Dozen, and Olympia—accompany the coffin with family and friends in a procession from the church to one of the city's vault-filled cemeteries. Led by a solemn-faced marshall, the bands play the appropriate dirges and march with a slow, respectful gait. "Just a Closer Walk with Thee," "Amazing Grace" and "Eternal Peace" are lined out by tubas, clarinets, saxes and drums as the mourners follow the deceased to his resting place. The marshall, a ribbon swathed across his chest and white doves of peace on his shoulders, maintains the pace and mood along the route.

Once the coffin arrives at the graveside and the formalities are completed, the band "cuts loose" the body, leaves the cemetery and swings back to town playing joyful music. The basic gravity shifts as the music speeds up, the solos fly and the step quickens. Faces light up as the marshall, band and "second lines" of friends and onlookers dance to "Didn't He Ramble," "It Feels so Good," and "Bourbon Street Parade."

The celebration of death and departed ancestors throughout Louisiana may seem morbid, but people continue to participate in the traditions of graveyard "scrapings" and all-day sings on church and burial grounds in the north, and the annual return to the cemeteries for All Saints Day to paint and clean tombs in the south. Some claim Louisiana's State Capitol is itself a gigantic tombstone marking the grave of Huey Long, its fallen builder (no matter that he died after it was erected). Tourists who visit Long's grave on the grounds are just as likely to seek out the Capitol's marble wall struck by his assassin's bullets.

Cemeteries in Louisiana are beautiful environments unto themselves. Best known are the above-ground tombs of French Louisiana. Built in a southern European vault style and raised above the high-water table, the ornate Catholic tombs feature statue decorations, inlaid shadowboxes, wreaths and crowns of flowers.

There are also a large number of religious shrines found in south Louisiana, some in cemeteries, but many others in towns and along roadsides. These shrines, which commemorate the lives and deaths of the saints, range from the medieval style of New Orleans' St. Roch Cemetery No. 1 — filled with discarded artifical limbs and other signs of triumph over affliction—to the St. Martin of Pourres (a black saint) vestibule in the tiny town of Davant on the east bank of the Mississippi River in Plaquemines Parish. Commemorating the death and rebirth of Christ are the remarkable roadside Stations of the Cross, reminiscent of similar Latin American Catholic displays, on the route from St. Martinville to Catahoula. In nearby St. Martinville printers still occasionally mark local deaths with small broadsides announcing "Died" tacked to telephone poles.

Items added to tombs and cemetery markers vary according to ethnicity and place. The graves in St. Bernard Parish occasionally have a small shrimp boat model set next to the Virgin Mary and flowers behind glass. Nearby, Filipino tombs in Lafitte may sport gilded conch shells on their surface. The Houma Indians near Dulac sometimes adorn their graves with shells as well as heart-shaped shadow boxes filled with icons. On the other hand, Jesuits buried in the Grand Coteau cemetery near Lafayette are set under straight, unmarked rows of simple crosses—appropiate perhaps to such soldiers of God.

South Louisiana cemeteries come to life in late October as families whitewash tombs and place wreaths of artificial flowers to honor dead ancestors on All Saints Day. In New Orleans the stacked vaults in the walled "cities of the dead" are suddenly shelved with flowers. In Lacombe across Lake Pontchartrain and in Barataria to the south, night services with flickering candle processions mark the remembrance of the dead in heaven and the wish for release of souls from purgatory. The candlelit white vaults project a sense of other worldliness to family and friends visiting at night.

North Louisiana Protestant graves are generally stark, down-to-earth and in the ground. The cemeteries, however, are not without

their special markers and ceremonies. The return to family plots for graveyard scraping, though an increasingly rare tradition, is still carried out as families come annually to remove weeds from around the graves. In Marthaville, near Natchitoches, people have gathered for years for a picnic and sacred singing at the tomb of an unknown Rebel soldier. Recently the affair has turned into an all-day, country music festival. What was a small music program in the 1960's has now become a major May event as Louisiana gospel quartets and string bands as well as country and western stars like George Jones sing in honor of the fallen Confederate.

The cemeteries of north Louisiana vary a great deal. Sometimes simple, roughed out graves are marked by reddish iron rock. In the hill country, graves are laced with stones or marked by cedar trees planted at head and foot. Granite spires and large family plots of the planter aristocracy are sometimes set apart with small fences. Black graveyards are occasionally decorated with objects used by the deceased, such as old light bulbs, bits of china and plastic cigarette packs. Also found on some black graves are special symbols of death, eternity and rebirth such as an egg or old clock. The personal touch of a hand-lettered, homemade cross often enhances the dignity of such simple graves. Some black Baptists in places like Natchitoches and Baton Rouge have also picked up Catholic traditions such as All Saints ceremonies which they refer to by the French word, *Toussaint,* without knowing an English translation.

Cemeteries speak silently about settlement, immigration, family life and change in a community. Prehistoric Indian middens and burial mounds are among our earliest evidence of cultural change. The grandest marker of all to an entire past civilization is the awesome earthworks site at Poverty Point (700 B.C.) in East Carroll Parish, thought by some to have been used in primitive astronomy and ceremonials. Many people feel it served as the governmental and religious center of a culture that covered a vast area of North America. Recently archaeologists, using satellite photography, have intensified the quest for the meaning of this ancient site.

Near Angola recent finds of Tunica burial treasures have sparked debate concerning the present and future rights of Indian cultures. In Sabine Parish, clustered tombs on a forested hill mark the gradual Anglicization of Indian and Spanish people there. Over generations, names like Garcia and Ramirez have become Garcee and Remedies. In Baton Rouge, Union dead from the Civil War lie in symmetrical rows under white crosses and the Stars and Stripes. Nearby in East Feliciana Parish a family graveyard reveals the family's New Jersey origins, hence the name "Blairstown" for the plantation they acquired. Today in New Orleans old Creole ladies continue to repaint the French names on the family tombs. The less socially minded still mark New Orleans voodoo queen Marie Laveau's nineteenth-century vault with X's wishing to invoke her power to "cross" their adversaries.

The whole landscape of Louisiana speaks of death as well as life. The neoclassical ruins of the Cottage Plantation on the River Road below Baton Rouge recall the demise of past civilizations. The remains of DeLaronde Plantation in St. Bernard Parish are perched awkwardly on the crowded neutral ground of the Chalmette Highway amongst fast-food stands and poodle-grooming parlors. The plantation's crumbling red brickwork reminds those who drive past it that they too may one day be buried under highways, suburbs, hamburger joints or landfills. Cultural geographer J.B. Jackson has suggested that there is a "necessity for ruins" in human civilization. Such remnants remind us of our individual mortality, our cultural and spiritual connectedness to the past and our hope for perpetuity. Rotting log cabins in the north Louisiana hills, vine-covered sawmills, boarded-up shotgun shacks and even Depression-era oil derricks that dot the Atchafalaya Basin tell of changes in peoples' lives and livelihoods.

These secular ruins as well as our sacred cemeteries and death-related rituals recall the ways people have worked, celebrated life and passed out of it. Louisiana is replete with such silent messages and surviving ceremonies on its landscape, through which its people commemorate the past or ponder the present and future.

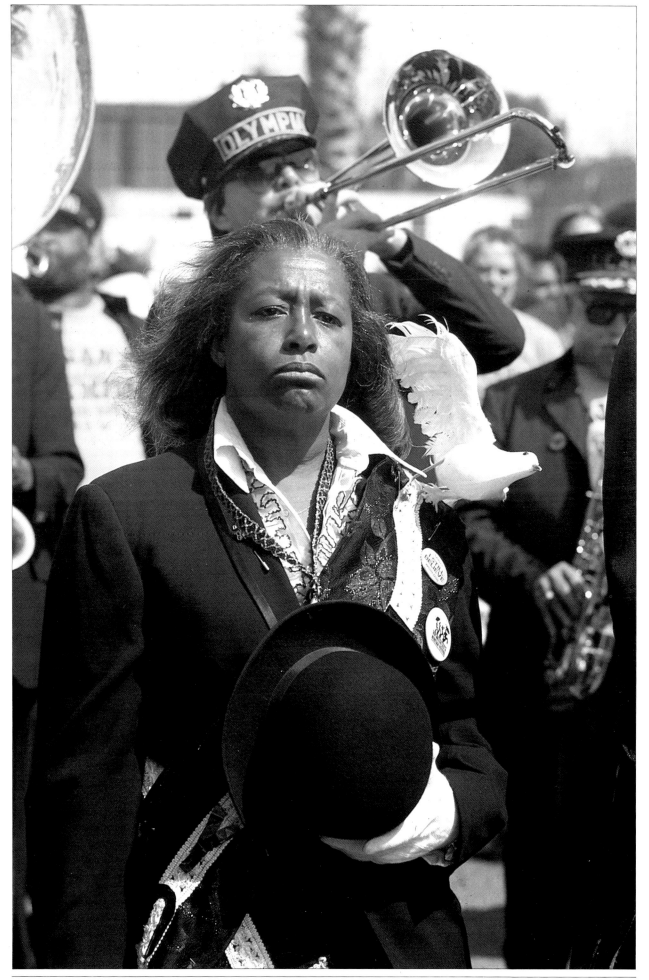

JAZZ FUNERAL; *NEW ORLEANS*

ALL SAINTS DAY PRAYER AT ST. ROCH'S CEMETERY; *NEW ORLEANS*

VISITING FAMILY CEMETERY; *UNIONVILLE*

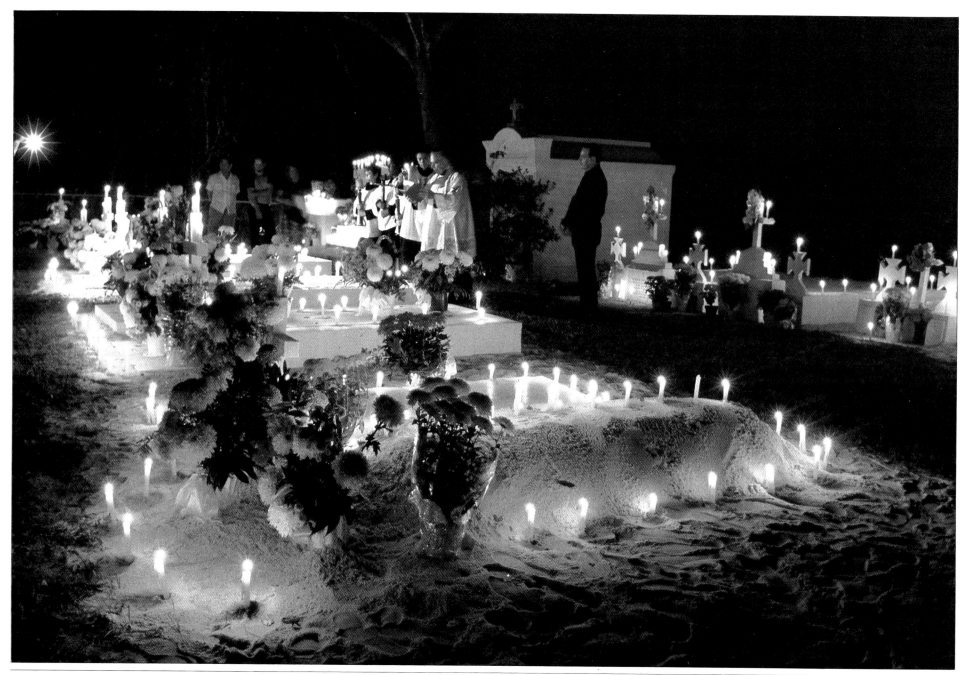

CEMETERY ON ALL SAINTS DAY; *LACOMBE*

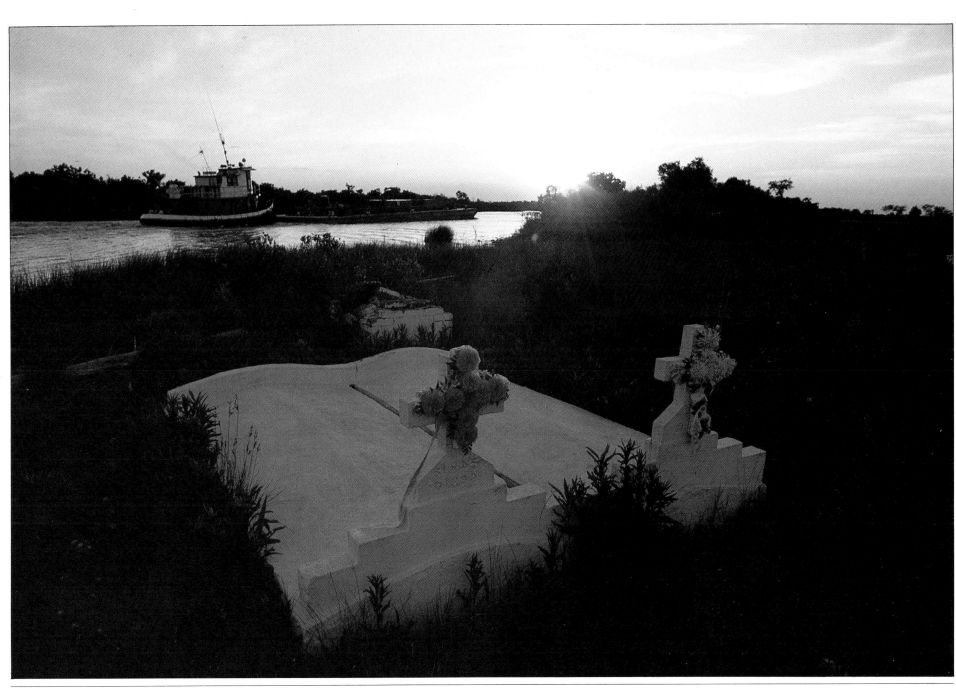

MARSH GRAVE; *LEEVILLE*

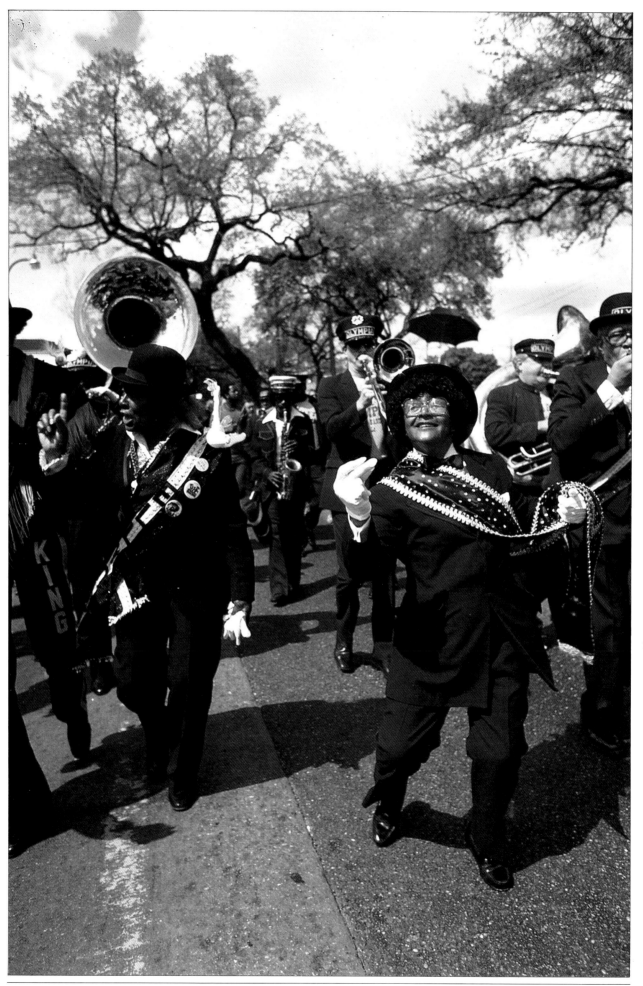

CUTTING LOOSE AT JAZZ FUNERAL; *NEW ORLEANS*

CREDITS AND ACKNOWLEDGMENTS

Barry Ancelet
Dewey Balfa
Hal Beridon
Thomas and Lynn Bertuccini
Catherine Bon
Gerald Breaux
Richard and Hal Broussard
Linwood and Irene Cheramie
Hank Danos
Jean Evans
James and Susan Edmunds
Joel Gardner
GEO Magazine

H.F. Gregory
Greg and Mary Guirard
Joseph Guillotte
C. Paige Gutierrez
Buck and Penny Guynes
Jeff Hand
Randy Haynie
Pat and Jean Hurley
Ruth Colvin Jones
John Kelly
Randall and Sandy LaBry
Amanda La Fleur
Vance and Liz Lanier

Susan Levitas
Patrick and Elizabeth Little
Louisiana Life Magazine
Don Marshall
Giffie Marshall
Tom and Nancy Marshall
Steve and Cherry Fisher May
Judith Meriwether
Elemore and Mary Morgan Jr.
Jim and Lily Morrow
William, Todd, Ryan and Lee Nevitt
Tom and Marjorie Nevitt
Nancy Oschenslager

Print Media Inc.
Denis Reggie
Ed Micheal Reggie
Margaret Ritchey
Susan Roach
Jana Rush
Ben Sandmel
Marc and Ann Savoy
Larry Sides
Michael P. Smith
SOHIO
Nicholas R. Spitzer
Martin Vandiver